The Sacred Community

The Sacred Community
Art, Sacrament, and the People of God

David Jasper

BAYLOR UNIVERSITY PRESS

Cover Design by Natalya Balnova
Cover Image: "Mountain, Ode to the Land," by Ding Fang. Provided courtesy of the artist. © Ding Fang.

Paul Celan's poems "Illegibility" and "Psalm" are from *Poems of Paul Celan*, translated by Michael Hamburger. Translation copyright ©1972, 1980, 1988, 2002 by Michael Hamburger. Reprinted by permission of Persea Books, Inc., New York, and by kind permission of Johnson & Alcock Ltd.

David Scott's poem "Parish Visit," is from David Scott, *Selected Poems* (Bloodaxe Books, 1984) and is used by permission of Bloodaxe Books.

Library of Congress Cataloging-in-Publication Data

Jasper, David.
 The sacred community: art, sacrament, and the people of God / David Jasper.
242 p. cm.
 Includes bibliographical references (p. 199) and index.
 ISBN 978-1-60258-558-4 (hardback : alk. paper)
 1. Communities--Religious aspects--Christianity. 2. Liturgics. 3. Public worship. 4. Christianity and the arts. I. Title.
 BV625.J37 2012
 260--dc23

 2011051776

Printed in the United States of America on acid-free paper with a minimum of 30% pcw recycled content.

For
Yang Huilin
in friendship

Contents

List of Illustrations

Acknowledgments

This book is the last of three exercises in theology and the arts that began with *The Sacred Desert* (2004) and continued with *The Sacred Body* (2009). It has to be the last, for it returns again and again to the *Sanctus* in the sacred liturgy—and there is nothing possible further than this—the singing of praise with angels and archangels. Whatever the final outcome, the writing of it has been a joy that has been shared with many others to whom, whatever value the result may have, I owe so much, intellectually and spiritually. Much of the material started life during happy periods of residence in Renmin University of China in Beijing, where I have been honored with the title of Changjiang Chair Professor for three years. Above all, I owe much to Professor Yang Huilin, Professor Geng Youzhuang, Dr. Wang Hai, Dr. Ge Tibiao, and Dr. Jing (Cathy) Zhang, who introduced me to the artist Ding Fang. I also thank colleagues in the Chinese University of Hong Kong, Anhui University of Science and Technology, and Wuhan University of Science and Technology. I continue to owe so much to Professor David E. Klemm of the University of Iowa, who has been a guiding light and dear friend for many years. Closer to home, I treasure my long friendships with Dr. Andrew Hass of Stirling University and Professor Elisabeth Jay of Oxford Brookes University, fellow laborers in the field of theology and literature. Of course, I could not survive without the continuing support and stimulation of my colleagues in the University of

Glasgow, and especially the staff and students of the Centre for the Study of Literature, Theology and the Arts, which has survived the philistine attacks of ever more managerialist policies in British higher education for more than two decades and will, I am convinced, see off a few more yet. In particular, I am grateful to Professor George Newlands, Dr. Heather Walton, Dr. Darlene Bird, Professor Werner Jeanrond and Dr. Vassiliki Kolocotroni for their wisdom, patience, and insights. As always, my family have put up with my many hours spent in my study, more often than not in company with one or more of our cats, none of which have shown the least interest in anything I read or write. Their wisdom is of an inscrutable kind, quite different from anything I might have picked up over the years. But I thank them, anyway, for their patience.

Earlier versions of some of the chapters have been published in various places. Chapter 9 was adapted from my article, "The Politics of Friendship in the Post-Christian West," in *Western Marxism and Theology: Journal for the Study of Christian Culture* 24 (Beijing, 2010), 20–31. Chapter 10 was adapted from my article "The Arts and Modern Christian Architecture," in *Theology* 114, no. 5 (2011), 353–62. Chapter 11 was adapted from my article, "The Artist and Religion in the Contemporary World," in *Text Matters: A Journal of Literature, Theory and Culture* I (2011), 214–25.

The Worshiping Community

The spiritual and intellectual origins of this book are manifold and complex, but as is so often the case in writing, the specific decision to embark upon it was sparked by a passing remark. For almost ten years now, I have been meditating upon an extended project on theology, literature, and the arts, and it was clear from the outset that this enterprise was going to be both too long and too episodic in its narrative to be contained in one volume. At the same time, its overall shape was apparent to me from the start, even if lacking in any clear definition. It began with a focus on the theme of the desert as a place of spiritual roots in human, and largely Christian, experience; that resulted in a book entitled *The Sacred Desert* (2004). This was, in a way, my first serious attempt to write (or even to *think*) "theology" through the medium of literature and art, abandoning the cloying restraints of academic composition for a manner of composition that has become for me far more important and certainly more difficult.

After I had completed that book, my old friend the theologian Tom Altizer wrote me one of his marvelous letters, in which he made the comment, with his usual direct insight, that there was too much "spirit" and not enough "body" in the book. I needed to try and get my feet back on the ground. And so the second book began to emerge (and I was already aware when I began to write it that this could not be the end of the matter: there was a third volume calling to me from afar). This stage of the work was finally concluded as *The*

Sacred Body (2009), and it explores the profound truth known in the early church but since very largely forgotten in Christianity—we already live the resurrection life here and now. It is not something merely to be anticipated in the world to come. Although that book's theme was the ascetic life, it was not at all about renunciation, but rather, it was an attempt (at least) to explore celebration, and above all the celebration of the body in the theological imagination of the Christian West. And so we move to the stray remark that was the seed for this present book, *The Sacred Community*. It was during a common or garden variety academic seminar in the University of Glasgow, one of those occasions that are the everyday stuff of university life, that I happened to be reading some of the pages from the last chapter of *The Sacred Body*, which at that stage had not yet been published. My colleague, the theologian Werner Jeanrond, commented that what was lacking was any sense of the body *in community*. In short, I had emerged from the desert and the spiritual life, and found a body, but it was now, it seemed, a solitary body. The last volume of the trilogy immediately presented itself to me and demanded that the question of the nature of the sacred community be given consideration.

The context of Werner's criticism was a meditation that eventually ended up in the last chapter of *The Sacred Body*, on the theme of what it means to live "liturgically," and that term had emerged from a reading of Jean-Yves Lacoste's book *Experience and the Absolute*. In fact my lifelong reflection upon and practice of Christian liturgy has a very different origin from Lacoste's brilliant and difficult book, being rooted in almost forty years as an Anglican priest, and before that growing up with a father, Ronald Jasper, who was also a priest, but perhaps more to the point, a liturgical scholar. Indeed, he had been at the very heart of the processes of liturgical revision that took place within the Church of England, as in many churches, in the second half of the twentieth century after the Second Vatican Council, and which finally led to the publication and approval for public use in the Church of England of the *Alternative Service Book* in 1980. It was the first wholly new liturgical book approved for use since 1662. With the return to the classical "Western" shape of Holy Communion in the *Alternative Service Book* after four centuries of Reformation liturgies largely based on the work of Archbishop

Thomas Cranmer,[1] I was brought up to an understanding that the theology and ancient practice of the liturgy of the Eucharist, and at its center the *Sanctus*, is the very heart, mind, and soul of the Christian community. This will be the theme of most constant reflection in this book.

But a word of warning before we proceed any further. My previous two books have been criticized, quite understandably, for trying to do too much and even for lacking rigor in a variety of ways—academically, as explorations of spiritual or meditative practice, for anachronistic leaps across the centuries and making links between different fields of enquiry or literary practice. The present book is clearly rooted in Christian theology and spirituality, but at times also draws on sources, texts, and art outside the Christian, and certainly the Western, tradition without attempting any exercises in comparative religion—though still taking, I hope, all human experience of the holy seriously and with respect.

I admit the justice of many of the comments of my critics, but at the same time wish to call to your attention the *nature* of this multivolume exercise. Certainly it does not attempt to be, except in places, an example of academic theology in the strict sense of the word, nor one even, perhaps, that will bear close theoretical scrutiny, at least in the Western sense of "theory." In the Eastern tradition, *theoria* is better translated as "contemplation,"[2] and it is more in this spirit that this book, in a deliberately broad-ranging manner, employs the resources of theology, literature, and the arts in its conversations. Chapters sound echoes from other chapters, perhaps suffering deliberate repetitions and revision. For in the composition of each chapter, I have become increasingly concerned with the creative nature of theological writing and theological thinking, and so the reader will be confronted with a number of different experiments in writing style—and therefore *how* you read can become as important, perhaps, as *what* you read and how you understand. And to think theologically, perhaps through the creative medium of a work of art by the German artist Anselm Kiefer or a novel by the Chinese writer Yu Hua, is necessarily, in the reading process, to *think liturgically*. That is, to think as a part of a reading and celebratory community for whom the text, in the first instance, is a place to "be," or, more precisely, to learn to be, in the inevitable activities of

argument, disagreement, appreciation, alienation, and so on. Thus, whether this particular book attracts critical praise or blame in the pages of academic review is, in the end, a matter of almost no importance, at least to myself as its "author." My concerns for my reader are of a different order.

* * *

We begin with the great divine vision of the prophet Isaiah in the Temple in Jerusalem.

> In the year that king Uzziah died I saw also the Lord sitting upon a throne, high and lifted up, and his train filled the temple. Above it stood the seraphims: each one had six wings; with twain he covered his face, and with twain he covered his feet, and with twain he did fly. And one cried unto another, and said, Holy, holy, holy, is the Lord of hosts: the whole earth is full of his glory. (Isa 6:1-3 KJV)

Many years ago, in his book *Religious Language*, Bishop Ian Ramsey stated that "a theology which cannot be preached is about as objectionable as preaching which cannot be theologically defended."[3] The language of theology exhibits what Ramsey calls an "appropriately odd logical structure," to be sure, but to search to the heart of this one must go even beyond preaching to the language of the act of worship itself. More recently, Geoffrey Wainwright has written a substantial "systematic theology" that he entitled *Doxology: The Praise of God in Worship, Doctrine and Life* (1980), in which he perceives the living worship of the Christian community to lie at the heart and center of all theological vision, language, and expression. More recently still, Philip H. Pfatteicher, a professor of English literature, has given extended attention in print to "liturgical spirituality" in a study of "that distinctive interior life of the spirit that is formed and nurtured by the church's liturgy," which begins in the "real world" but finally flowers in another realm.[4]

In the pages that follow, there will be, in some respects, an endorsement of such perspectives, but through a continual and repeated focus on one timeless moment in eucharistic worship that is at the very heart of the celebration of the sacred community of the Christian church. This is the moment in the Great Thanksgiving when the congregation utters or sings the *Sanctus*, the hymn

of praise that is drawn from Isaiah's vision in Isaiah 6:3. In classical Latin, the verb *celebrare* meant to run together to one place, and thus came to refer to congregating for a festival.[5] It was a term that came into use early in the Western church, but behind it lies a Greek word, ἑορτάζω, meaning to "keep festival," though it is in fact only used once in the New Testament, by Saint Paul in 1 Corinthians 5:8: "Therefore let us keep the feast (ἑορτάζωμεν), not with old leaven, neither with the leaven of malice and wickedness; but with the unleavened bread of sincerity and truth." Paul is referring not to a particular festival but to the whole of the Christian life as a celebration of the feast of the paschal lamb, that is Christ.

Thus, what is "done" in the celebration of the Eucharist is actually the focus for the totality of the Christian life. In the fifth century, Saint Augustine of Hippo makes a clear distinction in worship between the simple commemoration and remembering of past events and those events that are "sacramentally celebrated." He writes that

> the celebration of something becomes sacramental when the commemoration of the event is so ordered that something which is to be received with reverence (*quod sancte accipiendum est*) is also understood to be signified. Therefore we keep Easter in such a way that we not only recall to mind what happened, that is that Christ died and rose again, but also include all the other things which in connexion with this give evidence as to the meaning of the sacrament.[6]

At Easter, and specifically in the Eucharist, celebration is not only a remembrance, but a making present and effective of the event, whether that be in historical time or in the eternity of the Lord; and within the Eucharist, it is the one moment of the *Sanctus*, both within and beyond history, on which we shall dwell, the hymn sung by the congregation on earth with angels and archangels and the whole company of heaven:

> Holy, holy, holy, Lord God of hosts, heaven and earth are full of thy glory: Glory be to thee, O Lord most high.

The origins and early history of the *Sanctus* in Christian worship are unclear. From evidence found in the first Epistle of Saint Clement of Rome (fl. ca. 96 CE), the liturgist Joseph Jungmann suggests it was part of the prayers of the Christian community in Rome as early

as the first century, though he denies it formed part of the eucharistic liturgy of Hippolytus' *Apostolic Tradition* (ca. 215 CE), which probably reflects Roman practice as early as the middle years of the second century. E. C. Ratcliff, on the other hand, claimed that the *Sanctus* was part of the rite of Hippolytus. But by 350 there is clear indication in the treatise *De Spiritu Sancto*, which is attributed to Saint Ambrose, of the use of the *Sanctus* in the Western church, and in the East it is mentioned in sermons by Saint Gregory of Nyssa and Saint John Chrysostom. At the very latest, it is evident that by the fourth century in the East and by the sixth century in the West the *Sanctus* appears in almost every eucharistic liturgy, usually followed by the *Benedictus* ("Blessed is he who cometh in the name of the Lord. Hosannah in the highest"), linking the angelic cry with the human acclamation.[7]

In the singing of the *Sanctus* the church's liturgy on earth already participates in the songs of praise sung in the eternity of heaven. The history of this song of praise in the Latin rite is particularly revealing. The text from Isaiah 6:3 reads in the Latin Vulgate Bible thus:

> *Sanctus, sanctus, sanctus Dominus*
> *Deus exercituum;*
> *Plena est omnis terra Gloria eius.*

> (Holy, holy, holy, Lord God of armies;
> All the earth is full of his glory.)

In the Old Latin version, even the word "God" is an addition,[8] while the liturgical text uses, untranslated, the word *sabaoth*, a word that means all the beings God made in the six days of creation, rather than the Latin *exercituum*, which literally refers simply to any trained body of soldiers. Thus, the whole of creation in heaven and on earth joins in proclaiming the glory of God, and so the liturgical *Sanctus* adds to the Vulgate original the word "heaven" ("heaven and earth are full of thy glory"). The song is sung by the sacred community, which is at once both transcendent and in the earthly congregation.

Such unity of praise is made most splendidly clear in the ancient Egyptian liturgy of Saint Mark from the patriarch of Alexandria, which possibly dates back as far as 200 CE and is now preserved in its final form in a number of thirteenth-century manuscripts. This

extended preliminary form of the *Sanctus* draws directly on Isaiah and Daniel as well as Ephesians.

> *The Bishop bows and prays*: For you are "above every principality and power and virtue and domination and every name that is named, not only in this age but in the age to come" [Eph 1:21]. Beside you stand thousands of thousands and myriads of myriads of [armies of holy] angels and archangels. Beside you stand your two most honourable living creatures, the cherubim with many eyes and the seraphim with six wings, "which cover their faces with two wings, and their feet with two, and they fly with two." [Isa 6:2-3]; [and they cry one to the other with unwearying mouths and never-silent doxologies, singing, proclaiming, praising, crying and saying the triumphal and thrice-holy hymn to your magnificent glory: Holy, holy, holy, Lord of Sabaoth; heaven and earth are full of your holy glory. (*aloud*)] Everything at all times hallows you, but with all that hallow you receive also, Lord and Master, our hallowing, as with them we hymn you and say:
>
> *People*: Holy, holy, holy, Lord of Sabaoth; heaven and earth are full of your glory.[9]

It is the echoes of this song that will accompany us throughout the chapters of this book, for it lies at the heart of the life of the sacred community, an assembly that transcends the boundaries of time and space at the sacramental meeting point of time and eternity, the particular and the universal. It is a community in word and vision, and yet beyond both in the fullness of silence and pure light that reveals the unknown that is beyond our comprehension. As we follow the medieval community in pilgrimage, we realize that even as they make the earthly journey to Jerusalem and the holy places of the Middle East, for them space is also symbol, their maps, like the ancient *mappae mundi*, treating the world and history as a place in which we also live in an eternal moment caught between Creation and the Last Judgment, and focusing above all on the life and passion of Jesus Christ. Thus, in the Liturgy of Saint Mark, the bishop "seals the holy things" after the people have joined together in the singing of the *Sanctus*.

> *The bishop seals the holy things, saying*: Full in truth are heaven and earth of your holy glory through [the appearing of] our Lord and God and Saviour Jesus Christ: fill, O God, this sacrifice

also with the blessing from you through the descent of your [all-] Holy Spirit.[10]

Thus, in a sense, there is no passage of time but only a dwelling in eternity, though we shall make journeys also through history, in faith and in betrayal, from the ancient and medieval pilgrims, to the Reformation and Counter Reformation in word and image, to the wars of the twentieth century and to the church of our present society—but all remain one in the timeless and unrepeatable action of the Eucharist.

The often-quoted words of Dom Gregory Dix at the end of his classic study *The Shape of the Liturgy* (1945), so profoundly important for modern liturgical practice and published in the last year of the Second World War in a world weary of conflict and slaughter and on the brink of a new peace, celebrate the presence of the eucharistic sacrifice of praise in every conceivable human circumstance, great and small.

> And best of all, week by week and month by month, on a hundred thousand successive Sundays, faithfully, unfailingly, across all the parishes of Christendom, the pastors have done just this to *make* the *plebs sancta Dei*—the holy common people of God.[11]

The Bible and Liturgical Space
In memory of my father, liturgist and priest

Jean-Yves Lacoste's book *Experience and the Absolute*[1] presents the reader with a phenomenology of the liturgy and liturgical experience. Lacoste asks what it is to exist liturgically in the "place" of prayer. The question "Who am I?" must be asked concurrently with the question "Where am I?" In this chapter, we will seek to ground this phenomenological discussion in a fresh appraisal of the biblical foundations of Western liturgical "being." It will offer not so much a revisiting of biblical themes as a meditation upon them, in a fresh proposal as to the nature of "liturgical living" and the space it occupies in the largely postecclesial societies of the West. This theme will be revisited in Chapter 10. But we begin here in a very different place of writing, very far from such Western societies—in contemporary China and in an office in Renmin University of China, Beijing.

The place in which we write, the space of writing, cannot be without fundamental importance to what we say and to the community to which we seek to give utterance. I cannot write from nowhere, and the particular place in which the writing occurs gives voice to an apology that you, the reader, must accept as a prerequisite of any possible community of understanding: "understanding" not in any banal sense of mere cognition, but as a condition of "understanding between" those who agree willingly, and even gladly, to meet in the space of literature;[2] that is, a capacity to say "we have an understanding between us, you and me."

* * *

Two immediate senses of space now impinge upon me and upon who
I am. I have placed myself before my computer to begin to write,
while around me is a study, a room that happens to be "in" Beijing—
for me a temporary place of work. This has its consequences. Most
of the books behind which I would normally hide (I mean this quite
literally)—full of their references, their crude identification of "me"
as a writer and perhaps a scholar—are not here but "back at home"
in Europe. They are behind me, though perhaps also, in some sense,
partly within me. We readily identify with places, and in this particu-
lar place I am "away from home," exposed and lonely, dependent as a
writer to a high degree on the resources of my memory—dependent
on "myself." In that word, there is found the second sense of space.
Not this office in Beijing, China, but the space of myself or in myself,
which (who?) is a space in which resides an imperfectly remembered
hidden library about which I can warn you, my reader, in advance—
for here we will find near the surface though in various stages of
decomposition (for texts are composed and therefore must later, after
reading and perhaps many imperfect readings, also suffer a process of
decomposing) the remains, for the moment, of Martin Heidegger's
half-understood thoughts, Jean-Yves Lacoste, the Church of Eng-
land's *Book of Common Prayer* (which has inhabited "me" the longest
of all), the Bible in various translations, Maurice Blanchot. It would
be boring to go on further. It is a strange and mixed community
presented through the hermeneutical screen that is "me." If the first
sense of space is, though only for the moment, materially present
and familiar to "me" (though not to anyone else, and certainly not to
any possible reader who can only imagine it), and shortly to be left
behind for another material space, the second sense of space moves
together with me, although its absence does make a difference. For I
am not simply body (material) but a larger self, a body and soul, an
"I" that talks to itself (foolishly and possibly idiotically at times), a
tiny community of thought and being unto itself that ever anxiously
seeks communion with others through all the complexities of speech,
writing, and text—or perhaps even just the Other—in a condition
that we ought properly to call the liturgical. Only when we begin to
understand each other (an understanding that allows the possibil-
ity, and only the possibility, that this writing may eventually evoke

understanding as meaning) does that action (liturgy is at its heart, and most deeply a commitment to "doing" in remembrance lest we forget ourselves and each other) provoke my sense of being-here (in myself) into becoming a sense (more deeply felt and known) of being-toward.[3] Thus, as I reach out to you, the other, however foolishly, the new possibility of community is the beginning of redemption from what can otherwise only be a negation of self, a condition of pure idiocy in the confines of an eternal present; and in that possibility only can I (we) begin to understand "being" as entertained, impossibly, by the space of the *pure* absence that is beyond all possible being here, and therefore beyond your absence to me, which is, after all, always experienced as a hoped for and theoretically possible presence.[4] Properly speaking, then, being here can be said to be ordained, not actually as being-in-the-world but a being-before-God.[5] Thus, we, in community on a journey toward the other, our own Emmaus road, can ourselves entertain (truly a celebration and a running together) a divine presence that is, in its end, known only as perfect absence, for that which is most deeply with us "here" is always, in the time given to us, unknown.[6]

Such entertainment, which is truly a liturgical living (though always lived in becoming and therefore lived eschatologically) is wholly unknown to Plato when he speaks in the *Republic* of the ideal city (πόλις) that exists only in the ideal (τη ἐν λόγοις κειμένη):

"I doubt if it will ever exist on earth."
"Perhaps," I said, "it is laid up as a pattern in heaven, where those who wish can see it and found it in their own hearts. But it doesn't matter whether it exists or ever will exist . . ."
"I expect you are right."[7]

The eternal and immutable ideas that for Plato constitute reality, and which for him are present everywhere and always,[8] although important in the traditions of thinking of both Judaism and Christianity, can finally have no place in liturgical living that has it roots in the flesh (σάρξ) of my being. Furthermore, it is only across the silent space of the text that my writing is ever becoming (writing itself becomes a form of coming into being in an actual present that is at the same time present only as an anticipation), that community can, though impossibly, become a (non)space, a place of understanding of what it is to be in the absent presence of the other.

Thus, it comes to be in both Judaism and Christianity that the Temple, or more precisely the sanctuary, can never be reduced to an idea "laid up in heaven" and thus, everywhere and always, for contemplation. Rather, it is realized and made actual for us in celebration as that which is, at the same time, wholly other (of God) and therefore has its roots (if such a crude word can be used) not *in* but *before* time, before, indeed, any possible world in which being can be said to be. Built into the being and existence of such a Temple is the restlessness that knows liturgical living as a continual transgression of the moment—a waiting in anticipation—that alone allows us (you and I) to dare to dissolve the apparent safety of the present moment into the condition of being-toward.

Two crucial thoughts now present themselves. The condition of dwelling liturgically, which is close to (though not identical with) Heidegger's sense of dwelling poetically on earth,[9] differs crucially from it in the decision we make to dwell in the place that is ever becoming nonplace. Reaching out to one another (what other option have we?) across the space of writing, we only realize ourselves as essentially nomadic beings. Dwelling thus (as our ancestors dwelt in tents that simultaneously were pinned to the earth and yet demanded nothing permanent of it: it *matters* that I am here in this place for the moment, but tomorrow I will be elsewhere), permits us, as it did the German romantic poet Friedrich Hölderlin (who, we must remind ourselves, was probably mad), to claim to know the unknown God. We decide, thus, to dwell without permanence ("And the Word was made flesh and dwelt [or more precisely "tented"] among us" [John 1:14]) as an act of deliberate *disappropriation*. In daring to write as an act of faith and hope (of my faith in you, a humble enough beginning, and in the hope of friendship) I empty myself into the text in a precise and useless gesture that yet subverts my being-toward-death (which is inevitable), and is a gesture of pure being-toward in the space of the not yet.

Second, such a gesture is known only in its utter uselessness and its absolute, perhaps impossible, refusal of any sign of appropriation. It is the act of a fool, if not of a madman, utterly risky and a gesture of foolishness and deliberate weakness. I write to you as to one unknown—I do not know that I know you and you, perhaps, know me only by a name on the page, the name on the first page and

on the cover of this book that I, as a writer, have long left behind, so that I have no claim upon it. Only now, in this instant, can we become (or even for this fleeting moment can we be said to *be*) that unavowable community that with angels and archangels and with the whole company of heaven (a heaven unknown to Plato, whose ideas constitute a reality that is self-existent and self-identical—but who am "I"?)—in this instant alone can we, dare we, sing the *Sanctus* and *Benedictus* from the Great Thanksgiving of the Eucharist: "Holy, holy, holy is the Lord God of hosts. Blessed is he who comes in the name of the Lord."

Have we, then, in our stumbling, in the darkness of God, touched—no more, a merest trace of a sense at the very end of the finger tips—the sanctuary of the sacred community? Or should we say, first, without so much presumption, the secret community? The decision, in the first place, was ours, for which we must admit responsibility, but we stumble upon the gift, without deserving anything. To us, as to the bewildered disciples, has been given the secret of the kingdom that remains as wholly unknown ("Unto you it is given to know the mystery of the kingdom of God" [Mark 4:11]), and only in the darkness of such unknowing is there the impossible possibility of the sacred community. That is, to dare, scandalously, to accept the gift and thus to be "sacred," to be set apart: in this instant we, you and I (though these pronouns are now without significance), are set apart after (though not as a result of) the free choice and decision not to possess. The subordination (by our ordination—for as we have already acknowledged in the words of our writing and reading, we have been ordained) of being-in-the-world thus

> proves that nonpossession defines man more primitively than does his participation in the play of appropriation. And it proves—in particular—that this more primitive determination can govern the experience we have of ourselves and of the world.[10]

In our writing, in my reaching out to you as my unknown reader and neighbor in this place and at this time, I seek, though in hope only, the extravagance of the pure poet; that is, the one who does nothing but in pure speech undoes or overwhelms the abyss that divides poetry from praxis. This is only possible within the purity of thought that dares to think nothing or aspires to know

what it is to know nothing.[11] That is why I am always doomed to failure, though, miraculously, the very failure continues to prompt in me the gift of unknowing. Even as I admit that I cannot unthink thought, my stumbling upon my presumption to know leaves a trace of the passage through the world of the unknown. Such, were it all, would leave us only in the pure abjection of fear—the fear, merely, of knowing that we do not know—but yet in the voice of the pure poet there is a reminder, a remembrance, in us of the call to believe, in faith and hope, in the possibility of being-before-God, of the trace that dissolves, as in the Emmaus room, the moment it draws us into recognition.

How then (and the question is not a new one), before the claims of pure art, the claims of the space of the silent text that is alone the space of liturgical living in community, which knows no distinction between reading and writing, is any literature or any liturgy, possible? For such would claim to create, in Blanchot's words,

> a system that is absolute, comprehensive and indifferent to the ordinary circumstances of things, a system constituted by intrinsic relations and able to sustain itself without support from outside.[12]

Such a pure collapse of the distinction between form and content, if it were indeed possible, as it perhaps may be in music,[13] would be an act of pure faith that yet leaves intact the abyss that divides poetry from praxis. Even the purest of poets, a Paul Valéry or a Stéphane Mallarmé, would not dare to embark upon such an act of faith, whose only possible end is silence and madness. Rather, as Hölderlin knew (in the deep sanity which was his madness, barely touching the rim of the world) the greatest work of literature begins with a necessary act of bad faith—the poet the priest (ordination again) but always and necessarily the bad priest ("The false priest that I am, to sing, / For those who have ears to hear, the warning song."[14]) just as the true saint is not the one who repents, but the one who knows with utter and infinite pain the impossibility of true repentance and therefore the utter dependence on the gift of grace. The text between us, between you and I, then, continues to function as a sign—that is, it continues to say *something*, however banal and useless that may be, yet dares to carry that poor and humble deed, its feeble attempt at representation, into the vanishing point of signification, into the

disappearance into pure nothingness. Thus, in the work of art, the simplest of commonplaces are at once lost and found in the darkness of God and in our stumbling upon this in ways barely to be seen or heard, let alone (heaven forbid—μὴ γένοιτο[15]) understood, at least by us, the community that can begin to know itself as liturgical as it offers its useless gift back—to each other, to the Other—across the silent space of the text. Thus, we can perhaps say that the most profound liturgical moment in the art of the West, infinitely exceeding every elaboration and exactitude of the theologians and even the sacred liturgies of the church, is the discovery in the fifteenth century (is discovery the right word?) by Donatello, Perugino, and Masaccio of the vanishing point in perspective, the point of disambiguation, the *zim zum*,[16] the center in which we are lost, upon which our eye is fixed (though we do not know it) and which gives form, depth, and vitality to the world that at once emerges from it and disappears into it. At the vanishing point we are consumed by unknowing, an aching longing for that which is beyond the void: and thus the world, this world—our world—is made and brought into being.

How then may we speak of the necessity of bad faith; that without which, as Hölderlin reminds us, there would be no poetry and therefore no liturgical possibility? Do we speak, singing in unison, with communal *bad faith* in the daring to utter the *Sanctus*, our poor and mortal voices lost in the infinite music of the eucharistic Thanksgiving? But is not this, after all and above all, pure liturgical space, the sanctuary that is at once wholly set apart and emptied, neither within us nor outside, a space of utter purity, where even the merest traces of knowing are swept clean? Here we are simultaneously lost and found. And yet, in the necessary narrative and in the vale of restless mind[17] (for are we not restless even here, restless to share with one another our thoughts, however trivial, and our feelings, however boring?) we move on. The instant of eternity passes almost at once into a single moment in the history of the world—the night of betrayal. And it is here that we stay to consume and to be consumed. Without the act of betrayal, the necessity of bad faith, there is no word of communication, no place for the liturgical community (which is the community of being-toward) in the world. True, its place in the world is to do nothing (which is the hardest of all things to do, for this is to touch the world with its trace, not to

wound it with the idleness of negation or the ever-busyness of work),
and yet, for the gift to be given, we must admit our guilt of betrayal
as at the very heart of liturgical celebration, admit the truth of the
words of Nietzsche's fool in *The Gay Science* (beyond even what
Nietzsche's parable intends), that God is dead, and we have killed
him. And so, even as we come to the place of invitation, foolishly
expectant of participation, it is with the burden of the knowledge
that we are the betrayers. Archbishop Thomas Cranmer knows well
this dark secret when he calls upon us to utter, intervening at the
crucial moment of celebration in the 1549 Anglican liturgy in the
first *Prayer Book of Edward VI* (drawn from the earlier Sarum Rite),
the Prayer of Humble Access.[18] We participate *knowing* only that we
are presumptuous, unworthy to do the sacrifice that we presume (by
the very gift granted to us) to do. In this prayer, we *are* unworthy
(in our being-in-the-world) but yet (in the Other who alone is at rest
and without the restlessness of our being, ever the same Lord) "our
sinful bodies *may be* made clean" (in our being-toward).

> We do not presume to come to this thy Table, O merciful Lord,
> trusting in our own righteousness, but in thy manifold and great
> mercies. We are not worthy so much as to gather up the crumbs
> under thy Table. But thou art the same Lord, whose property is
> always to have mercy: Grant us therefore, gracious Lord, so to eat
> the flesh of thy dear son Jesus Christ, and to drink his blood, that
> our sinful bodies may be made clean by his body, and our souls
> washed through his most precious blood, and that we may ever-
> more dwell in him and he in us. Amen.[19]

What utter presumption, to draw within ourselves (body and
soul) the being (flesh—σάρξ) of the vanishing point of the Unknown:
but only thus do we communicate, you and I, in the enormity of this
act, this doing (ποιεῖν) in a remembering—a re-membering, perhaps
even a rebuilding, of the manifold of our members into one body
across the space of the table—in the words, spoken and consumed.
It is this enormity that Justin Martyr, Tertullian, and Irenaeus never
let us forget. We act liturgically, and yet, crucially, we do precisely
nothing. For only in this space, in this presumption (not unmixed
with cowardice and ignorance—by which we claim to know and are
known in the world) of doing nothing does this moment of betrayal
(a sacrificial royal feast in anticipation of the moment of utter

impossibility) open a way for the supreme, uninterpretable moment of the cross and its searing exposure of the humanity of God.

> The Cross is, in fact, and in the mode of a paroxysm, the place of inexperience. The existence of God is affirmed there, for one does not speak ("My God, my God, why . . . ?) to one who does not exist. God, however is not absent: just as the humanity of Jesus of Nazareth is the humanity of *God*, so the death of Jesus is *his* death, *his* Passion, and not a human drama for which he might show a distant compassion.[20]

Only here can the perpetual and even unending hermeneutics of our existence cease, and yet at this moment, in this space, and only here, do they aspire to be a remote possibility. We here, who have already, though unworthy, consumed, and been consumed by, the body in anticipation, *do nothing*. It is to this that all our exchanges, all our writings and readings, our stumblings, our wanderings and self-effacements, the moments of impossibility in literature and art—lead us. *And we do nothing*. We who, but moments before, have presumed to sing the *Sanctus* with angels and archangels, know that we know in our dim discernment *nothing* in the terrible conjunction of presence and absence.

Only now, and it remains yet the faintest of all possibilities, the merest trace on the material being of the world and upon our flesh, no sooner recognized but it is gone, may we, you and I, claim (presumption upon presumption) to know the joy of the sacred community, set apart from the world while yet its deepest reality. Even to whisper this claim between ourselves, you and I, unknown writer to unknown reader, is to speak as fools. "I speak as a fool" (2 Cor 11:23). The words are not new, but how hard it is for us to utter them, knowing that they may be believed, and that they are indeed true (a term I prefer to dismiss as too hard.) But it is the fool, in his humor, who knows the terrible truth that God is dead. It is the fool who, finally, lives most lightly in her being-in-the-world and yet remains, who is closest to the contentment of doing nothing, and who laughs (how we despise that laughter) at our deepest woes—the laughter that is heard at the foot of the Cross.[21] It is the fool, in his naïveté, who dares to enter the place of sanctuary, and who yet rejoices in the *désert absolu*—knowing that the sanctuary and the desert are one. The fool alone knows nothing of the bad faith of

literature as she enters its depths and finds in them the silence of the vanishing point. We, poor fools that we are, dare not even be truly foolish; at best we are sad tragicomic artists who turn again in relief to the world after the book is closed or the last scene has been played.

Saint Francis of Assisi asks:

> What then is true joy?
> I return from Perugia and arrive here in the dead of night; and it is winter time, muddy and so cold that icicles have formed on the edges of my habit and keep striking my legs, and blood flows from such wounds. And all covered with mud and cold, I come to the gate and after I have knocked and called for some time, a brother comes and asks: "Who are you?" I answer, "Brother Francis." And he says: "Go away; this is not a proper hour for going about; you may not come in." And when I insist, he answers: "Go away, you are a simple and stupid person; we are so many and we have no need of you. You are certainly not coming to us at this hour!" And I stand again at the door and say: "For the love of God, take me in tonight." And he answers: "I will not. Go to the Crosiers' place and ask there." I tell you this: If I had patience and did not get upset, there would be true joy in this and true virtue and the salvation of the soul.[22]

We have come, you and I, in a short space in this brief chapter, a long way from my study, this room in Beijing, where I write, sitting at a desk, in spirit both here and not here, and with you—whom I can but imagine. But you are there, with me in part, and, perhaps in part, shutting me out for one reason or another. But yet even so, for fleeting moments, we are one. And the hardest of all is to know true joy—for we have not the patience and we quickly get upset and irritated. My insistent sense of self returns to me and the other is sent away, and I do not like to admit, least of all to you, that it is I who am the simple and stupid person. The door is shut on liturgical space, which is entirely a being-toward in a restless emptying of self unconstrained by any logic, except the logic of pure absence when my being is found only as a trace in the silence of its negation, and there, without getting upset, I (we) are finally content simply to be. There are moments in literature, moments in the shadow's light,[23] that grasp, in word and look, a shade of the liturgical moment, and they are capable of reducing us to silence, a silence in which again

might be heard the possibility of the song that is the *Sanctus*: it is the faint vision of peace that is glimpsed in literature at very end of Anton Chekhov's *Uncle Vanya*, perhaps; the end (which is also the beginning) of James Joyce's *Finnegans Wake*; the end of *King Lear* as, with Cordelia in his arms, the dying king utters the most moving line that Shakespeare ever wrote, capable of bringing a full theatre to a silent communion of tears—"Never, never, never, never, never." It is the briefest moment in time held above the abyss between life and death, neither and both, as the dying, courteous king, now beyond his former madness, sees into a future that we who are left behind cannot know but only wonder at as we grow old.

It was Sir Philip Sidney in his *An Apology for Poetry* (ca. 1579) who wrote that the poet "nothing affirms." Therefore, the poet never lies. For "[the goal of the poet is not] to tell you what is or what is not, but what should or should not be."[24] But again, as Hölderlin knew, there can only be, for us, a false or a bad or an imperfect poet. The artist who comes to know truly (almost) what an artist is pays the ultimate price and is rarely heard, listened to, or understood in his own time. Hölderlin comes close to utter madness; William Blake is almost entirely hidden and unknown; van Gogh sacrifices himself for his art, as later does Paul Celan, in suicide. Saint Francis knows what it is (though it is beyond even him) to find pure joy in negation. And finally, for us who are left (you and me), there is the space of the text, poor enough but which may yet become for us a liturgical text, a moment to dwell in, of necessity bound to the imperfections of this world, and yet a momentary pause in which to know, if only as a faintest whisper, in anticipation, the liturgical space of the sacred community, truly a community that alone knows the promise of the total presence at the vanishing point by which the world is kept in being by the grace of God.

CHAPTER 2

The Sacrificial Praise
of the Eucharist
A Meditation

A quarrel over a sacrifice disturbs the peace of the postlapsarian world of the Bible very early in its history, in the disastrous, second-generation exchange between Cain and his brother Abel (Genesis 4). The cultic offering of sacrifices, usually involving the slaughter of animals, is present everywhere in the Hebrew Bible, but not always seen by biblical authors in a positive light. For example, the prophetic writer of the first chapters of the book of Isaiah denounces the obsessive cultic practices and blood sacrifices, indeed the religiosity, including liturgical sacrifices, of his people and calls them instead to pursue more practically useful, ethical activities in the care for orphans and widows and the general maintenance of the well-being of society. Not the offering of burnt sacrifices but the sacrifice and offering of a pure heart is God's desire.[1]

Sacrifice—sacrament—sacred: the root word means that which is set apart, separated out for God rather than for human use. It is the giving back to God of a portion (a tithe, or a tenth) of that which he has given us for our use, but which remains his, and which ensures a right relationship—*at-onement*—between God and the people he has blessed with good things. The church itself—the "ecclesia"—is the community that is called out to be "sacred" or distinct from the rest of the world and to be offered back to God that good order is maintained and "human life is preserved and honoured by God."[2] Properly, the service of the church, therefore, is to God and then only through God and his purposes, to the world.

21

At the same time, there is the related sense in the root word that has come to predominate in the meaning of sacrifice in broad modern usage: that is, the sense of "giving something up"—that which is set apart is costly and involves loss and perhaps pain, both to those who have "sacrificed" something valuable and to the "victim," that which is sacrificed and is therefore cut away and lost from the rest of the world. In Leviticus 16 is described the fate of the "scapegoat," the sin eater on whom all the sins of the community are placed, so that the animal released alone into the wilderness to die carries away all the sins of the people with it, in a sense offering them to the Lord. "But the goat on which the lot fell to be the scapegoat, shall be presented alive before the Lord, to make atonement with him, and to let him go for a scapegoat into the wilderness" (Lev 16:10).

The Pre-Raphaelite Holman Hunt's painting, *The Scapegoat* (1854), which was painted by the very shores of the Dead Sea, captures the desolation and agony of the poor, innocent animal on whom sins are heaped—a desolation that is both internal and external (see plate 1).[3] Hunt brings to bear his developing theory of painting to a relentless and distressing accuracy of detail in his work, so that to see this picture is actually to see the desolation of the sins of the people, the desert a hell, the red garland on the goat's head a savage reminder of the transgressions it bears. The *innocence* of the poor goat is crucial, for it bears away the sins of others. And so the cultic tradition is never finally eradicated by the rational common sense of the ethical revisionism of the prophetic tradition. For it is the offering of the body of the innocent victim, and the offering of the lifeblood back to God, that effects not simply the rebalance of society, but, far more importantly, the covenantal balance of the relationship between the divine and the human, between God and his people. That which is innocent and pure is given back to God and is given up to him to effect an atonement—a making one and whole of the fundamental and necessary relationship between the human and the divine upon which all else depends.

It is upon this theological tradition that the Christian Eucharist is founded, its roots in the Jewish festival of the Passover and the sacrifice of the lamb as an *anamnesis*, an enactment as a memorial of the passage of the Children of Israel from slavery in Egypt, through the waters of the Red Sea and the wanderings in the wilderness, to

the freedom promised to them by God in the land of Canaan. Like the Passover, the Eucharist, from the very earliest days of the Christian church as recorded in Saint Paul's writings to the Corinthians (1 Cor 11:20-26) and in the gospel tradition, was grounded in a precise moment in history, "on the night that he was betrayed," that is, the Last Supper between Jesus and his disciples. The gospel tradition is ambivalent as to whether the earliest celebration of the Eucharist, with its Institution Narrative descriptive of the Maundy Thursday meal, was linked with the actual Passover meal, with Jesus understood to be the embodiment of the Passover lamb, slain and consumed.[4] But there is certainly a very close connection made between them, which is continued in later Christian iconography, and only one of the early eucharistic rites that survive, the Syrian Rite of Addai and Mari, actually omits the narrative of the Last Supper.

For contemporary Western liturgies, the most important of the early rites, after the biblical tradition itself, is probably that of Hippolytus in the *Apostolic Tradition*, dating possibly from as early as the second century of the Christian era.[5] The "shape" of the Great Thanksgiving is established here, to be broken in the Western tradition only by the theological upheaval of the European Reformation, and today largely recovered ecumenically in both the Catholic and Protestant traditions of liturgical revision after the watershed of the Second Vatican Council in the middle years of the twentieth century. Here, after the liturgy of the word of scripture, intercession, confession, and the peace, that is, the "ante-Communion," the congregation is made ready for the moment that opens the prayer of the Great Thanksgiving, announcing the presence of the Lord in the midst of his people.

> The Lord is here!
> His Spirit is with us!

Then follows a narrative, spoken by the president on behalf of the whole congregation, which describes the events of divine creation and redemption of all things, so that finally the people gathered for worship can sing with one voice the *Sanctus*, the great hymn of praise from Isaiah, which is echoed in Revelation 4, in fellowship with angels and archangels and the whole company of heaven, the church past, present, and future on earth, and the church in heaven.

But then the tone of the eucharistic prayer begins to change. For the universal hymn of praise turns to the Son, born in human flesh, and it is drawn back into the specific moment in human history— the moment of betrayal and the words of Jesus uttered at the Last Supper, rooted in Jewish ritual. The primitive language of the cult surfaces again—not the ethical language of the First Isaiah, but the more ancient language of sacrifice of flesh and blood, now devoured by all present to the bitter dregs. The utterance by the priest of the "words of institution" is a complex, sacramental moment. They embrace a moment of *offering*—the offering of Christ's body and blood at his passion. They herald a moment of *consumption*—the lips of the people dripping with the lifeblood of the victim (as so vividly portrayed by Tertullian in the face of accusations of cannibalism against the Christian community[6]). They are a moment of *remembering*—the remembrance of the death of the one who died "for us and for our salvation." Such remembering, as in the Passover rite, is not simply a casting of one's mind back to an event that is past, but a bringing of that event into the present, so that properly there is only one possible Eucharist, eternal and eternally present. In the remainder of the eucharistic narrative, there is what can best be described as a consolidation in the *epiclesis*, which is the calling down of the Holy Spirit upon the church, and the final offering—that is the offering not of the singular victim who is the crucified Christ, but now of the whole people back to God, united as they are in their bodily participation in the elements of Christ's own body and blood: "we being many are one body, for we all partake of the one blood." We are the Body of Christ, the word "body" being understood at once in both senses—singular and communal.

The sacrifice that has been made thus becomes the sacrifice of the whole church as it participates in the communion of Christ's body and blood, and those who have received gifts from God become, at the same time, those who offer themselves to God, a sacred people who have been set apart or *sacrificed*—for what?

Let us begin to answer that question on a more philosophical level. It has been said that the fundamental, perhaps the only, problem in Greek philosophy can be summed up in this way: how can the one become the many and yet remain the one? In this sense, the sacrifice of the Eucharist has an *ontological* dimension. In accordance

with the theological narrative of Christian salvation, the eucharistic community is reserved for God's purposes to establish—or more precisely to re-establish—the unity and harmony of the created order of all things under God. As erring and fragmented human beings they, or we, are broken, devoured—body and blood—and dispersed after the manner of Christ's bodily and spiritual breaking on the cross, only to be made one in the offering to God, in symbol and in sacramental reality, a realization of the only possible unity of all things in God. This is the chiasmic vision that mends the chasm in our being—that only by losing ourselves do we truly find ourselves in God: to borrow from the words of Saint Augustine of Hippo, our hearts are restless until they find their rest in God.[7]

Second, the sacrifice of the Eucharist has an *existential* dimension. As beings created by God and disordered by our own wilfulness and frailty, we experience the Eucharist as an act of betrayal that is instantly and at the same time a moment of restoration in and through the necessity of the very betrayal itself. The very agony and ghastly loss of self (one might think of Holman Hunt's scapegoat again) is the sole necessary condition of a transfiguration of our being, just as Christ's moment of abandonment on the cross, as recorded in the gospels of Matthew and Mark ("My God, my God, why have you forsaken me?" [Ps 22:1]), and his death, is the very moment of his glory,[8] its hideousness in our eyes but a failure in our perception, for the very death of Christ and the moment of his sacrifice is alone the condition of our salvation and therefore his resurrection. If we do not celebrate the Eucharist on Good Friday, it is because that day is entirely eucharistic and needs no further sacramental presencing to us. For now, at his furthest remove from us, Christ is at the same time wholly with us and one with us. Thus, perhaps the greatest of all Western paintings of Christ's awful agony on the cross—the terrible *Isenheim Altarpiece* by Mattias Grünewald—might in fact be the greatest image we have of Christ in glory, for here true "being" is at one with all human existence, a purely kenotic unification of the divine glory found only in the depths of human suffering and degradation.

Third, the sacrifice of the Eucharist has an *ethical* dimension. For we, the eucharistic community, are called to offer to God and his purposes not only all that we have but all that we are. Nothing

could be more depraved or degraded than the imagery of the consumption of the body and blood of the beloved one. And yet this is also the greatest of all acts of love—or that *caritas* celebrated by Saint Paul in his great hymn to charity (Gk, ἀγάπη) in 1 Corinthians 13.

> Though I speak with the tongues of men and of angels, and have not charity, I am become as sounding brass, or a tinkling cymbal.
>
> And though I have the gift of prophecy, and understand all mysteries, and all knowledge; and though I have all faith, so that I could remove mountains, and have not charity, I am nothing.
>
> And though I bestow all my goods to feed the poor, and though I give my body to be burned, and have not charity, it profiteth me nothing. (1 Cor 13:1-3)

For this is a daring act, offering everything we have and we are in every fiber of our being in order to participate in the utter self-emptying (and therefore self-realization), the *kenosis*, of Christ on the cross. As the scapegoat or the sin-eater, the eucharistic community itself must become the sponge that absorbs and removes all the filth of the world, and thus the sacrifice is complete only when we recognize to our horror (in our own moment of desolation) that the most holy moment, when our tongue touches the fragment of consecrated bread and our lips feel the coolness of the drop of wine, is also the moment of appalling desecration, as we gorge ourselves on flesh and grow sated, with lips that drip with the blood of the beloved one. In the ancient *Lausiac History* (ca. 417) of Palladius, a pupil of the great Evagrius of Pontus, we read that the good monk Piteroum, in search of true holiness, only realizes this in the moment when it dawns on him that the filthy, neglected, and degraded scullery maid, who has been the sponge for all the off-scourings of the good and godly sisters of the convent where he is staying, drinking up the dregs of their dish-water and eating the filthy scraps of food left over from their meals, is in fact the true sacred heart of the community, alone keeping it clean and holy before God, yet totally unrecognized and unknown to all. She is the object of their scorn, hardly worth even noticing, until the moment when she is recognized in her glory—at which precise moment she disappears from their sight.[9]

Thus, in the end, the sacrifice of the Eucharist must ensure that the true eucharistic community is wholly hidden and unknown, finally unrecognized by the world, perhaps even by itself, and

known only to God. For that which is offered is known only as it disappears in every sense of the word, and yet in that disappearance alone—as on the cross and as with the women fleeing in the moment of horrified recognition from the empty tomb at the end of Saint Mark's Gospel[10]—is the fullest presence of the divine known. Christ's moment of abandonment by God on the cross, the moment of his sacrifice, is actually the one moment of his utter oneness and unity with God, present to us only in his total absence. It is, in the phrase of Nicholas of Cusa, the moment of the *coincidentia oppositorum*, the impossible moment when opposites meet.

All such sacramental reflections must put into the question, at least to an extent, the theology of the Reformers as they reconstructed the language, narrative, and theology of the Eucharist in the sixteenth and then the seventeenth centuries. In Thomas Cranmer's predominantly Lutheran liturgy of the sixteenth century, which has largely been preserved in current usage in the Church of England in the *Book of Common Prayer* of 1662, the real presence of the sacrament is edged away, as the coherent narrative of the Great Thanksgiving prayer is disturbed and fragmented by continued self-conscious reversions to our sense of unworthiness, an inability finally to enter into the awful self-abandonment and forgetfulness of the true narrative of sacrifice. In the words of the Prayer of Humble Access—"we are not worthy," like the Canaanite woman in the gospel, even to gather up the crumbs, gathered by the dogs, that fall under the Lord's table (Matt 15:27). But paradoxically, our utter unworthiness, beyond all self-consciousness—like that of the scapegoat or the scullery maid of the *Lausiac History*, or, above all, the broken figure of Christ on the cross—is our qualification to become the true sacrifice, the ethical condition being overcome by the greater claim of true "charity."

At the same time, the Reformation tendency, stronger in some reformers than in others, to shift the understanding of "memorial" to the more limited and modern sense of memory as "reminder," dilutes and finally loses the experience of *anamnesis* as identification with the one momentary and universal event of the Last Supper and Christ's passion, whereby we become shockingly one with the divine being who is offered to us and to whom we are offered as an "oblation" in an exchange that restores all things in creation to

unity—the one finally become many and the many become one. In the Reformation shift to the sacrament of the word, the presence of Christ realized in the spoken word of the preacher, as in the images in the art of Cranach and others, is in one sense a return to the Word (λόγος) of the Fourth Gospel, though at the same time it begins to diminish the necessary power of the "Word made flesh"—σάρξ, flesh, a messy and vulnerable substance that can at once absorb and be shockingly eaten and absorbed, be broken, and be healed. Thus, Marshall McLuhan could speak in *The Gutenberg Galaxy* (1962) of the desacralizing of the world as the Word becomes technological rather than sacramental.

Yet, at the same time, Cranmer's liturgy speaks of the "full, perfect and sufficient sacrifice, oblation and satisfaction" of the Eucharist—a gift in which, by its act of betrayal and consumption, the eucharistic community participates. As a fragment set apart in history and in the body, the body of Christ is taken and offered as a sacrifice, not as a substitution for anyone or anything, but as a vicarious gift—an element offered from the whole so that the whole may be made entirely holy. Thus, the sacrifice of the Eucharist is the truly enacted acknowledgment that the bloody death of one man on the cross is taken into the universality of all being so that finally that one sacrificial death is utterly and necessarily distinct (or else it would cost nothing) and yet utterly absorbed into the being of all things. In modern theology, nowhere is this more fully explored than in the writings of Father Teilhard de Chardin.[11]

Saint Bernard of Clairvaux gives us an image of the souls of the saints lying on their beds awaiting the return of their bodies at the final resurrection of the dead, when the bodies of all shall rise from their graves. He makes clear to us why the Christian tradition has always insisted on the resurrection of the body and not simply of the soul or the spirit. In his image, the saints—the holy people of God—rest on the beds of their earthly graves as spirits, their earthly flesh decaying to dust, and awaiting the moment known to the women at the tomb in Saint Mark's Gospel, when the body of Christ is no longer a heap of mouldering dust and decaying bones, but is present in a new form that is at once entirely absent and wholly present. On the great final day of resurrection, they will be reunited with their bodies, though now transformed and transfigured,

and enter upon the great banquet that awaits them in heaven—the messianic banquet of which the Last Supper is the earthly forerunner. Then follows an extraordinary scene in the writings of Saint Bernard: for at this meal the saints both feast upon the flesh of the Lamb that is freely given to them and they themselves are thankfully devoured—all-consuming and all-consumed. Thus, all become one in a final unification, alpha to omega, as in the great scene of the New Jerusalem in Revelation 21, when all else has passed away.[12]

Giving and given, every gift in the great sacrifice is entirely free and freely offered, a gift of grace, a gratuity without reserve. Thus, in the economy of sacrifice, there is nothing owed and no terms, no percentage and no calculation of interest. We return, finally then, to the ancient world in which we began this chapter, to the world of Genesis 4 and the fatal dispute between Cain and his brother Abel.

> And in process of time it came to pass, that Cain brought of the fruit of the ground an offering unto the Lord. And Abel, he also brought of the firstlings of his flock and of the fat thereof. And the Lord had respect unto Abel and to his offering: But unto Cain and to his offering he had not respect. (Gen 4:3-5)

The clear suggestion is that Cain's gift—his sacrifice—is given without generosity, taken out at random from his crop. Abel, on the other hand, gives up with an open hand the best that he has to offer and the plumpest of his flock, and the Lord responds accordingly. The sacrifice is given freely and with a generosity that is without reserve. And so the eucharistic community is realized only as the beneficiary of the gift given to it without reservation, which is devoured so that it is wholly received and nothing is left over and not taken. But it has already been costly, for it can only be received after the sins of all, in a terrible act of betrayal (was Judas Iscariot after all the only true disciple for whom the cost of this betrayal was his life?), have been heaped on the sacrificial gift. But in this devouring, the community itself becomes the offered sacrifice, wholly offering itself to find its true vocation as the incarnate Body of Christ on earth, dispersed and unknown, absorbed into the stuff of all creation, a seed that dies and becomes one with the earth before it again grows and gives life: the Eucharist, the one and only true sacrifice at the heart and in the being of all things.

Evil and Betrayal at the Heart of the Sacred Community

We return now, and more insistently, to the theme of betrayal that was present so often in the previous chapter and its reflections on the sacrificial praise of the Eucharist.

Immanuel Kant begins his essay *Religion within the Limits of Reason Alone* (1793) with words taken from 1 John 5:19: "And we know that we are of God, and the whole world lieth in wickedness." It is a plaint, he remarks, as old as history, even as ancient as the older art of poetry, and as old, indeed, as "that oldest of all fictions, the religion of priest-craft."[1] What follows in this chapter is neither, precisely, philosophy, nor even strictly, perhaps, an essay in theology, but rather a reading of a text of fiction and of betrayal in the light of its later place in Christian belief and practice—the text, that is, of the Passion Narrative of Saint Mark's Gospel. It might, as a reading, be said to be bordering on the obsessive, lingering on the edges of a madness that is caught between two worlds, but yet a madness something like that of that most courteous of knights, Don Quixote himself, and which is at least born out of duty and a devotion to the truth of the book.

But, under the shadow of Kant's dour reminder, let us begin, as we shall end, in the place we have already been exploring and which takes us closest, perhaps actually, to Saint Mark's Gospel fiction, as the eucharistic community that dares in worship to sing, beyond all limits of time and space, with angels and archangels and all the company of heaven in the words of the *Sanctus* from Isaiah 6:3 and

31

Revelation 4:8, only to be drawn back again in our celebrations in an instant, in a narrative of sudden dramatic shifts, to the singular, historical moment—"in the same night that he was betrayed." In the sacred event of betrayal, everything is suddenly dragged back from the heavenly realm into the world Kant knew (and we know)—the world that lies in evil—but it is precisely that instant of betrayal we are bidden to remember and even more, to rehearse in the liturgical and sacramental celebration.

Now hold that instant in your memory while we move back to another moment in my own personal memory some fifty years ago, as I struggled heroically and perhaps unthinkingly as a schoolboy to make the distinction in the grammar of classical Attic Greek between the subjunctive and the optative moods of the Greek verb, tutored by that excellent *Primer of Greek Accidence*, composed by Messrs Abbott and Mansfield in 1933, which sought, with a warning we would now and in our own time of educational confusion do well to heed, "how to teach the elements with such scientific precision and thoroughness as may most effectually guard against the inaccurate and superficial habit which is perhaps the one danger that requires our special attention as we widen the range of school studies."[2] "No language but Greek," cries J. H. Moulton, in the first volume of his earlier great work *A Grammar of New Testament Greek*, "has preserved both Subjunctive and Optative as separate and living elements in speech."[3] Imagine my dismay, then, when much later I came to study, for the purposes of ordination in the Church of England, the debased *koine* Greek of the New Testament, and realized that this grammatical distinction had been all but erased, and indeed the optative mood had more or less vanished from the native language of the sacred scriptures of Christianity: a gentle mood that, when compared to the harsher subjunctive, remarked the Cambridge New Testament scholar Charles Moule, "might be said to be remoter, vaguer, less assured in tone, [expressive of] a *wish*, one might say, as distinct from the more resolute *resolve* of the hortatory Subjunctive."[4] All this is rehearsed for you by way of preface to the discovery I made while reading Saint Mark's evangelical novel in *koine* Greek, which both indicates the sad loss to culture we have suffered in the decline of the study of this ancient language (that we can take nothing for granted) and gives a clear, perhaps surprising, hint as to the kind of

wistful[5] gospel text we have before us, and therefore how it should be read, marked, learned, and inwardly digested. For I discovered that in Mark 11:14 we find, miraculously, a blessed and ancient optative mood at the point when Jesus, a better grammarian than he is usually given credit for, seems in the English translation of the Authorized Version so roundly to curse the barren fig tree with the words, "No man eat fruit of thee hereafter for ever." But the mood of the Greek here is, in fact, the gentle optative—vaguer and less assured than the crueller and more uncompromising subjunctive. A wishful, even salving tone is set in Jesus' oft-misunderstood words—let him that readeth, indeed, understand (Mark 13:14)—and the same tone runs close under the surface of the whole language of the passion in Mark, its violent and often cruel-seeming narrative softened within the very texture and grammar of the words; its truth the truth of fiction—deeper, subtler, more shaded, and more demanding than the crude and cruel truths of history. (The good Saint Mark, I surmise, had probably read his Aristotle, and thus rightly prized the poet over the historian.[6]) Mark's is, after all, a textual world in which, when words are spoken, their meanings often draw the reader— even unbeknownst to himself or herself—in subtle ways, so that in the act of reading good may come out of seeming or even actual evil.

Long before Jesus and his disciples reach Jerusalem, those with them on the road are amazed and afraid (Mark 10:32). They certainly had good reason to be both as events unfolded. For what follows in the narrative is a story of one act of betrayal after another. On the Mount of Olives, Jesus warns his faithful followers that they will all fall foul of what Henry George Liddell and Robert Scott describe in their great *Greek-English Lexicon* as "the stick of a trap on which the bait is set."[7] In short, they will stumble into sin and become "deserters" (NRSV) or betrayers of their Lord. Indeed, despite his protestations to the contrary, Peter is told that he will even refuse to recognize Jesus as many as three times over. He, like all the rest of us, cannot see that the common order must be shaken in an act of treachery—that common order or ordinariness, which, as Saint Mark's fellow novelist of a later age, Joseph Conrad, perfectly well knew lies at the heart of darkness and in which evil festers in a "sickly atmosphere of tepid scepticism."[8] But to be wrenched from this gray familiarity, to betray it in denying its very loss, makes

possible the meeting of worlds in a breathtaking moment of impossibility that Aristotle, once again, knew the poet will always prefer in its ultimate and utterly extraordinary plausibility to a boring but finally improbable possibility.

And so, as the fateful night grows darker, Saint Mark's story takes us on from the Last Supper to the Garden of Gethsemane where the evil becomes palpable, the "unique enigma," as Paul Ricoeur calls it, that is "never completely demythologized."[9] For the disciples, sleep offers momentary respite, though the evil cannot be finally denied: and Jesus himself, left alone with his thoughts and with God, would betray the narrative flow—even he for the moment seeking the seductions of normality and the ordinary (Mark 14:36). Saint Mark, the novelist and poet, is here at full stretch, playing the omniscient fictive narrator who alone can report on the words of the solitary Jesus. Saint Mark knows, and we, his readers, shall know also in due course, why sustaining the fiction is so vital in the final confrontation and exposure of evil.[10] And now there is the kiss of Judas—the traitor's kiss—that has burned its way into the very fabric of history: it is the moment of supreme betrayal and supreme truth, perhaps even love, and without which nothing in Jesus' mission would be possible. Nikos Kazantzakis knows this. Dostoevsky, in *The Brothers Karamozov*, knows equally that when the kiss is transferred to the Grand Inquisitor, in Ivan's great parable, he is condemned by its love in his refusal to change; "The kiss glows in his heart, but the old man sticks to his idea": betrayal upon betrayal in the double negative of the old man's life.[11]

And let us not forget here in Mark's story the mysterious boy in the linen shirt (Mark 14:51-52) who runs away naked. He, too, is a betrayer of the moment, but perhaps he is found again much later in the story, at the end and in the tomb, clothed once more, a herald of the miracle of divine absence. In him, Mark's poetry plays upon the narrative, revealing and concealing—but to expose the young man to the truths of poetry (far more risky than the exposure of his naked body), just as the New Testament scholar Austin Farrer once did (Frank Kermode, a literary critic himself, reminds us), and thus brought about his own rejection and betrayal, in a way, even in modern Oxford itself. Kermode writes:

As to Farrer, *his work was rejected by the establishment, and eventually by himself, largely because it was so literary.* The institution knew intuitively that such literary elaboration, such emphasis on elements that must be called fictive, was unacceptable because damaging to what remained of the idea that the gospel narratives were still, in some measure, transparent upon history.[12]

There is here a curiously familiar pattern of betrayal and denial repeated in the academic career of a scholar and gentle man of letters who dares to enter into the fiction and expose its heart of darkness against the good and sensible reasons of history and the establishment.

Betrayal upon betrayal. We move in Saint Mark's Gospel to the trial scene, rife with false testimonies and witnesses. Jesus himself stands for the moment at the intersection of two universes—the vision of the messianic community of Daniel and this dark, chilly corner of the history of the ancient world, the necessary impossibility of their explosive encounter exposed only in repeated acts of betrayal—uncomprehending, deliberate, tragic—perhaps, finally, cathartic. (Aristotle would have approved of my reading, even if Christian theology perhaps does not.) Aside from the main action of the narrative, we find Peter the betrayer skulking in a corner. But has he himself not been betrayed also, his hopes dashed—for which he had given up everything? To hell with everything, we understand very well how one can prefer the banality of everyday evil with kitchen maids and other such ordinary people like ourselves, even all the little unremembered acts of unkindness, to this awful, overturning, unbearable, unnecessary violence. Of course, being human, we prefer to keep our heads down and to know nothing of that. "I know not this man of whom ye speak" (Mark 14:71). Peter rarely speaks anything but the truth, even when he does not know it himself. In betraying his dearest friend, he admits that he has no idea who that friend is; he cannot know the fissure that has been opened on the mythic shadows of evil as the clouds of heaven are rent by the coming of the Son of Man. For Peter, there are only the tears that are all too human, a response beyond words in the very moment of that faint glimmer of recognition (*anagnorisis*—Aristotle again), just as later the women who emerge from the tomb are beyond speaking, struck dumb in their moment of blinding truth.

But this is all just a story bathed (though, perhaps, as we are carried along by it, we have already forgotten this) in the gentle optative, which subtly changes everything: a story and a supreme fiction, and we are the readers turning it page by page, perhaps with the madness of the old gentleman of La Mancha (akin, in its way, to the madness of Hölderlin). For after two thousand years of the reading of Saint Mark's novel, we are in danger of forgetting the link between the madness that provokes endless betrayals (or, if you prefer, slippages back into "reality"—the moment when we say, "Dear Lord, this is madness, this is just crazy. It has to stop.") and the power of the novel that portrays it. In his reading of Cervantes' novel, the French philosopher Jacques Rancière writes in his book *The Flesh of Words* also, for us, of Saint Mark:

> In short, what does this "madness" consist of, if we are not content to divide it, in the Romantic manner, between the representation of the ideal confronting reality and the creative "fantasy" surrounding that opposition? In the interpretation of the relationship between the madness of the character and the "fantasy" of the author, the whole question of the "theological-poetical" nature of the novel is at stake.[13]

The point is, of course, that Don Quixote, in his madness, never for one moment falls into the error of *mistaking* "the green cheese of reality for the moon in a book," but wholly *imitates* "the act that the book makes a duty." In short, the Don is mad out of duty to the truth of the book, especially in his imitation of the madness of his role models, Anadis and Roland.

The further point is that we ourselves cannot summon up the courage—or perhaps do not dare to inhabit our imaginations seriously enough—to enter such an *imitatio*, or take our fictions wholeheartedly enough. We are ever deserters, ever looking with amazement, sorrow, or fear on the abyss of truth they reveal, the impossible confluence of the heart of darkness and the light it cannot comprehend. (No one has ever really grasped what John 1:5 *means*—"and the darkness has not *discovered* it"—κατέλαβεν.) As Cervantes facetiously reminds us in the prologue to his great novel, we are at heart mere scholars and therefore lack the ultimate courage to engage in the supreme willing suspension of disbelief, begging the writer, "Tell me. By what means do you propose to fill the void

of my fear and reduce the chaos of my confusion to clarity?"[14] Well, the answer is simple: we fall back on the old trick of all scholars and try to blind our readers with science—fill them up with footnotes and references: as Cervantes says, ". . . all you have to do is to work in some pat phrases or bits of Latin that you know by heart, or at least that cost you small pains to look out. For example. . . . If you are on the subject of evil thoughts, make use of the gospel: *'De corde exeunt cogitationes malae.'*"[15] The text is just a trick on the reader and another betrayal, and as learned readers and academics, we have all wondered when we shall be found out for the imposters that we really are, have we not?

But does it not all come down to plausibility? How *implausible* is Don Quixote, or Jesus, or any other character in supreme fictions? To this question, Rancière makes the following response, which seems obvious enough until we try to take it absolutely seriously:

> Finally, it is the social body of the readership of the fiction, which validates the impossible nature of the madness as psychologically plausible, yet belonging to the category of what happens only in fiction. *The social body is itself fictionalized as a condition of the poem.* The poet represents himself as in the privileged position of a story-teller who is addressing a literate audience.[16]

We have seen already that Mark (along with Cervantes, Dostoyevsky, George Eliot, Iris Murdoch, and many other great novelists) readily constructs for himself the role of the omniscient narrator. How far do we, the social body of his readership, adapt to our fictional condition—a genuinely liturgical action that partakes simultaneously of the ascetic madness in the truth of the book, and the necessary betrayal of that? We have to step outside this fictive nonsense, this mythical realm, confronting two worlds whereby the banality of evil ("Jesus, be sensible [we would say] and grow up, we do love you, you don't need to do this . . .") is exposed in its truly mythic dimensions. Is the Last Supper just a meal between friends, or a foretaste of the messianic banquet at which we finally and in truth sing the chorus that is the *Sanctus*? Another of Saint Mark's colleagues in the circular and synchronic Reading Room of the British Museum[17] got the point exactly, in parabolic form, as you might expect from him. Jorge Luis Borges in the "Parable of Cervantes and the *Quixote*" writes,

> For both of them, for the dreamer and the dreamed one, the whole scheme of the work consisted in the opposition of two worlds: the unreal world of the books of chivalry, the ordinary everyday world of the seventeenth century. . . .
>
> For in the beginning of literature is the myth, and in the end as well.[18]

Through the looking glass of fiction, the question is how we tell the difference between real and unreal. Or perhaps the real question is, in a world where finally only truth really matters, should we even try to do so, and simply remain content to be mad out of duty?

But let us get on with the story. We cannot proceed much further without greeting another member of the company of writers, the Irishman James Joyce. One of his fellow countrymen suggests: "A Gospel is a nocturnal writing, then. Mark is a Gospel of the dark, close kin to the oneiric writing that finds its most daring model in Joyce's *Finnegans Wake*":[19] the *Wake*, which dares to present itself to us as a see-through "nightynovel,"[20] darkly concealing and provocatively revealing its secrets at the same time, being a self-respecting narrative but also an obsessive one. Texts, into whose worlds both writers and the social body of readers can be seduced, at once reveal and conceal their obsessions, especially along the fault lines in their narratives and between different levels of discourse—moments in which the text betrays itself or betrays us. Joyce once said: "In writing of the night I really could not . . . use words in their ordinary connections. Used that way, they do not express how things are in the night."[21] How then can we trace back to the genesis of secrecy of one of the darkest texts ever composed—the Gospel of Mark? Mary Ann Tolbert, without claiming to, lays it on the psychoanalyst's couch in her book *Sowing the Gospel*, and then picks away at Mark's obsessive (unconscious?) use of the preposition κατά (down) in dizzying, descending literary exercises in paronomasia, at the height of his narrative of the passion. The passersby mock Jesus on the cross as one who would tear *down* the Temple (καταλύων) (15:29), challenging him to *come down* from the cross (καταβάς) (30), a challenge echoed by the scribes a moment later (καταβάτω) (32). Perhaps, they surmise, Elijah will come and take him down (καθελεῖν) (36), after Jesus himself has cried in the moment of supreme betrayal by the God who has left him behind, let him down (ἐγκατέλιπες) (34). Still

there is no rest in the downward spiral, as the curtain of the Temple is ripped downward from top to bottom (καταπέτασμα . . . ἕως κάτω) (38), as the conclusion of the slippage that Tolbert calls "this series of wordplays (which) connects the tear with Jesus' cry and further supports its symbolic role as an image of transportation from realm to realm."[22] Tolbert follows a necessary betrayal or tear in the very fabric of the language in obsessive repetitions that Freud, in *The Interpretation of Dreams*, might have identified as *displacement*, a mazy movement "along an associative chain linked by associative pathways."[23]

Have we entered the dark realm of the unconscious, or fictions, crazily awaiting a cleansing therapy, or does Saint Mark (or Jesus, or indeed anyone?) actually know exactly what he is doing: or is this simply implausible, and you must make of it what you will—"let him that readeth understand" (Mark 13:14)? But only at this last great rending, or descent, in the text—the final descent into hell—can the least likely interpreter of all, a Roman soldier, utter a word of truth in the first clear statement of who is actually the subject of this fiction? Is it that only within the body of readers, who will become in due course the liturgical community, this can be taken with any seriousness?

(Allow me an aside in a chapter that might seem already to be becoming just another shaggy dog story—but Mark, we may be sure, would have loved *Tristram Shandy*. We are really talking about scapegoats here: who will shoulder the blame for all this evil? Remember the ghastliness of it—lest we forget what is happening in our academic concern for wordplay: we prettily talk of *paronomasia* while this poor guy is dying in agony on the cross, for Christ's sake. Holman Hunt, whom we have visited once before in the previous chapter, understood it in one of the greatest of Pre-Raphaelite paintings, *The Scapegoat*. In this work, we contemplate not just words in the mind but an image of death and dying that is burnt upon the retina, evoking the response of one art historian (who clearly did *not* understand it): "it [the painting] seems to have been a case of a dogmatic sliding into eccentricity: not the mild English eccentricity associated with the country clergy, but the gleaming-eyed variety of a man whose beliefs have become obsessive. No other interpretation of his behavior can ever explain the touch of the madman in such a totally uncompromising image as *The Scapegoat*."[24] Well—as we

have seen, put Mark on the psychiatrist's couch and he seems pretty obsessive, not to speak of most of the characters in his novel. And what does that say about us?)

But the story, and after all it is only a story, continues. We move onward to a distant perspective on a group of women who are gradually identified as characters familiar to us common readers from earlier in the narrative—Mary Magdalene, Mary the mother of James, Salome, and others. We have reverted once more to the ordinary everyday world of the early first century. Life, as always at the end of tragedies, must go on. But here there is one more great betrayal before we are finally dismissed and released from the world of the fiction, though hardly to go in peace. As with the first great betrayal, it begins in a clear moment of historical time: from "on the night that he was betrayed" to "very early in the morning the first day of the week" at the rising of the sun. New Testament critics and theologians would tell us that we are about to switch in time from *chronos* to *kairos* (Greek always knows best). Novelists and poets make the switch more dramatically and less dryly.

The women enter the tomb and sitting there is a bit-part actor in the play, the director (we have switched to the medium of film for a moment) having saved a bit of money by using the young man last seen in the buff in the Garden of Gethsemane again for this one-line part as an angel and another betrayal. The body of Jesus has vanished, a further rent in the fabric of the everyday. And then one of the greatest novel endings of all time—the women rushing out of the empty tomb beside themselves with fear and amazement and beyond the reach of language (Mark 16:8). The only writers who have ever approached the genius of Saint Mark in their endings are Dostoevsky (the silver medal for *Crime and Punishment*) and Joyce (the bronze to be divided equally between *Ulysses* and *Finnegans Wake*). But smirking in the literary background is Aristotle, whispering again that word that does not seem to be in the vocabulary of biblical critics: *anagnorisis*—the moment of recognition. There is a clue here, an echo lurking in our literary memories that dimly begins to make sense. Back in Genesis, which we once read ages ago, Joseph (his name not so unlike Jesus—a clue?) has a story full of betrayals—until the moment when he reveals himself in all his power and glory to his treacherous and abject brothers in Egypt, and

later to his father Jacob, who, like the women in Mark's narrative, is not unnaturally "beside himself"—ἐξίστημι (Mark even gives us another clue by using the same word as in the Septuagint of Genesis 45:26)—and beyond belief. Betrayal upon betrayal, until finally we find (picking up a familiar image in Saint Mark's book) that we can, after all, see—we can *read*. What? I go back to my schooldays again and to a lesson learned the hard way when the classics master (I will not tell you his name) barks at me: "Read the text, boy, you won't find anything looking blankly into space." What do I see—the Gospel of Mark, which begins—"The beginning of the Good News of Jesus Christ, the Son of God." (1:1)? *So that's it*—the text itself will teach you to read the text, and so, poetically, in our end is our beginning. All those betrayals were necessary after all, purgatives so we can (if we will) see by a hard road what the centurion, for heaven's sake—not too bright a fellow, we might imagine, and one of the bad guys, to boot—saw in an instant.

And so, closing the book, that was a great read, we say. And we did it together, in community, like Mark's first readers—and as willing members of the fictionalized social body of readers of *this* text and no other, following (in Rancière's words) a theology symbolized in Borges' paradox in "Pierre Ménard, Author of the *Quixote*," that the new version of *Don Quixote*, word-for-word identical with Cervantes himself, is utterly different in voice and mood from the first, the only, the original. We join a body of readers that is two thousand years old in one celebration, one that could not for an instant begin to understand the grim and superior solipsism of the self-imposed solitude of a Harold Bloom, another nonparticipant reader, who suggests that his "aesthetic criticism returns us to the autonomy of imaginative literature and the sovereignty of the solitary soul, the reader not as a person in society but as the deep self, our ultimate inwardness."[25] But what is there in this darkest of places, my ultimate inwardness (which, to be fair, Kant knew as well as the rest of us lesser mortals), where I can but starkly realize again and again the validity of Susan Neiman's reminder that "humankind's faith in its ability to overcome its self-incurred immaturity was dispelled long before 1945."[26] And she quotes those tremulous words of Henry James in 1916 (omitting to say that this was also the year of the novelist's death) that to have to take the present "for what

the *treacherous* years were all making for and *meaning* is too tragic for any words" (emphasis added). And so we, too, are propelled (as any novelist worth his or her salt knows) into silence, but literature might, just might, offer us a glimpse of recognition of something that emerges out of the very depths even of the nameless darkness we might call evil itself, a darkness, which, if left alone, will horridly dilute into the Conradian, ubiquitous grayness of the uninterrupted day. Jacques Rancière, who has been with us all the time, off and on, offers us the shadow of hope in his celebration of the genius of Gustave Flaubert:

> The Flaubertian absolutization of literature is not the sovereignty of writing that makes art out of all non-meaning. It is rather the inversion of this sovereignty, the revelation of its secret. And this secret is not the glorious "pattern in the carpet" which symbolizes the master of fictions playing with the reader's desire. *It is the constitutive contradiction of literature.*[27]

In such contradictions are opened up, in acts of real and seeming, and necessary betrayal (and sometimes both at the same time), the impossible meetings in which evil (I have left that word "evil" to speak for itself; like Augustine and time, "I know well enough what it is, provided that nobody asks me" [*Confessions* XI, 14]) is confronted and finally outed. It can indeed consume those whom it confronts, starkly, in the *literary* depths (for in *actuality*, when faced by such a confrontation we would be reduced to what science calls antimatter in the twinkling of an eye). As Georges Bataille shockingly puts it in a book that even by his standards barely balances on the very limits and possibilities of experience (I can cope even with de Sade with more equanimity than I can Bataille, for Bataille knows yet more vividly of the resistance of evil to demythologizing, and how close we are to the edge of the abyss even in acts of seeming innocence):

> Literature is either the essential or nothing. I believe that the Evil—an acute form of Evil—which it expresses, has a sovereign value for us. But this concept does not exclude morality: on the contrary, it demands a "hypermorality."
>
> Literature is *communication*. Communication requires loyalty. A rigorous morality results from complicity in the knowledge of Evil, which is the basis of intense communication.[28]

I believe that Saint Mark would have understood this—and even more so the hero of his novel. Of the shadowy figure who lies behind the fiction, I cannot speak. But he understood it just as he knew full well that throughout the narrative, the dear, stupid disciples do not get it at all, and Peter, bless him (we would be the same, wishing to hold to the loyalty required by communication, but doomed to be traitors), would just prefer it all to go away. It is too unthinkable. Judas—maybe he got it in a way (if Kazantzakis is to be believed). Raskolnikov comes to have an idea of it, but Thomas Hardy's Michael Henchard is utterly defeated by it.

And we—of the community of readers, though of them the least? Let us end this chapter as we began, in the gentle optative mood, and in a place we have visited already and will visit again. As long ago as the *Apostolic Tradition* of Hippolytus in the early third century of the Christian era, and probably earlier than that, the Great Thanksgiving of the Eucharistic Prayer has opened with a short dialogue that comes, in English, as close as anything you will find anywhere in our language to a consistent optative. (Interestingly, modern word processors and computers regard it as bad grammar. I pass no comment.)

> The Lord be with you.
> And with your spirit.
> Up with your hearts.[29]
> We have (them) with the Lord.
> Let us give thanks to the Lord our God.
> It is fitting and right.[30]

Under the benign eye of this mood in grammar, the community of the faithful rehearse the great mysteries of creation and salvation until, with the whole company of heaven (as *chronos* slips for the moment into *kairos*), they too presume to utter the *Sanctus*. And then, almost immediately, that switch back into history, back into that particular night, back into brokenness, death, and betrayal: "On the night when he was given up to death." It is over this abyss in the narrative, between these two supreme moments, that Mark writes his novel, a true fiction perhaps, but one that renders history speechless, even while it makes for us the impossible plausible. It is only a pity—but I speak as a mere literary critic—that someone writing after Saint Mark could not leave his work with its brilliant

ending alone, but had to tidy it up and expand it for better ease of popular consumption (16:9-20). It is a fate not altogether uncommon in the history of fiction: Charles Dickens, for example, had to soften his far superior and darker first ending of *Great Expectations* to satisfy Victorian sentimentality. But I wonder if, in the gospel's case, the later editor, no doubt a good and even godly person, was also somehow an ancestor of the Grand Inquisitor of Ivan Karamazov's parable—not a bad man in the end, I have often thought, in his concern to protect the church from harsh reality (though not immune to typical human lust for power), but one who never faced his own demons, let alone dared to look evil in the face, lest he saw his own reflection, and therefore could not believe in God.

And so, at the true end of every fiction, we are left at the beginning of a journey to the next narrative, reading always in anticipation and as a community in pilgrimage. It is to the pilgrim church that we now turn.

CHAPTER 4

The Community in Pilgrimage
Egeria and Her Fellow Travelers

The soul in paraphrase, heart in pilgrimage.
—*George Herbert*

When Geoffrey Chaucer's pilgrims set out in springtime from Southwark for the shrine of the "holy blissful martyr" Saint Thomas à Becket in Canterbury Cathedral, at the end of the fifteenth century, the heyday of pilgrimages to sacred places was already at an end. Their journey from an inn just south of London was made as a motley company of talkative travelers drawn from all parts of late medieval society, both sacred and profane, pious and rumbustious, from the worthy Knight, who had fought against the "hethen" in the Crusades and who loves chivalry, truth, and honor, freedom and courtesy, to the lusty Wife of Bath, the pious Parson, poor yet rich in holy thought and work, the wanton and merry Friar, and the learned Clerk of Oxford University. Farmers and gentry, sailors and clergy, men and women—they all mix together in their common purpose. They form what Victor Turner calls *communitas*—a liminal community bound not by the structural ties of society so much as by "an essential and generic human bond, without which there could be *no* society."[1] For the period of their journey, they live both in and out of time, bound together by a kind of holiday spirit, the traveling and talking as much a part of their purpose as their devotional destination, the shrine of the saint. In an England fast approaching the political and religious trauma of the Reformation, they were not

45

far from Thomas Cromwell's Injunctions of 1536 and 1538, which attacked, with increasing severity, the practice of pilgrimage and the cult of saints as "phantasies" to be replaced by more scripturally validated works of charity and mercy.[2] Already in the late fifteenth century, the practice of pilgrimages to sacred places associated with the saints was being criticized by, among others, Thomas à Kempis in his best-selling *Imitation of Christ* (first translated into English in 1503), to be replaced by devotion to the divine presence in the Sacrament of the Altar. Thomas writes curtly and dismissively:

> When visiting such places, men are often moved by curiosity and the urge for sight-seeing, and one seldom hears that any amendment of life results, especially as their conversation is trivial and lacks true contrition.[3]

Early in the fifteenth century in England, the Catholic poet and playwright John Heywood (ca. 1497–1578), who was to leave England during the reign of Elizabeth and die in exile, wrote an entertaining interlude entitled *The Play Called the Four PP* (ca. 1544), which begins with a dialogue between a Palmer—that is, a pilgrim who has visited the Holy Land and carries a palm leaf as a sign of this—and a Pardoner, who doubts the value of the Palmer's "labour and ghostly intent." This Palmer is a much-traveled man, having spent most of his life in journeys to Jerusalem, where he visited Christ's sepulchre, Calvary, "Josophat and Olivet"; then Rome, to see the shrine of Saint Peter; as far as Armenia, where he saw Noah's Ark; and a whole catalogue of English places of pilgrimage from Walsingham to Muswell, Willesden, Canterbury, and Dagenham. The journeys, he admits, were not easy, for he traveled on foot and "many salt tear did I sweat / Before this carcase could come there."[4] When asked by the Pardoner why he went on pilgrimage, the Palmer replies that his primary purpose was penitential—to "rid the bondage of my sin" by asking the saints to intercede for him. In short, it was for his "soul's health" in a search for the holy in places made sacred by the lives of saints, but above all by the earthly life and passion of Jesus Christ. In the same way, that indefatigable traveler and mystic Margery Kempe (ca. 1373–1438), having visited the Holy Land in 1413, made pilgrimage on Lammas Day in 1414 to Assisi, where there was "gret pardon of plenyr remyssyon, for to purchasyn grace, mercy, & foryevenes for hir self, for alle hir frendys, for alle

hir enemys, & for alle the sowlys in Purgatory."[5] She goes, in other words, not simply for herself, but to seek indulgence for a great community of friends and enemies, both living and departed.

Undoubtedly pilgrims like Margery Kempe tramped and rode vast distances at no little risk to life and limb. They lived in a real world, though at the same time they saw the world in a way that is utterly alien to us. One of the most celebrated—and now largely forgotten—works of medieval literature is *The Travels of Sir. John Mandeville* (ca. 1356), which, at least for the first half of the text, gives another pilgrim's guide to the Holy Land, drawing upon contemporary pilgrims' manuals, and quite possibly the firsthand experience of Mandeville himself, though who he actually was is still unknown.[6] Significantly, perhaps, Mandeville's greatest influence has been on English literature, as he was read by Shakespeare, Spenser, Milton, Swift, Defoe, Coleridge, and many others, but his strange and often ludicrous book, with its subtle critique of the abuses in Western Christendom, is not mere fiction. Rather, it offers a worldview, with its center in Jerusalem, and not one defined by physical geography as much as by a sense of the sacred in time and space. Nor, despite their seemingly credulous—or incredible—accounts of their journeys, are these medieval pilgrims and travelers as naïve as we sometimes may think. As one modern editor of Mandeville's *Travels* has concluded:

> It is meaningless to attempt, as editors did once upon a time, to plot Mandeville's journey on a modern map outline, for the rigid spatial relationships of the modern map, for us so important a part of the meaning of map conventions, are simply irrelevant. We easily forget how much the relatively modern conventions of coordinates and the compass rose unconsciously affect our modes of understanding our world. Even direction is vague to the medieval mind: north and south can be, as required, up or down. But that we see the world differently does not imply that the medieval model was in its time unworkable—clearly it was not—nor that we are more "right" than they were.[7]

<p style="text-align:center">✳ ✳ ✳</p>

But let us now go back some one thousand years more, to the travelers who journey outside the safety of the cities to visit both the living saints—the Fathers and Mothers of the Deserts of the Middle

East—and those departed this life whose graves (like the crucifixion itself, at least in biblical times[8]) were outside the walls of the cities. The author of *Historia Monachorum* (*The Lives of the Desert Fathers*) was one of a company of seven monks from Palestine who in 394 were brought by God, "who desires all men to be saved" (1 Tim 2:4), to Egypt in order to give an account of those who dwell in the desert as a place beyond human society, situated between heaven and earth. Of these early Christian monastics, he records that "many of them, are astonished when they hear what goes on in the world, for they have attained a complete forgetfulness of earthly affairs."[9] Yet their habitations are real and solid enough, demanding much both physically and spiritually of the travelers. We shall return to their desert in a little while in the account of the travels of a fifteenth-century German pilgrim to Sinai, Brother Felix Fabri. In the fourth century, pilgrimages to the shrines of the saints in the West did not necessarily entail vast journeys—at least in the physical sense—but still a shift from the city to a place "outside." As Peter Brown has commented of more modest pilgrimages:

> Christians who trooped out, on ever more frequent and clearly defined occasions as the fourth century progressed, experienced in a mercifully untaxing form the thrill of passing an invisible frontier: they left a world of highly explicit structures for a "liminal" state.[10]

And these mixed communities of pilgrims to sacred places took on a character not at all unlike the motley crew who chattered their way to Canterbury in the last years of the fifteenth century in England. The Latin poet and hymn writer Prudentius (348–410?), in his *Peristephanon*, in which he sings the praises of Spanish and Italian martyrs, describes the real community of the city of Rome as it travels to the nearby country shrine of Saint Hippolytus:

> The love of their religion masses Latins and strangers together in one body. . . . The majestic city disgorges her Romans in a stream; with equal ardour patricians and the plebeian host are jumbled together, shoulder to shoulder, for the faith banishes distinctions of birth.[11]

Such places, and the growing discovery and veneration of relics—material fragments of the holy here on earth—represented in the

fourth century a divine harmony rarely replicated elsewhere in the disintegrating society of the later Roman Empire in the West. Wealthy citizens like Gaudentius, Bishop of Brescia and a friend of Saint Ambrose, traveled to the Holy Land and in Cappadocia received a gift of holy relics of the forty martyrs of Sebaste that, on his return to Brescia, he placed in his Church of the Gathering of the Saints as symbols of unity under the mercy of God.[12]

Moving further westward and to the Celtic Church of Ireland and the harsher landscapes of Britain, the characteristics of pilgrimage are found again, if with somewhat different emphases. Ian Bradley has indicated the communal values that undergird the monastic traditions of the Celtic Christians, with their sense of common property in the "colonies of heaven" established by monks from Iona and Lindisfarne.[13] Often, like the saints of the deserts of the Middle East, these Western monks sought remote places where, in the words of the author of the *Historia Monachorum*, "while dwelling on earth . . . they live as citizens of heaven."[14] Their lives were a mixture of ascetic retreat from the world combined with a profound sense of the social, understood in its very liminality as a legitimizing of the common humanity in which we all participate during our lives on earth, and they share, in a way, with Chaucer's pilgrims a sense of unity informed by humor and common sense in charity as much as piety and asceticism. In the words of David Adam:

> The Celtic church did not so much seek to bring Christ as to discover Him: not to possess Him, but to see Him in "friend and stranger"; to liberate the Christ who is already there in all his riches.[15]

The Celtic Christians were restless, wandering on pilgrimage as a kind of exile and a constant reminder that on earth they were far from perfect but, in the words of Adamnan, the biographer of Saint Columba, "*pro Christo peregrinari volens*" ("wishing to be a pilgrim for Christ"). The Celts certainly did follow the pilgrim routes to Jerusalem and Rome, though even in these early days there was already an element of the scepticism of Thomas à Kempis that such arduous journeying to sacred places could miss the true pilgrimage to Christ, which is of the heart and soul. The point is, of course, that pilgrimage is properly both of body *and* spirit. For the true traveler

follows in the way of Christ, who had no home in which to lay his head, and like the patriarchs described in the Epistle to the Hebrews, "desire a better country, that is, a heavenly one" (Heb 11:16). On the journey, the pilgrim takes his or her imperfect self and travels in hope. The seventh-century Irish missionary Saint Columbanus spent his life in perpetual pilgrimage—though he was at the same time no stranger to worldly controversy—affirming that "it is the end of the road that travelers look for and desire, and because we are travelers and pilgrims through this world, it is the road's end, that is of our lives, that we should always be thinking about. For that road's end is our true homeland."[16]

If this seems rather a gloomy view of the Christian pilgrimage made merely in anticipation of the world to come, such a frame of mind hardly describes an earlier Spanish pilgrim to Jerusalem, the indomitably cheerful Egeria, and perhaps she would make little distinction between the earthly Jerusalem that she visited somewhere between 381 and 384, and the heavenly city that is the final goal desired by Columbanus.[17] The manuscript of Egeria's travels, written by way of a report on her journeys to her sisters, possibly back in Spain or perhaps Gaul, was discovered only in 1884, this one surviving manuscript probably dating from the eleventh century and written in the monastery of Monte Cassino in Italy. It later passed to the library of the Community of Saint Flora at Arezzo, where it lay bound together with a work by Saint Hilary.[18] The manuscript is incomplete, and we are not even sure of the pilgrim's name, generally now known as Egeria, though to some as Sylvia of Aquitaine,[19] but its value lies in its being almost the sole evidence available to us of the liturgical practices of the fourth-century Christian community in Jerusalem, seen through the perceptive eyes of a pilgrim from the far West.

Egeria is rooted, heart and mind, in the Bible, and as she visits the sacred sites, beginning with Mount Sinai, her map exactly follows events recorded in scripture; and each place, she maintains, "must have been planned by God" for the edification of pilgrims. Thus, as she approaches Sinai she notes that "it was at the head of this very valley that holy Moses pastured the cattle of his father-in-law and God spoke to him twice from the burning bush."[20] Yet, what is perhaps most remarkable about this intrepid traveler is

how down-to-earth she is, exact and practical in her descriptions and endlessly sociable with all whom she meets and from whom she receives hospitality. She has a boundless capacity for sightseeing, repeatedly asserting that "I wanted to see all the places" where the events recorded in the Bible had taken place, and when she arrives, inhabiting them almost timelessly, yet always careful not to assert that she saw things that she did not. So as she passes by the Dead Sea and the place where the Bible speaks of a memorial to Lot's wife, she tells her sisters: "But what we saw, reverend ladies, was not the actual pillar, but only the place where it had once been. The pillar itself, they say, has been submerged in the Dead Sea—at any rate we did not see it, and I cannot pretend we did."[21]

After her travels in Asia Minor and Constantinople, the primary focus of Egeria's report to her "loving sisters" is the liturgy of Holy Week, the "Great Week," and Christian initiation as celebrated in Jerusalem. As the devout crowd moves from site to site, from the Mount of Olives and on into the city on Palm Sunday, Egeria communicates a lively sense of the worshiping community of all ages. "The babies and the ones too young to walk are carried on their parents' shoulders . . . but they have to go pretty gently on account of the older women and men among them who might get tired."[22] Following closely the events of the Passion Narrative, the worship is both physically and emotionally demanding—as the people hear the reading of Judas' betrayal they "groan and lament . . . in a way that would make you weep to hear them."[23] For Egeria, pilgrimage is about touching, feeling, being in the presence of the sacred and sacred history, yet in the midst of a living community that chatters, needs to rest and eat—and is far from perfect. The very wood of the Cross itself is venerated and kissed, though on one occasion "one of [the worshipers] bit off a piece of the holy Wood and stole it away."[24]

The history of the worship of relics and its abuses has been often and well recorded,[25] but less frequently noted is the easy and intelligent way in which Egeria and her fellow pilgrims merge their liturgical use within the sense of a community assured of salvation in the presence of the holy. In describing the Jerusalem congregation of the fourth century, she notes that three languages are spoken—Greek, Syriac, and Latin—but to everyone everything is explained so that all can participate and understand, and all is in accordance

with or related to scripture—even the day on which the church on Golgotha (the *Martyrium*) was consecrated, for example, was the very day on which "Solomon stood in prayer before God's altar, as we read in the Book of Chronicles."[26]

In the centuries following Egeria, pilgrims continued to travel to Jerusalem. We will mention but two of their great company. In about 570, a pilgrim from Piacenza, whose name we do not know, gives a vivid account of his journey to the Holy Land. More famously and a few years later, Sophronius, the traveling companion of John Moschus, author of *The Spiritual Meadow*,[27] who was later to become the Patriarch of Jerusalem, records his longing for the Holy Places in his *Anacreontica* 19 and 20, written some time after 631.[28]

The Piacenza pilgrim's narrative of his journey is a sociable account through a world described in fine detail with the eye of a seasoned tourist and replete with miracles and places sanctified by events in the Gospels both canonical and apocryphal. He sees the chair on which Mary sat at the moment of the annunciation; visits the synagogue in Nazareth in which there is a book "in which the Lord wrote his ABC";[29] venerates the Wood of the Cross, still bearing the title "This is the King of the Jews." He affirms that the wood is from the nut tree—probably a reference to Song of Songs 6:11, "I went down to the nut orchard"[30]—and insists, lest there is any doubt in the mind of his reader, "This I have seen, and had it in my hand and kissed it."[31] His is a world that seems outrageously credulous to a modern sensibility, yet his account is an extraordinary mixture of the practical, and even prosaic, with a profound sense of the sacred, and everywhere the presence of the biblical world in fine detail. On the feast of Christ's baptism, shortly after Epiphany, all the Alexandrian shipowners send men to the Jordan to collect holy water to sprinkle on their ships for a blessing, a commendable precautionary act before the days of the modern insurance policy. Rahab's house in Jericho "is now a guest house"[32]—its shrewd proprietor clearly with an eye on the business of the pilgrim trade, and not alone in the commercial profit to be had from wine made from grapes that have been watered by the spring of Elisha (2 Kgs 3:20), gifts to the keepers of the basilica at the Oak of Mamre, and sellers of supplies for the pilgrims in Jerusalem.[33] Everywhere the pilgrims witness miracles, though not all requests for a miracle are answered: one fellow

pilgrim whose hopes were disappointed, despite his generous gifts, concludes, "Devil take it, what's the use of being a Christian!"[34]

The Piacenza pilgrim's description of his visit to the holy places in Jerusalem might almost come from the diary of a modern Christian traveler on an organized "pilgrim" tour of the Holy Land. He is anxious to describe each place in fine detail and to fix its geography in his mind, precisely pacing out the distances between the sites of greatest significance.

> From the Tomb it is eighty paces to Golgotha; you go up on one side of it by the very steps up which our Lord went to be crucified. You can see the place where he was crucified, and on the actual rock there is a bloodstain. Beside this is the altar of Abraham, which is where he intended to offer Isaac, and where Melchizedech offered sacrifice. Next to the altar is a crack, and if you put your ear to it you hear streams of water. If you throw an apple into it, or anything else that will float, and then go to Siloam, you can pick it up there. I suppose it is a mile between Siloam and Golgotha.[35]

There is here the instinct of the curious, almost childlike traveler throwing sticks over the bridge and watching them float out on the other side,[36] but far more the profound sense of being in the most holy of places, touching the very surfaces that, perhaps, carried the weight of the events of the passion itself, such that it is not hard to begin to sense the actual blood, almost to feel the very pain. The pilgrim in Jerusalem is not so far away in spirit and vivid imagination from Dame Julian of Norwich who, in her first revelation of divine love, "saw the red blood trickling down from under the garland, hot, fresh and plentiful,"[37] or perhaps the faithful following the passion through the *Spiritual Exercises* of Saint Ignatius of Loyola. There are many kinds of journeys to the heart of faith.

Like his predecessor Egeria, and, as we shall see, like so many after him, the Piacenza pilgrim and his fellow travelers, climbed Mount Sinai in the company of a "crowd of monks and hermits, singing and carrying a cross."[38] Like her, he visits the place of the burning bush within the walls of the monastery (to which we shall return in due course in the company of nineteenth-century travelers),[39] and like her he appreciates the provision of languages for international pilgrims—in the monastery of Saint Catherine at Sinai

Latin, Greek, Syriac, Egyptian, and Bessan are spoken—so that all may understand, just as in the modern tourist guides provided in the bookstalls, in all major world languages.

Unlike the Piacenza pilgrim, his near contemporary Saint Sophronius (ca. 560–638) was a native of Damascus and knew Jerusalem well from his years as a monk at nearby Saint Theodosius' monastery. Although he was to return to Jerusalem as Patriarch about 633, he spent some time in North Africa, where he reflected on his longing to see the sacred places again in verses known as his *Anacreontica*, composed on the very eve of the Persian invasion and the surrender of Jerusalem to the Arabs under Caliph Umar ibn el Khattab in 638, the year of Sophronius' death. A creative writer of some sophistication, Sophronius captures the sense of place with the longing eye of the exile—and with the knowledge of one who knows the place intimately.

> How sweet a thing it is, City of God,
> to see your comeliness from the Mount of Olives.

> And having passed through up to the tomb of Lazarus,
> dead for four days,
> may I give glory to the Lord
> who raised him.

> And holding in check
> the seething of godly desire in my heart,
> may I quickly reach the small town of Bethlehem,
> where the Lord of all was born.

> And going to the middle of the holy place of four column-rows,
> of the exceedingly remarkable triple-apsed home,
> going to the middle of that holy house
> I will dance in joy.

> May Christ, who came into being there, grant me
> to see the whole beauty of shining Bethlehem.

> And often looking upon pillars gleaming gold
> and the especially beautifully built work of art,
> may I escape
> the clouds of pain.[40]

Sophronius is writing in the tradition of the Pilgrim Songs of the Psalter, above all the great Psalm 122, perhaps used at the pilgrimage Feast of Tabernacles—

> I was glad when they said unto me,
> Let us go into the house of the Lord.
> Our feet shall stand within thy gates,
> O Jerusalem.[41]

Through the millennia, the pilgrim exults in being physically present in the holiest of places. Sophronius rejoices in the church built in Bethlehem by the Emperor Justinian in the sixth century to replace that of Constantine, describing exactly its nave (four rows of columns) and the east end (three apses).[42] To be present there is to touch the very mystery of the incarnation, and to rejoice in the splendid craftsmanship is to be consoled by its glory.

Such pilgrims and pilgrim communities as we have been encountering were not, by and large, of a particularly mystical bent. They were not wanderers and religious nomads like Jean de Labadie, who in the seventeenth century traversed the spiritual and theological boundaries of Christianity and the physical geography of Europe,[43] nor the cherubinic *Wandersmann* ("wanderer") of Angelus Silesius (1624–1677), of whom Michel de Certeau writes,

> He or she is mystic who cannot stop walking and, with the certainty of what is lacking, knows of every place and object that it is *not that*; one cannot stay *there* nor be content with *that*. Desire creates an excess. Places are exceeded, passed, lost behind it. It makes one go further, elsewhere. It lives nowhere. . . . Of that self-surpassing spirit, seduced by an impregnable origin or end called God, it seems that what for the most part still remains, in contemporary culture, is the movement of perpetual departure.[44]

But our community of pilgrims, through the ages, by contrast is utterly intent on its place of arrival. It is clearly journeying *to* somewhere, to a real place—Jerusalem, Compostella, Rome, Walsingham, Canterbury, or a host of other places in a landscape made sacred by miracles of the Virgin or the lives of the saints. It is seeking heaven here on earth and in an earth whose very stuff can make salvation possible. Our pilgrims, by and large, are not themselves saints or even very saintly, though some, like Egeria, can be touchingly so.

But they are members of a holy community, though in the Middle Ages, to which we now turn again, their motives could be very mixed. In the words of Ronald Finucane:

> The motives for pilgrimage were very varied: people went simply to express piety; to show opposition to kings by honouring their slain enemies; to have a sight-seeing holiday away from farmyard drudgery; to carry out a penance; to collect free alms and food from monasteries and wealthier travellers, even to rob them; to ask for some special favour from the saints (or to thank them for favours received) such as male heirs, or business success, or overall protection. Many went to shrines to be cured of physical or mental afflictions.[45]

So far, it has to be admitted, I could be accused of at least giving our pilgrims the benefit of the doubt as regards their sacred rather than profane purposes. Certainly, however, they are nothing if not human. Here we are not lost in the communion of saints, but in the community of ordinary folk (though the point is that they too have their share in that communion and sing the *Sanctus* with the best of them)—inquisitive, argumentative, ribald at times or worse, not above a bit of shady dealing or even robbery, frightened, poor . . . and sometimes pious, at the very least grasping for a sense of the reality of the salvation promised by Christ and the church (itself far from being a perfect institution on earth), and capable now and then of seeing heaven in the ordinary in a world where an occasional touch of a naïve spirit can show us truths that reason and common sense will sometimes too quickly dismiss. And with that we return to the fifteenth-century German pilgrim Brother Felix Fabri, and approach him through the medium of the two volumes by the now rather neglected historian and novelist H. F. M. Prescott, once well known for her historical novel about the Pilgrimage of Grace, *The Man on a Donkey* (1952), but whose two works on Felix Fabri, *Jerusalem Journey* (1954) and *Once to Sinai* (1957), she considered her greatest achievement.

By Felix Fabri's time, the great age of the Crusades to the Holy Land and Egypt had long passed. True, Chaucer's fictional knight, almost his contemporary, had "foughten for oure faith at Tramyssene" and against various "hethen" enemies, but his was a chivalric ideal, rather than a serious campaign for the defense of the Christian

Mediterranean.[46] Certainly his world was a far cry from the great Crusades that begin with Pope Urban II in 1095 and ended in the failed enterprises of the thirteenth century. If crusaders and pilgrims had in common a confusion between the heavenly and the earthly Jerusalem, born sometimes of ignorance, sometimes of genuine piety, the crusader knights were fueled by what Andrew Jotischky has called a "penitential violence"—a seeking of divine forgiveness for their sins by the fighting of a holy war—an attitude far removed from the more gentle world of Fabri and his knightly companions. Pilgrimages continued long into the late Middle Ages and "Jerusalem and the Holy Land did not cease to appeal to Western Christians even when hopes of their recovery must have dimmed."[47] Even if a certain antiquarian curiosity is by then present, still the real devotional piety of the Christian community outlived the complex political motives of the crusading centuries, a piety found at its purest (at least arguably) in the preaching of Bernard of Clairvaux on the spiritual essence of the Second Crusade in 1146, and in his treatise *In Praise of the New Knighthood*. But turning now to Fabri, we find a form of piety far less elevated than that of Bernard, yet touchingly real nonetheless, and thereby somehow closer to the life of the real, everyday Christian community here on earth.

Hilda Prescott's books are, in essence, a selection from the two volumes of Fabri's "little book," his *Evagatorium in Terrae Sanctae*, not so little but that they fill the three volumes of the edition of C. D. Hassler, published in Stuttgart between 1843 and 1849. An English edition, also in three volumes, and translated by A. Stewart, was published by the Palestine Pilgrims' Text Society during the years 1892 to 1897. But in the pages of Prescott's lighter volumes Fabri comes alive for us—a Dominican friar, garrulous, with a sense of humor that could extend to laughing at himself, partial to food and wine, brave, and sometimes reckless—but undoubtedly a genuinely pious man. He is a person of inexhaustible curiosity, a tourist for whom no mountain can remain unclimbed, no place left unvisited. In his second pilgrimage to the Holy Land and Sinai in 1483, Fabri acts as chaplain to a court official and in the company of some rather well-born pilgrims who could be difficult fellow travelers. We take up his story as the pilgrims—like all travelers to that unsettled part of the world then, as now, carefully guided

and controlled—travel by donkeys to their principal goal, the city of Jerusalem, where every stone and experience has its place within biblical history. They enter the Church of the Holy Sepulchre "whose walls, none doubted, contained that very hill, that very tomb, where Christ had died, and from which Christ had risen."[48] Like the worshipers in Jerusalem described by Egeria a thousand years before, Fabri's community of pilgrims feel the presence of place and history with profound physical and emotional energy, entering into every experience with an unbounded enthusiasm that fills every moment of their visit. From their cramped lodgings in the Franciscan house in Jerusalem they set out each day, enduring

> the intense heat of the sun, the walking from place to place, kneeling and prostration; above all . . . the strain which everyone puts on himself in striving with all his might to rouse himself to earnest piety and comprehension of what is shown him . . . and to devout prayer and meditation. . . . To struggle after mental abstraction whilst bodily walking from place to place is exceeding toilsome.[49]

Piety is no easy task, and the demands of body and soul are never easy to keep in balance. The mixed little group pursues holiness in the midst of struggles with locals out to make business from them, strange food, extremes of heat, cramped quarters—in travel, perhaps, little changes. Not the least exhausting element is the wandering in a landscape and "ritually-managed neighbourhood"[50] in which every stone and every object brings them into direct touch with biblical history and later legend. They see the pillar on which stood the cock that crowed for Saint Peter, the houses of Dives and Lazarus and Saint Veronica. They stand bowed under the weight of memories made present, above all in the Church of the Holy Sepulchre, in which they pass three nights, while the days are spent on tourist trips to Bethlehem, the Jordan, Jericho, the Dead Sea. Their celebrations of the Mass and devotions are constantly interrupted by haggling with officials on the Moslem festivals during which sightseeing would be ill-advised. They are nothing if not energetic, tourists determined to get their money's worth.

Jerusalem being a Moslem city in the fifteenth century, certain sights holy to Christian pilgrims were simply inaccessible, while devout imagination constructed others from the promptings of the

biblical story, such as the crossroads where the disciples separated and set out to preach to the world "at the bidding of the Blessed Virgin."[51] Nor is Fabri, though a friar, immune to other more worldly attractions, such as during the visit to Pilate's house (where the vaulted chapel was the place in which, by tradition, Jesus was scourged), which occurred while the Moslem owner was out and in which, he records, "we knocked, and were let in by his daughters . . . two good-looking, rather tall girls, and, when we came in, they laid aside their veils, and spoke to us with smiling countenances, a thing they would not have dared to do with Saracens."[52] As they left the house, the visitors were assured of a welcome any time—only provided the father was not at home. Fabri, with disarming honesty, records that he, at least, took advantage of the girls' invitation.

As the reader travels with Fabri and his companions through Jerusalem and the Holy Land, the sense grows of a garrulous, chattering group, immersed at once and in equal measure in piety and worldliness. Their human frailties are all too familiar, and yet they carry them into lives that are at the same time governed by the rhythms of Christian worship and a sense of a world sanctified in place and object, rooted in history, in the Bible, and in later legends of piety, with the all-pervading presence of the divine. Like tourists of all ages, and despite warnings to the contrary, they cannot resist the temptation to leave their names etched on the walls of holy places. Even those of a class that ought to know better scratch the stones of the Calvary Chapel while kneeling to touch the socket hole of the cross, earning a somewhat sanctimonious comment from Fabri: "within the circle of their arms [they] would secretly scratch with exceeding sharp tools their shields, with the marks—I cannot say, of their noble birth—but rather of their silliness."[53] But it is in the pages of Fabri's books that one finds expressed with unnerving similarity the observation made in our own time by Hannah Arendt in her work on the state of modern humanity, *The Human Condition* (1958), that it was Jesus of Nazareth who discovered the role of forgiveness in the realm of human affairs, releasing us from the endless treadmill of vengeance and inevitable repetition. Fabri would, no doubt, agree with Arendt (or perhaps she with him) that humankind is far more liable to be silly than to be evil, to trespass than to will great crimes. As she says,

But trespassing is an everyday occurrence which is in the very nature of action's constant establishment of new relationships within a web of relations, and it needs forgiving, dismissing, in order to make it possible for life to go on by constantly releasing men from what they have done unknowingly. Only through this constant mutual release from what they do can men remain free agents, only by constant willingness to change their minds and start again can they be trusted with so great a power as that to begin something anew.[54]

Fabri's pilgrimage of 1483 did not end in Jerusalem. His account, supplemented by the narratives of two of his German fellow pilgrims, Bernhard von Breydenbach and Paul Walther, tells further of their journey across the desert to make their own ascent of Mount Sinai, the holy mountain where Moses received the Law.[55] The account of the journey itself is remarkable, not least inasmuch as it is little different from that described by the nineteenth-century explorer Charles M. Doughty in his great, and unjustly neglected, *Travels in Arabia Deserta* (1888), a book beloved by T. E. Lawrence. Oddly, too, Fabri's often gothic style of Latin finds an echo in Doughty's archly constructed English, which is a deliberate throwback to the medieval world of Chaucer and European chivalry. They share, in addition, an awareness of both the romance and the harshness of the desert, though Doughty has none of Fabri's sense of the divine presence or of following in the steps of those whose ancient journeys are recorded in the pages of scripture.

But their texts, so widely separated by time and culture, give some evidence of the way in which time vanishes in the desert, or at least of its minuscule pace between the fifteenth and the nineteenth centuries. And as Fabri approaches the great monastery of Saint Catherine, founded in 527, Prescott remarks that "in the desert wadis round about, associations with God's Chosen People, uncritically enjoyed by pilgrims of the Middle Ages, and no less enjoyably debated by modern scholars, are common, almost, as blackberries. In addition to all this, the whole has perhaps undergone as little change as any frequented locality in the whole world."[56] But the medieval pilgrims' arrival at the famous monastery of Saint Catherine, within whose walls is the very place where Moses stood before the burning bush, illustrates well the conflicts that too often divide

those who follow the Christian tradition: for if the monks saw in the pilgrims the possibility of commercial gain, Fabri dismisses these monks as outlandish heretics who would not allow any celebration of the Latin Mass in their church.

It is, however, in the ascent of Mount Sinai itself that a sense is recovered of the holy people of God united in praise through time and space. For in their accounts of the climb to the place of Moses' theophany on the summit of the mountain, Egeria and Fabri, divided by a thousand years, might almost be walking hand in hand. Each, with their fellow pilgrims, finds the climb almost too much for them. Egeria, clearly a robust lady under any circumstances, manages the ascent, as she puts it, "impelled by Christ our God and assisted by the prayers of the holy men who accompanied us."[57] Her medieval companions seem to lack her devout energy, or perhaps the chivalrous hands (and prayers) of holy men helping their sister on her journey. One of Fabri's companions, Nicolò Martoni, felt his feet to be "so heavy that they seemed like beams of wood, and several times I said to myself, 'Turn back! You see! You can't keep up with the other pilgrims.'"[58] But finally the last steep ascent is made, and, for Egeria, she is taken back to inhabit again the moment of Exodus 19:18, when the Lord descends upon the mountain in smoke. All pilgrims, from the fourth and the fifteenth centuries, now enter the church on Sinai and make their devotions—in Egeria's case it is to receive Communion, for Fabri to read from his processional, a book of prayers especially compiled for pilgrims. Overcome by joy, Fabri reflects for a moment and with a degree of envy on the life of the contemplative monk lived out in the cave of Moses, so "big and wide," which, Egeria had noted, was uninhabited.

In the accounts of Egeria and Fabri we stand together for one moment as in the *Sanctus*, human time and space entirely embraced by the physical appropriation of a moment when heaven and earth meet, and when Moses is summoned by God who speaks to him the words of the Commandments (Exod 20:1-17). What in the biblical account is entirely shrouded and hidden, at God's command, from the view of people and priests, is now, in a sense, shared in the devotions of these later pilgrims. In their accounts of their descents from Mount Sinai, Egeria and Fabri, having met in spirit, nicely illustrate the different spirits of their ages. Egeria, writing to her

beloved sisters back home, seeks to bring together in their minds and imaginations the holy places "the better to picture what happened in those places when you read the holy books of Moses."[59] She is wholly undeterred by a mountainous landscape that Baedeker, in his guide for modern travelers, was to describe as "hardly suitable for ladies."[60] Fabri and his rather motley company, on the other hand, find themselves struggling with one knight who simply feels it all too much and "sitting down on a blazing hot slope, could go no further." After much cajoling he is forced on his way, but, says Fabri, "a terrible business we had with that pilgrim."[61]

Egeria, one feels, might have shared with two other women travelers of a later age in the Sinai Desert, a certain lack of patience with the moaning knight. These two later Victorian twin sisters, Agnes Lewis and Margaret Dunlop, are the subject of a recent book by Janet Soskice, *Sisters of Sinai* (2010), which recounts their remarkable travels in the Middle East and elsewhere and their extraordinary scholarly exploits in discovering an early copy of the gospels in the library of the same Monastery of Saint Catherine visited by Fabri five hundred years before. Although they were not precisely pilgrims in any strict sense, the sisters' travels to Mount Sinai had nevertheless originated "simply on account of its hallowed associations,"[62] and, like Egeria and Fabri before them, they recorded their journeys in a vivid account. The sisters, devout Scottish Presbyterians, were also accompanied by a difficult party of fellow travelers: in the main, Cambridge scholars of divinity who were men less than comfortable at having their male academic world invaded by two women who possessed a formidable combination of physical stamina and courage, as well as remarkable scholarly abilities.

If our earlier pilgrims literally entered the world of the Bible in the sacred places of Jerusalem and Sinai, Agnes and Margaret discovered in the same Saint Catherine's Monastery (where the burning bush still flourished, now recorded by them in modern photographs) a palimpsest of ancient Syriac gospels that dates to a time almost, if not quite, contemporary with the very writing of the Bible texts themselves. Their pursuit of holiness, in Soskice's account of these two lady adventurers, takes us back immediately to the world of Fabri and fifteenth-century pilgrimage—their struggles in Egypt and Alexandria with all manner of shady characters and holy people

in a world in which nothing is simple and the pursuit of the truth and God is beset on every side. Formidable they were, and if the same can hardly be said of Brother Fabri, they share with him a tireless inquisitiveness, energy, and sense of adventure. In this sense, they join the pilgrim community that travels with an ineradicable consciousness of the divine in the world, a feel for the sacredness of place, and eyes that pierce through all the limitations of history and its divisions. As Janet Soskice remarks:

> It was their fierce commitment to the truth that most impresses. At a time when many feared that new manuscript finds would destroy the trust of the faithful in their Scriptures . . . Agnes and Margaret were convinced that, if the Bible was God's truth, then no scientific finds could damage its fundamental integrity.
>
> Of course one had to grow and that, in their view, was part of God's plan. . . . It was this openness to truth, and thirst to get at the truth behind tradition, that endeared Agnes and Margaret to the great scholars with whom they worked and corresponded, and which still excites us today.[63]

In an age that seems to be endlessly fascinated by fictional and highly sensational and careless accounts of hidden gospels—like Dan Brown's *The Da Vinci Code* and the rather more respectable, but still racy, *The Secret Gospel of Mary Magdalene* of Michèle Roberts—that seem to link us, in some vague sense, with the origins of Christianity, the discovery of Mrs. Lewis and Mrs. Dunlop seems even more remarkable and sensational, as it touches upon the very stuff of faith through a community that survives the passing of millennia. And if Egeria, the Piacenza pilgrim, Sophronius, and Fabri, together with a multitude of other pilgrims to holy places up to the end of the Middle Ages, seem to us to be naïve and literal, unable to distinguish between the truths of religion and the stuff of legend and hagiography, from the New Testament to *The Golden Legend* of the thirteenth century, can we really compare their profound sense of the sacred, their intuitive sense of the incarnation and the community of saints, with the facile and sensationalist imagination of popular contemporary fiction writers? In such pilgrims as we have been considering, we find the warmth of humanity gathered as one at the meeting points of history and belief, places that hold extraordinary sacramental power over the human mind and heart, the heart in

pilgrimage. In Brother Felix Fabri's time, at the end of the fifteenth century, this world of pilgrimage was largely coming to an end, as it was for Chaucer's Canterbury pilgrims, to be replaced by the more prosaic, rational, and desacralized world of the Reformation.[64] Fabri, however, was the child of the world that, a century before his time, had given us the great *chanson d'aventure*:

> In the vale of restless mind
>> I sought in mountain and in mead,
> Trusting a true love for to find.
>> Upon an hill then took I heed;
>> A voice I heard—and near I yede –
>>> In huge dolour complaining tho:
>> "See, dear soul, my sidès bleed,
>>> *Quia amore langueo.*"[65]

Here, in macaronic verse, the poet overhears a love-complaint, the speaker being Christ himself, the Knight-lover, its refrain in Latin drawn from the greatest of all biblical love poems, the Song of Songs. Here, in the liminal "vale" of the poem, there is little distinction made between the external world and internal world of the spirit, the journey being made in both. In every sense, Christ and his passion are close, his words a direct address to all humankind and to each one individually. Beyond reason and in the reasons of the heart, this is the world of Fabri's spiritual quest and his imagination. It is a world in which Christ is stumbled upon in the stones themselves, above all in those on which faith and scripture inform us he walked himself as a man. It is also a world of pretty girls and whining knights, as well as the two Victorian Scottish ladies, who stumbled in their own time upon an ancient object that brought them that much closer, in their own way, to the center of their faith, to the meeting point of finite and infinite.

> Upon this mount I found a tree;
>> Under this tree a man sitting;
> From head to foot wounded was he,
>> His heartè-blood I saw bleeding;
>> A seemly man to be a king
>>> A gracious face to look unto.
>> I asked him how he had paining.
>>> He said: "*Quia amore langueo.*"

The Community of the Book and the King James Bible

Domine labia. Lord þow schalt opene my lyppes.
 And my mouþ schal schewe thi preisyng.
 God tak hede to myn help.
 Lord hiȝe the to helpe me.
 Ioyȝe be to the fadir and to the sone and to the holygoost.
As it was in the bigynnynge and now and euere in to the werldis of werdlis.

 —Henry Littlehales, *The Prymer*[1]

In the Qur'an, Islam, Judaism and Christianity are spoken of as communities of the book.[2] In different ways, they hear and receive the word of God through the pages of a sacred text. But what is it to understand this designation in a more immediate and domestic sense, not through the text of scripture itself, but rather through a book of prayers? The first half of this chapter has its beginnings in the reading of two books by the historian Eamon Duffy on the changes that took place in English religion at the end of the Middle Ages and in the early years of the English Reformation. The first book is his well known *The Stripping of the Altars*, and the second, with which I shall be more concerned, his more recent *Marking the Hours: English People and Their Prayers, 1240–1570* (2006), which is based on his Riddell Lectures, given at the University of Newcastle-upon-Tyne in 2002. This latter volume is an investigation into the history and widespread use in the late Middles Ages in England of family books called the books of hours, or more popularly "primers"—manuals of

private devotion based on the daily monastic pattern of prayer, the *Opus Dei* called the hours, in the seven offices from Matins to Vespers and Compline. There was no standardized content, though a fairly typical manuscript of about 1410 contains the Hours of our Lady, the seven Penitential Psalms, the fifteen Gradual Psalms, the Litany, Vespers and Matins from the Office of the Dead, the Commendations (Psalms 119 and 139), the Lord's Prayer, the Hail Mary, the Apostles' Creed, the Ten Commandments, and the Seven Deadly Sins.[3]

These books for the community of the Christian laity ranged in the earlier part of the sixteenth century from the sumptuous to humble printed volumes, as laboriously copied and beautifully illustrated copies written on vellum began to give way to the technology of mechanical and mass reproduction, printed on paper and in simple, portable bindings. Within families, these books were often a symbol of status or a treasured possession, frequently marked with the records of events in the history of the family or bearing the traces of sometimes cruel political and religious changes as the English Reformation took its course and the more stark liturgical forms of Protestantism replaced the Catholic devotions of medieval Christendom. As Henry Littlehales notes in his introduction to his edition of *The Prymer*:

> It is impossible to withhold one's sympathy from those who for many years had been wont to reverence and care for their Prayer-book, a book that had in probably many cases been for generations a cherished possession and family heirloom. To be compelled to give it up for public destruction must have been very hard. . . . Every existing Prymer must have a stirring history, many an one, probably, a history filled with pathetic details, of which we know nothing and can guess but little.[4]

Although there were primers edited and printed in the 1530s in the reign of Henry VIII that reflected strong leanings toward Lutheran reform, and anticipated the later prayer books of Archbishop Thomas Cranmer produced under Edward VI, their days as manuals of popular devotion were numbered.[5]

In later centuries, as those devotions and affiliations that gave rise to the primers vanished, they were replaced in family use by the great family Bibles on which often were written the names of those born, married, and deceased within the families—a record and history of a small community kept within the covers of the word of

God itself, some of which Bibles survive to this day. Duffy's interest in *Marking the Hours* is in precisely those writings and scratchings in the margins or end covers, the marginalia, emendations, deletions, and additions that might, by some, be regarded as deviations from and desecrations of the pristine text, but which embed the sacred words that are shared with the wider Christian community within the particular life and experience of the family that is a small part of it: scribblings that are often an intimate record of the history of our human loves, our jealousies, our pride, and our fears. Within the community held together by its prayers printed on the pages of the primers, such changes might also reflect the wider effect of edicts of state and the changes of politics, as when, on June 9, 1535, a Royal Injunction required that in books used in church, wherever the bishop of Rome "is named or his presumption and proud pomp and authority preferred, utterly to be abolished, eradicated and erased out."[6] Or, on the other hand, they might more domestically offer a change of name when a widow remarries and alters the name of the husband to whom she is bound. Duffy offers the example of Anne Withypole who, in the reign of Henry VIII, records in her primer her second and third marriages, first to William Rede and then, less enthusiastically, to Paul Withypole.[7]

What is clear is that these books accompanied people in their everyday life and habits. People would carry them about with them, attached by a chain to the waist, while a book of manners from the fifteenth century indicates their use throughout the day, from morning until night.

> In the morenynge whan ye vp rise
> To worshipe gode haue in memorie,
> Wyth crystes crosse loke ye blesse you thrise,
> Your pater noster saye in deuoute wyse,
> Aue marias with the holy crede,
> Thenne alle the day the better shal ye spede.
>
> And while that ye be aboute honestly
> To dresse your self & do on your araye
> With youre felawe wel and tretably,
> Oure lady matins loke that ye saye,
> And this obseruance vse ye every daye
> With prime and ouris.[8]

One characteristic of these communal, family texts of devotion is their inherent conservatism. As well as ensuring private participation in the wider community of the worshiping church, they also provided a sense of personal continuity within the tradition and a devotional practice that was handed down through the generations, binding one to another. And so, as the printing press replaced the laborious, expensive, and, therefore, socially highly exclusive, processes of hand copying, the mass-produced texts both aped and sought to emulate the beauties of the ancient art of the scribe. Technology, as today with the advent of the computer, propels changes in the appearance and presentation of texts, but the community, and above all the community of believers and worshipers—even in the face of such momentous political, religious, and social pressures as those imposed by the Reformation in England—feels deeply bound to traditions that both devotionally and aesthetically resist those changes of expression and textual practice that work against the very sense of community we seek with those who have gone before and try to instill in those who follow us. Primers often survived because they were included in wills and thus were handed on from generation to generation. In one will of 1493, we read, "Also I will that she have my primer clothed in purpill damaske. . . . Also that Anne the daughter of the said Roberd have my primer clothed in bawdekyn [cloth of gold]."[9]

Duffy describes how it was the Fourth Lateran Council of 1215 that had sought to expand religious provision for laypeople, and it was largely through the phenomenon of the popular Christianity of the friars that a rising new class of increasingly affluent and leisured people in Europe were seeking to participate in the interior devotional life of the church as pursued by its clergy and monasteries. Interior and singular their devotional practice was, perhaps, but it was precisely through the prayers of the offices that lay folk could join in with the devotional life of the universal church—thereby becoming part of the wider sacred community, even in the privacy of their own rooms or, if wealthy enough, their private stall set within the context of the parish church.[10] And at this point a contemporary and hermeneutical question arises, as these texts and prayers were adopted and often changed within domestic, lay use. For the precise status and value of books of hours, or primers, was

complex and hard specifically to pin down. Precisely because they were held in common in an increasingly diverse society in Europe and England, and they varied greatly in quality from the luxurious to the humble, such books became symbols of many things—power, wealth, religion, devotion, family politics, human affection as well as disagreement, and so on. And so, we come to ask of them, as the student of a colleague of the critic Stanley Fish at Johns Hopkins University once famously asked (and to change her wording slightly), "Is there a text in this religious community, or is it just us?"[11] As these prayers and offices were read and prayed, so they were interpreted, adapted, and embellished to cover the eventualities and particularities of everyday, personal life from prayers against illness to prayers for a good harvest or protection against enemies at home and abroad. Jonathan Hughes in his book *The Religious Life of Richard III* (1997) suggests that the standard language of complaint in the psalms of the books of hours could be turned from concerns about spiritual forces to more immediate enemies "and it is likely that merchants in using such prayers had in mind their competitors, creditors and craftsmen."[12] The dividing line between the religious and devotional and the secular and pragmatic could be very thin indeed. In the fine mid-fifteenth-century copy of the primer that was commissioned by the soldier John Talbot, Earl of Shrewsbury—Shakespeare's "Warlike and martial Talbot"[13]—the Earl clearly had his own political enemies in mind in a prayer that adds a reference to the rebellion of Absalom and Achitophel. And so the Bible lends its authority to a personal prayer, and in an analogy that English literature will develop some two hundred years later, in John Dryden's great political satire of 1681 based on 2 Samuel 13–19. But it would not be right or fair, therefore, to call these people—the merchants anxious about their creditors, or the tough soldier-statesman wary of his enemies—hypocrites or dishonest in their prayers. Rather, they are, in the end, and like the pilgrims of the previous chapter, people like you and me, and members in their own time of a community of faith through their books, who were professing that communal faith through their own particular lives and experience: a text or "just us"? Actually they were part of what Fish would call an "interpretive community" whose approach to the sacred through a common text is bound by a confidence that "has its source in a set of beliefs [and]

those beliefs are not individual-specific or idiosyncratic but communal and conventional."[14] And so the sacred community is not and cannot be a mass of perfection that remains an eschatological idea, or ideal, located only in the hope of heaven, but one which, for the greater part at least, finds the holy in the crevasses and fractures of the rag and bone shop of the world in which we each play our part with all our imperfections. Nor need this exclude us from the eucharistic community as it joins together for that one eternal instant in the singing of the *Sanctus*.

But we cannot stop there. Duffy gives us a moving historical insight into the book of hours of one man who, if not precisely average, was certainly deeply human in his aspirations and his failings. When Sir Thomas More was imprisoned in the Tower of London in May 1534 on his refusal to take the Oath of Supremacy, he had with him his modest book of hours in the 1530 edition of the French publisher François Regnault, bound together with the psalms in Latin. One of Hans Holbein's drawings, made in 1527, is of the extended family of Thomas More at prayer together, his wife Lady Alice actually kneeling at her prayers, and with almost everyone holding an identical book—a prayer book that is, in fact, the book of hours (see plate 2).

And so, when Thomas is later languishing alone in his prison cell, it is the book of hours that continues to bind him to and keep him one with his family and the wider community of the church. As, in his solitary condition, he reads and prays, so he marks his book in a manner that reflects his spiritual state and his natural fears, as his death by execution becomes ever more inevitable. Thus, in the margin of Psalm 87(88):5-10, which speaks of the descent into the pit and into the shadow of death, More writes in Latin, "*in tribulata vehemente et in carcere*" ("in severe tribulation and in prison"). His marginalia and annotations speak to us with acute and moving individuality, his own personal prayer written on a blank space in his book standing as a dignified expression of his deeply personal fears in the face of accusation and death.

> Gyve me thy grace good lord
> To sett the world at nought
>
> To sett my mynd faste vppon the
> And not to hange vppon the blaste of mennys mowthis.

To be content to be solitary
Not to long for worldly company

Lytle & litle vtterly to caste of the world
And ridde my mynd of all the bysynes therof.[15]

More's lines give us a poignant insight into both his personal predicament and his heroic Christian struggles to come to terms with it. And that is precisely the point. For these marginalia and scribblings represent the struggles of a man who is drawing on the resources of his highly conventional Christian spirituality, a man who has read in company with his family his book of hours and through it, therefore, the ancient tradition of Christian renunciation of the world within the monastic tradition. As Geoffrey Cuming says of the primer, its great attraction "was the invariability of the services, which thus became extremely familiar to the laity, as the canonical Hours were to the clergy."[16] More is not saying or writing anything new, but he is struggling to find the reality of what he has been accustomed to say with his family, now within the bleak necessities of his present situation, alone in his cell in the Tower. Thus, he can only survive as an individual because he is a member of that sacred community, whose conventionalities in the book he now resorts to for that very survival. Eamon Duffy puts it this way.

> More's piety was surprisingly conventional: the most heavily thumbed sections of his prayer-book were the pages containing the Fifteen odes of St. Brigid, the Penitential Psalms and the Litany, suggesting that he gravitated instinctively and most often to these prayers of penitence and ardent supplication, and shared the devotional tastes of the majority of his late medieval contemporaries.[17]

More, of all people, would have been puzzled by the question of Fish's student: Is there a text, or is it just us? Of course it was "just him," for even though he is, for some people at least, a saint, even saints are human, and it is always "just us." Yet it is also the common text of his prayer book as read by everyone in his family—that which binds him to the community of readers in the church of which he was necessarily still a conventional member. He could not have survived in his soul otherwise.

And so More writes in the margins of his prayer book, making the psalms his own in his isolation and solving in his own, tragic way

that old fundamental problem of Western and Greek philosophy, though not as a philosopher—how the one becomes the many and yet remains the one. More's scribblings in Latin become intertexts with the psalms, his annotations and additions to the book not desecrations and deviations from its purity, but absorptions of it into his very deepest self, cries from the heart so that his family, still and at the same time reading this book together at home, though without him present in their midst, can draw his scribbles into their prayers and into a common voice. As lonely prisoners through the ages everywhere have known, the urge to write is powerful, scrawling on walls or on fragments of paper, even when they are almost certain that those to whom they write will not read them. So the modern Russian Christian poet Irena Ratushinskaya, imprisoned like More for her beliefs and for her poetry, wrote her poem "Pencil Letter" to her husband from her isolation cell in the KGB prison in Kiev, in November 1982, as she awaited trial for "anti-Soviet agitation and propaganda." Its writing was an act of community whose spirit is stronger than any erasure.

> I know it won't be received
> Or sent. The page will be
> In shreds as soon as I have scribbled it.
> Later. Sometime. You've grown used to it,
> Reading between the lines that never reached you,
> Understanding everything.[18]

Miraculously, her poem survived, as texts do, written on a tiny strip of paper that was smuggled out of her prison.

The constant and common text of the books of hours provokes words in the margins, one might even say on the very margins of life itself, and on its borders and edges these words become powerful and acute. Thomas More, like so many others of his time, took literally the words of the Collect that we now find set for the Second Sunday of Advent in the *Book of Common Prayer*, that we "read, mark, learn and inwardly digest" the words of holy scripture and, by extension, the common prayers of the universal church. More made his mark on the text of his book of hours, and through it found his personal place in the universal discipline of the life of the Spirit in his time.

But by the end of the sixteenth century, the family primers and books of hours of the late medieval church in England had almost

been eradicated by the Protestant Reformation begun under Henry VIII and concluded under Queen Elizabeth I, with the exception of the few, hardly exemplary, years of the reign of the Catholic Queen "bloody" Mary. Textual habits do not die easily or immediately, even under the immense pressure of government edict and threat, but they rarely survive more than one or two generations under such duress, as children beget grandchildren and personal contact with the older generations is finally lost and forgotten. Yet even so, the echoes and shadows of such habits can be almost infinitely long, for strange are the particular workings of the divine in our midst, and perhaps almost impossible finally to eradicate, even when the conscious mind has lost its awareness of them. For the cadences and prayers of the medieval books of hours found new textual authority within the English community of the faithful through two new (though at heart ancient) books—the King James Authorized Version of Bible issued in 1611, and the Anglican *Book of Common Prayer*, largely the work of the genius of Archbishop Cranmer, which reached its final form after the Commonwealth period in 1662.

The publication of the King James Bible in 1611 was at least as much a political as a religious event in the life of Christian England, though its translators, or at least Miles Smith writing on their behalf, made clear in the introductory essay (which is, in itself, one of the greatest essays ever written in English) their understanding of the Holy Bible as, above all, the means of salvation, life eternal, and the good health of the people.

> [The Scripture] is a tree, or rather a whole paradise of trees of life, which bring forth fruits every month, and the fruit thereof is for meat, and the leaves for medicine. It is not a pot of *Manna* or a cruse of oil, which were for memory only, or for a meal's meat or two, but as it were, a shower of heavenly bread sufficient for a whole host, be it never so great, and as it were, a whole cellar full of oil vessels; whereby all our necessities may be provided for, and our debts discharged. In a word it is a panary of wholesome food against fenowed [mildewed] traditions; a physician's shop (Saint Basil calls it) of preservatives against poisoned heresies; a pandect [complete code] of profitable laws against rebellious spirits; a treasury of most costly jewels against beggarly rudiments. Finally, a fountain of most pure water springing up unto everlasting life.[19]

The sacred scripture keeps the Christian community ever new and alive within the word of God. The reference to the monthly fruition of scripture is to the monthly cycle of daily prayer and readings that comprise the daily office of Matins and Evensong in the Church of England, followed at least by every priest in the vicarious ministry of worship within the community, and the Prayer Book is the descendent of the Hours of the medieval monastic tradition and the primer.

But these translators were under no delusion as to the difficulty of their task and the distrust of all things that seem new in the matter of religion. Their essay begins: "Zeal to promote the common good, whether it be by devising anything ourselves, or revising that which hath been laboured by others, deserveth certainly much respect and esteem, but yet findeth but cold entertainment in the world. It is welcomed with suspicion instead of love, and with emulation instead of thanks."[20] Certainly, the political philosopher Thomas Hobbes in his use of the biblical sources for the nature of the Christian Commonwealth in *Leviathan* (1651) still prefers and trusts the "Vulgar Latine" of Jerome above any English translation, while a few years later Robert Gell published his massive eight hundred-page *Essay Towards the Amendment of the Last English Translation of the Bible: Or, a proof, by many instances, that the last translation of the Bible may be improved* (1659).[21]

Nevertheless, the King James Bible of 1611 was itself essentially a conservative project, and behind it lies the long history of English Bibles in the sixteenth century. It would be hard to deny the literary genius in the translations of Miles Coverdale (1487/8–1569) or William Tyndale (1494?–1536), and it is Tyndale above all who fixes the tone and language of the later King James Bible. The Reformer Tyndale published his first New Testament in exile in 1526, though copies soon reached England. Revised versions of his work were published in 1534 and 1535, with the Pentateuch and a translation of Jonah. Tyndale was nothing if not a scholar, working from not only the original languages but also Erasmus' Latin New Testament, the Latin Vulgate, and Luther's German version. But for the Protestant Tyndale, who finally paid the ultimate price of his life for his beliefs, a vernacular Bible for the people would remove, above all, the mediatory role of the clergy and thus weaken the power of the church; he recognized "how it was impossible to establish in the lay-people

any truth except the Scriptures were laid before their eyes in their mother tongue."[22] It was Tyndale, after Erasmus' *Exhortations to the Diligent Study of Scripture* (1529), who offered us the famous vision of the pious plowboy and the weaver who, with the scripture laid open before him "would drive away the tediousness of time" as he labors over his beam. For these cheerful (and surprisingly well-educated) laborers, the Bible is literature read for the good of the soul and not, as Tyndale makes clear in his work *The Obedience of the Christian Man* (1528), like other characters from literature available to all in English, such as Robin Hood, Bevis of Hampton, Hercules, Hector, and Troilus "with a thousand histories and fables of love and wantonness and of ribaldry as filthy as heart can think, to corrupt the minds of you withal, clean contrary to the doctrine of Christ and of his apostles."[23]

Tyndale's genius derives first from his exceptional language skills—good Hebrew (unusual for the time and which Coverdale did not know) and Greek, as well as his innate sense, like John Bunyan after him, of the power of common English in its everyday usage and rhythms. His dismissal of the idea that English is simply "rude" when set beside the learned language of Latin is founded upon a remarkable insight: that English is, in fact, much closer than Latin to the ancient languages of the Bible. In *The Obedience of a Christian Man* Tyndale writes against his detractors:

> They will say it [the Bible] cannot be translated into our tongue, it is so rude. It is not so rude as they are false liars. For the Greek tongue agreeth more with the English than with the Latin. And the properties of the Hebrew tongue agreeth a thousand times more with the English than with the Latin. The manner of speaking is both one, so that in a thousand places thou needest not but to translate it in to the English word for word when thou must seek a compass in the Latin. . . .[24]

In short, the Bible in Tyndale's English is closer, he believes, to the originals of scripture than anything in the church's Latin Vulgate.

The first "authorized" Bible in English was initially published in 1537, known as "Matthew's Bible," though Thomas Matthew was in fact a pseudonym for John Rogers, a close follower and disciple of William Tyndale. It was this version, heavily dependent on Tyndale's earlier work and with revisions by Miles Coverdale, that

finally appeared in 1539 as the Great Bible, printed in Paris under the patronage of Thomas Cromwell. What is of particular interest is Archbishop Thomas Cranmer's Preface to the Great Bible of 1540, in which he establishes three principles for biblical translation. First it is "God's will and commandment," Cranmer affirms, that scripture be read to people in a language and with words that they can understand "and take profit thereby." Second, custom and tradition are to be given full due weight—the weight, that is, of conservatism in all matters of translation. But third, and in balance to this, no translation should be regarded as definitive and unaffected by changes in the customs and manners of common speech. Communities and their customs of speech change, and Cranmer points out that even the ancient Saxons had their translations, "and when this language waxed old and out of common usage, because folk should not lack the fruit of reading, it was again translated in the new language." No translation lasts for ever if it is to speak in a living language.[25]

Cranmer would have agreed with Tyndale that ordinary folk should not first have to cross a language barrier before they may be inducted into the Word itself. Yet, in the reign of Queen Elizabeth and by the end of the sixteenth century, it was not the officially sanctioned and authorized Great Bible that captured the popular imagination but the version of 1557, largely prepared by William Whittingham in Geneva for the use of Protestants in exile, and still drawing heavily on the work of Tyndale. This was the so-called "Breeches Bible" (after its translation of Genesis 3:7, in which Adam and Eve clothe themselves in breeches, where the KJV has "aprons"), or more properly the Geneva Bible. But though most would have agreed that the 1568 revision of the Great Bible by Archbishop Parker and also "authorized," known as the Bishops' Bible, was nowhere near as good as the Geneva version, King James I hated the latter because of its marginal notes (Henry VIII had called Tyndale's notes "pestilent glosses"), and the official standing of the 1568 Bishops' Bible had to be respected by the translators who were commissioned by the King as a result of the Hampton Court Conference of 1604.[26] Still, if the Bishops' Bible was the measure against which all judgements were to be made, then the desks of the translators were littered with a substantial history of scholarship, not only in the earlier English translations but also in the Complutensian Polyglot

(1517), in which Hebrew, Greek, and Latin were printed in parallel, numerous Latin translations, and Luther's German Bible, as well as versions in French, Spanish, and Italian and the ancient commentaries of the Fathers.[27]

To the English church and people of 1611, the language and cadences of the new Bible would have already been familiar from the work of these earlier English translators, and they were already absorbed into the consciousness and the devotional life of the people through the book that was etched and written, as it were, in the margins of everyday life. The first audiences who saw and listened to William Shakespeare's *A Midsummer Night's Dream* will have been perfectly well aware to a man and woman of the humor of Bottom's misquotation from 1 Corinthians 2:9 regarding "the things which God hath prepared for those who love him" as he awakens from his dream of Titania and her fairies: "The eye of man has not heard, the ear of man has not seen, man's hand is not able to taste, his tongue to conceive, nor his heart to report, what my dream was."[28] It is a humor meant not unkindly, and one that assumes the Bible, in whose margins we scribble, is familiar and at the very heart of daily and common life.

In the community of the book, the Bible was and remains forever at once both new and old, ancient and modern. Thomas Cranmer, the reforming Archbishop of Canterbury, facing death under the Catholic Queen Mary, writes that when the words of scripture, like the words of the preacher and the language of prayer, become old and out of use and fashion, they must be changed to remain alive in the ears of each new generation, for their language is a living and changing part of a living community.

> God's will and commandment is, that when the people be gathered together ministers should use such language as the people may understand and take profit thereby, or else hold their peace. For as a harp or lute, if it give no certain sound, that men may know what is stricken, who can dance after it? for all the sound is in vain: so it is vain and profiteth nothing, saith Almighty God by St. Paul, if the priest speak to the people in a language which they know not.[29]

But in their being changed, the worshiping community brings along with it the old mysteries that are deeply embedded in ancient

sentences and formularies. Just so, Thomas More and others like him in the previous age had "updated" their books of hours and primers to fit their own situations and needs, yet necessarily remained bound within the common texts of the old offices and their prayers. Thus, too, the 1662 Anglican *Book of Common Prayer*, like the King James Bible, was not at all new in essence, but rather was the final flowering of a history of vernacular Protestant prayer books that began with the work of Thomas Cranmer in the earlier years of the sixteenth century, and then behind that the centuries of the primers, the lay folk's mass books, the Sarum Rite—a veritable forest of trees of paradise uttered in the prayers of the people. The history of the English prayer book from Henry VIII to the Edwardine books, and through to the reign of Elizabeth I, reflects a continuity in discontinuity—a community at prayer in times of religious change and political upheaval negotiating the niceties of shifts in the theology of the Reformers and the political power struggles of state. For the *Prayer Book* of 1662, like the King James Bible, was indeed a book of state, powerfully ensuring conformity of worship and belief within the realm. At its heart are prayers for the monarch and the good government of all those who are set in authority under him or her, and yet it is also an inherited wealth of "common" prayer for all people, for times of baptism, matrimony, and funeral, in sickness and in health, in times of want and in times of prosperity. Thus, Tyndale's plowman at his plow and weaver at his beam were bound by common word and act with the whole nation to cadences and rhythms that live through the daily offices and epistle and gospel readings set in the *Prayer Book* lectionary for each Sunday of the year from the King James Bible. True, the Psalter that was finally established in 1662 was not that of the King James Bible but actually Coverdale's earlier translation (which, it has to be admitted, is superior), though the overlap is considerable and the style consistent. But for clergy and at least some of the people in every parish in the land, the King James Bible was present at least twice a day in the daily office. This would certainly have been true for the poet George Herbert during his years as parish priest of Bemerton near Salisbury during the early 1630s. Herbert's paraphrase version of the Twenty-third Psalm, written in common meter for congregational singing, clearly draws upon both the King James and the Coverdale (*Prayer Book*) translations—the latter he would

have recited on the fourth day of each month at Evening Prayer. The first stanza in Herbert's version ends with the lines:

> While he is mine, and I am his
> What can I want or need?[30]

The word "want," meaning "lack" is used in the first verse of King James, "The Lord is my shepherd; I shall not want." In the second line of the second stanza, "Where I both feed and rest," Herbert is using both the *Prayer Book* and the King James Bible, the first having "he shall feed me" and the second "he maketh me to lie down."

Herbert's hymn remains familiar to congregations even today. And even beyond the community at worship, his words and the liturgical and scriptural texts that lie behind and within them remain rooted in the hearts and minds of those for whom their religious beliefs and doctrines are perhaps but a distant memory. Thus, in the years of liturgical revision in the Church of England following the Second Vatican Council in the late twentieth century, many a stalwart sceptic such as Iris Murdoch fought alongside worshiping members of the church for the maintenance of a book and the language of common prayer that, though old in its expression, was embedded deeply in the heart of the community and its sense of identity. The *Book of Common Prayer*, like the King James Bible, continues even today to hold the community of the Church of England together far beyond any general adhesion to the religious doctrine expressed within it, giving a sense of identity and coherence to a "sacred community," even after its ethos, in other respects, has faded into something far closer to the secular and unbelieving. The very titles of books published in England in opposition to any liturgical change from the *Book of Common Prayer* and the language of the King James Bible speak volumes: *No Alternative* (1981) or *Ritual Murder* (1980), though, paradoxically, the very Cranmer they sought to preserve would have found their resistance to change very strange.[31] Perhaps what they most felt was being eroded was the extraordinary and lasting unity these centuries-old texts represented—the "unity and concord" that is the ideal where God is expressed as "the author of peace and lover of concord" (Morning Prayer) or where the invitation to draw near with faith is addressed to those who are in "love and charity" with their neighbors (Holy Communion)."[32]

The contemporary poet and Anglican priest David Scott captures in a brief poem the commonality, the blending of the sacred with the everyday, of the 1549 *Prayer Book of King Edward VI.*

> This is just what you might expect
> a Prayer Book to be like. This is
> what we always thought about rain;
> about dying, about marriage, and God.
> We needed only the help which
> The right placing of a relative pronoun
> Could manage. Words, then, said what they meant;
> They bit. A man was a houseband
> Until death departed him.
> And all was for common use:
> printed in Fleet Street,
> at the sign of the sun,
> over against the conduit.[33]

The romantic poet Samuel Taylor Coleridge once remarked that "if words are not THINGS, they are LIVING POWERS, by which the things of most importance to mankind are actuated, combined, and humanized."[34] Through the language and words of the King James Bible and the *Book of Common Prayer* is heard a vast community of voices through the ages: echoes of Sir Thomas More—and of Thomas Cranmer and George Herbert, of Richard Hooker, John Keble, and Michael Ramsey, and behind them Dame Julian in her solitary cell and the countless multitudes of the church of medieval Christendom and later. They are bound by text and place in a sacred community that extends beyond that merely of believers and the "faithful" in the narrow sense of the word. In such a community—and these named are but those recorded in the church and its literature—it is often hard to distinguish prayer from whingeing, belief from superstition and folklore, true devotion from self-interest. Of course, the differences are there and no one should doubt Thomas More's devotion to his Christian beliefs, but the "book"—the books of hours, the primers, the *Book of Common Prayer*, the King James Bible—embraces in its text and in its marginalia the sacred life of a community that is complex, often devout despite itself, finding God in enmity and jealousies, as well as in piety and devotion, an imperfect community that yet harbors within itself a hunger to be more serious—to be, in

short, a sacred community. The books of hours and the *Book of Common Prayer* are texts that are used and read in tension between private piety and social concerns, private concerns and the piety of the whole church of God's common people.[35]

At the beginning of the seventeenth century, contemporary with the publication of the King James Bible and nurtured on the liturgy and daily offices of the *Prayer Book*, George Herbert captures in his verse the simultaneous levels of life lived within the sacred community: that is, not one that is cut off from and separated from the world, but rather nurtured within it, scribbling its concerns on the pages of the sacred text that lies at its heart by both law and grace. As a poet, Herbert knows full well the power of words to resonate on different levels simultaneously in a polyphony that jars for a moment, only to seek harmonious resolution. One of his greatest poems, which begins with the line "Love bade me welcome,"[36] sustains simultaneously three levels of significance—the sacramental, the social, and the sexual—even to the final image of the eating of flesh that binds in one moment love sacred, social, and profane, without division: "So I did sit and eat." Thus, the sacred community in all its acts is simultaneously fragmented and harmonious in its divisions. Drawing upon the piety of the books of hours, on the sacramental life, on the devotion to the Bible that inspires the Translators' Preface to the King James Bible, on the traditions of Renaissance theatre, on human vanity, on the need for medicine for the body, on politics, and on the theology of the Reformation—in one short poem, Herbert celebrates the scriptures of the sacred community of his church:

> Oh Book! Infinite Sweetness! Let my heart
> Suck every letter and a honey gain,
> Precious for any grief in any part;
> To clear the breast, to mollify all pain.
> Thou art all health, health thriving till it make
> A full eternity: thou art a mass
> Of strange delights, where we may wish and take.
> Ladies, look here; this is the thankful glass,
> That mends the looker's eyes: this is the well
> That washes what it shows. Who can endear
> Thy praise too much? Thou art heaven's Lidger here,
> Working against the states of death and hell.

Thou art joy's handsell: heaven lies flat in thee,
Subject to every mounter's bended knee.[37]

The words and their images tumble out, yet in due and perfect order: of the bee sucking on each letter as on a flower, of the woman attending to her makeup before the mirror, of the gazing into the water of the well, of the ambassador striving to maintain international peace,[38] of the book that lies flat on the table yet contains within its covers the words of salvation and of heaven itself.

Without the resonance of Tyndale, Cranmer, and the King James Bible, above all the psalms of King David, whom Jerome in the fourth century called "our Simonides, Pindar, and Alcaeus, our Homer, our Horace, our Catullus, and our Sirenus all in one,"[39] it would be hard to imagine English poetry. From Donne to Milton, Vaughan to Blake, Swift to T. S. Eliot, their language holds an instantly recognizable voice, and it is not one that is ever long removed from the stuff of everyday.[40] Herbert's own Bible and his *Prayer Book*, which he used every day, we may surmise, were not pristine but worn and dog-eared. Like the family Bibles of a later generation, inscribed with the details of every birth, baptism, marriage, and death, they necessarily carried with them the blots and scratches of the trivia of the daily round. As their words inflect into every corner of human life, both private and public, so life leaves its marks on them, unsystematically and sometimes unexpectedly, and that is as it should be. Just as Thomas More wrote on his book of hours to connect his loneliness in prison with the community of his family as they prayed for him at home from the very same text, with words blotched and made indistinct by tears, even as they were distorted in sense by the fears and doubts that assail all faith, so our misreadings of texts, perhaps especially in childhood, may grasp at truths that much learning and over-nicety in interpretation can only serve to obscure. The American poet and professor of English Literature, writing from the Jewish tradition, John Hollander, recalls his exposure at school to the King James Version and his attendance at the college chapel for the music, which gave him his "strange but nonetheless telling outsider's sense of the chanted psalms of the *The Book of Common Prayer*."[41] But even earlier, at home, he had learned the twenty-third Psalm in the Coverdale translation and, as a small child, was convinced that the penultimate verse ran, "Surely good

Mrs. Murphy shall follow me all the days of my life." From this beneficent attendance of Mrs. Murphy he had derived much comfort, and thus this childish mishearing became somehow profoundly right in its personification of goodness and mercy—the *tov vachesed* of the Hebrew—a truth in "misreading" and a blot on the text, like many another mark and scrawl, with which the text holds harmonious and sympathetic discourse.

As we look back to the books of hours and the household primers, we are reminded that books are things to be written on, and sacred texts are perfectly capable of absorbing all the scratchings of our everyday lives and turning even them—like the elixir celebrated by George Herbert—to perfect gold.[42] The prayer books of the English Protestant church of the sixteenth century, beginning with 1549, contained lengthy exhortations to ensure a good and proper state for participation in and reception of the sacrament of the Lord's Supper.[43] The modern communion rites of the Anglican church, in common with most eucharistic rites after Vatican II, are modeled on the *Apostolic Tradition* of Hippolytus and the early Western Church and move toward a point of perfection in the community of the gathered congregation—through the narrative of intercession, confession, and absolution, and the peace—when the point is reached at which Great Thanksgiving can finally be uttered and we may truly say as a community that "The Lord is here." But afterward, we return to the confusion of the everyday, priest and people alike, accompanied by our prayer books which we mark our slow and halting progress in the world.

Cranmer warned us not to read our Bibles or to utter our prayers in language that had waxed old and out of use, and he told his clergy to speak in words that their congregations could clearly understand "or else hold their peace." And yet in common worship and private prayer, there is a balance to be maintained between words so long uttered that, even when the vocabulary is barely understood to the conscious mind, they open doors on eternity by their beauty and familiarity, and words that allow our more prosaic selves to find their way into the sanctuary, perhaps rather embarrassed because we are not dressed in the aura of antiquity. Although Marshall McLuhan in *The Gutenberg Galaxy* wrote of the desacralizing of the world with the advent of the printed word and all its systematic conformity,[44] it

is to be remembered that the later, printed books of hours often first appeared as copies of the earlier handwritten texts, and also made available their tradition, by virtue of their relative cheapness, to a far larger proportion of Christian society.[45] Texts are conservative in their nature—and above all sacred texts—yet make their claims on the everyday and the immediate in human experience. And between these two levels of the textuality of the sacred word, the ancient and the modern, there remains the mystery of the silent text that is unheard and unuttered, yet finally the text of truth, which is known to every true poet, for it is silence the poet finally seeks in words. And it is that which lies between our anxious marginalia, our strivings to interpret and understand, and the ancient texts of scripture and prayer on the page: the silent text of the Word made flesh and rendered silent for us by the final condition of our mortality, death. In the aftermath of that, our books come to life.

As an afterword to this chapter, one is led to wonder what will become of all the scratchings and scribbles that have marked the hours of Christian devotion in times of joy and in times of distress and enmity, in our electronic age when, on our computer screens, mistakes can be deleted and eradicated, leaving only a pure and perfect text. There is no place here for marginalia and crossings out that leave the original still seen beneath, for all are ruthlessly deleted and standardization has reached its zenith. The personal voice is dumbed down, and there is only beauty in an order that forgets that the beauty of holiness lies in the muddle and contradiction—or perhaps, better, the paradoxes and dense polyphonies, that the King James Bible, Donne, and Herbert, like the English church music of their time, understood so well. As I write these words, I have actually written nothing with my own hand, but merely punched keys on a machine whose relentless logic seems continually to wage war with my intentions. Are we any longer, or at least in the same way, a community of the book passed on down through the family and families, like the primers and the family Bibles, as a guardian of the community of belief that is bound by the words on its pages? Eamon Duffy describes the book of hours as a book of remembrance, both particular and universal.

Books of Hours, were, from the start, intensely personal objects
. . . Passed from hand to hand . . . This process of transmission
within families and kinship groups might go on for generations
and even centuries.[46]

—truly a binding of the word within the hands of the common peo-
ple of God.

CHAPTER 6

The Community in Repentance
Georges de La Tour and the Art
of the Counter Reformation

John did baptize in the wilderness, and preach the baptism of repen-
tance for the remission of sins.

 Now after that John was put in prison, Jesus came into Galilee,
preaching the gospel of the kingdom of God, and saying, The time
is fulfilled, and the kingdom of God is at hand: repent ye, and
believe the gospel.

—Mark 1:4, 14-15

The common note in the ministries of John the Baptist and Jesus
is the call to repentance. In the first words that he utters at the
beginning of his ministry in Saint Mark's Gospel, Jesus makes two
demands—that people repent and believe the gospel. The clue to
the idea of repentance—μετάνοια—in the New Testament lies in the
Septuagint version of the Old Testament, where its usual meaning is
to feel sorry for something with the intention of change.[1] The sense is
invariably that of turning away from one way of life toward another,
a change of mind and heart, and it is the prerequisite for belief and
entry into the kingdom of heaven. In the parable of the Prodigal Son
(Luke 15), the errant boy finally "came to himself" and returned to
his father with the words, "I have sinned against heaven, and in thy
sight" before he was accepted back with great celebrations, the com-
munity of the family restored into new life.

 In the preaching of the apostolic and early church the call to
repentance was invariable, for without it faith is impossible. The

Apostolic Tradition of Hippolytus lists at length those who must change their way of life "or be rejected," including gladiators, soothsayers, and actors. Harlots, those castrated, or "any other who does things not to be named" are simply rejected outright, "for they are defiled."[2] Canonical penance in the early Christian centuries was severe and public, for the community of the faithful was to be kept pure, though penitents, although excluded from the liturgy, were the focus of a "brotherly spirit" of correction. The Greek historian Sozomen describes the practice in Rome about 450:

> There the place of those who are in penance is conspicuous: they stand with downcast eyes and with the countenance of mourners. But when the divine liturgy is concluded, without taking part in those things which are lawful to the initiated, they throw themselves prostrate on the ground with wailing and lamentation. Facing them with tears in his eyes, the bishop hurries towards them and likewise falls on the ground. And the whole congregation of the church with loud crying is filled with tears.[3]

In his description of the Lenten penance of all the faithful, Saint Ambrose (ca. 339–397), expands on the Pauline image of the athlete in training to perfect the body, and he reminds his congregation that they are always under surveillance, for the heavenly community, with whom, finally, they are one, is watching them: "The Archangels, the Powers and Dominions, the ten thousand times ten thousand Angels are all watching you."[4]

But our focus in this chapter will be later in the history of the Western church. For by the Middles Ages, Mary Magdalene had become the most prominent female saint after the Virgin herself, and for two reasons.[5] First, for her role in Christ's passion and as *"apostola apostolorum,"* but perhaps even more for her status as a penitent, emphasized after the Fourth Lateran Council (1215), whose Canon 25, *Omnis utriusque sexus*, required a minimum of annual confession to a priest of all believers. By the seventeenth century, the statutes of the Convento delle Convertite in Venice refer to Mary Magdalene as the "Mirror of Repentance" and the patron saint of women who had been "taken from the hands of the devil . . . and from the filth of the flesh . . . to the chaste life of the spirit."[6]

To her story we now turn.

* * *

One of the most important books for the understanding of later medieval art and literature is that extraordinary, perverse, beautiful, and persistently influential work by Jacobus de Voragine entitled *The Golden Legend* (ca. 1260). It portrays the lives of the saints in stories both factual and fictional that range from the preposterous to the profound, from the shocking to the theologically acute, and its influence was often greater than the official voice of the church itself. Indeed, although the work was intended as a sourcebook for preachers, and its author was to become Archbishop of Genoa in 1292, it met with a lukewarm response from Jacobus' own order, the Dominicans, even as its popularity with a wider audience grew. Translated many times into every western European language, over one thousand medieval manuscripts of the Latin text of the *Legend* still survive, indicating its huge influence on popular religious thought. The *Legend* presents Mary Magdalene as the unlikely sister of Martha and of Lazarus, informing the reader that:

> She was wellborn, descended of royal stock. Her father's name was Syrus, her mother was called Eucharia. With her brother Lazarus and her sister Martha she owned Magdalum, a walled town two miles from Genezareth, along with Bethany, not far from Jerusalem, and a considerable part of Jerusalem itself.[7]

According to Jacobus, Mary is also the woman from whom Jesus cast out seven devils and whom he defended "when the Pharisee said she was unclean, when her sister implied that she was lazy, when Judas called her wasteful."[8]

In the gospel episode recorded in Saint Luke 10:38-42, Jesus is welcomed by Martha into the home of Martha and Mary, after which Mary "sat at Jesus' feet, and heard his word" while Martha distractedly busies herself with domestic chores. In what was to become a key passage in the traditional Christian distinction between the *vita activa* and the *vita contemplativa*, Jesus upbraids Martha for being "careful and troubled about many things" and commends Mary with the words, "But one thing is needful: and Mary hath chosen that good part, which shall not be taken away from her." This "good part" is described in *The Golden Legend* not as contemplation but significantly, in view of the Magdalene's previous

life, as the virtue of penitence, or "penance," the end of which is the attainment of holiness. Thus, of Mary, the greatest of all Christianity's repentant sinners, Jacobus writes,

> Before her conversion she remained in guilt, burdened with the debt of eternal punishment. In her conversion she was armed and rendered unconquerable by the armour of penance: she armed herself the best possible way—with all the weapons of penance—because for every pleasure she had enjoyed she found a way of immolating herself. After her conversion she was magnificent in the superabundance of grace, because where trespass abounded, grace was superabundant.[9]

In the Lenten liturgy of the Western church, Mary Magdalene is one of the biblical figures used to illustrate the theme of repentance, and to guide the penitential community in their reflections in the weeks before Easter. In the East, her semi-mythical sister, Saint Mary of Egypt, another reformed "harlot," is also celebrated as a model of repentance when her life is read at Matins on the Thursday after the fifth Sunday in Lent "as an icon in words of the theological truths about repentance."[10]

Jacobus' complex account of the life of Mary Magdalene is fabulous and almost entirely unscriptural. It consists of a collection of stories that by the thirteenth century were already many hundreds of years old, handed down largely through an oral tradition, and that portray Mary, together with her sister Martha and their brother Lazarus (who by this time is portrayed as elected bishop of Marseilles!), as the evangelist of Provence in southern France. She is presented as a formidable preacher and a penitent, whose customary pose in countless paintings and sculptures was in a cave with a skull (symbol of the transitoriness of life and wealth), a crucifix (a combination of images she shares with her fellow saints Francis of Assisi and, in the Counter Reformation, Charles Borromeo), and an open Bible from which she is often seen reading, together with a jar of perfume (reminiscent of her sinful life before her "conversion') and, always, abundant and flowing red hair. Jacobus recounts that in the time of Charlemagne (ca. 769), Gerard, Duke of Burgundy, devoted himself to works of religious charity and moved Mary's relics from Aix to the Cathedral of Vézelay, which by the twelfth century had become an important site of pilgrimage.[11] His narrative in

the *Legend* concludes with a series of miracles associated with Mary's remains in Vézelay.

Not only was this utterly fabulous medieval Mary Magdalene a conflation of three biblical women (the sister of Martha, the woman who washed Jesus' feet with her tears, and the Mary of John 20, who at first mistakes Jesus for the gardener and is the first witness to his resurrection), but she has also become confused and partly conflated with her legendary namesake Saint Mary of Egypt. Like her sister of Egypt, Mary Magdalene, at least from the thirteenth century onward, has a complex and various history in art and iconography, portrayed sometimes as a beautiful, young woman either elegantly or simply dressed, or more often naked but for her long hair, or else as an ancient woman, drawn and haggard after years of harsh penitential living in the wilderness, her former physical beauty remaining evident only in her long flowing hair, which now serves as a covering over her body to preserve her modesty. By the sixteenth century in Italy, Mary Magdalene, bathing in the glories of Renaissance humanism and art and with a glance back to her old profession, combines the vocabulary of Eros and Christian love to become the "Venus of Divine Love," above all in the many paintings of her by Titian, and most famously that which is now in the Pitti Palace in Florence. Here, her generously revealed beauty led the flamboyant and often extravagant Neapolitan poet Giambattista Marino in 1620 to become rather carried away and begin to wax lyrical about her "flowing mane which makes a golden necklace around the naked alabaster breasts."[12]

The theology of the church, invariably less flamboyant than the imagination of artists, and in the pious spirit of the Counter Reformation, undertook the recovery of the lives of the saints in the face of the Reformers' more grim, iconoclastic spirit, though with a theological scholarship far more sober than that of Voragine. In 1606, the Belgian Jesuit Herbert Rosweyde set to work on a critical collection of the lives of the saints, his task later taken up by his fellow Jesuit, John van Bolland (1596–1665), the founder of the society of Bollandists as editors of the *Acta Sanctorum*, a task that continues to the present day.[13]

It is in this more somber Counter-Reformation spirit that we return to Mary's varied ecclesiastical and artistic history, and yet to

a moment in art which still carries with it many of the provoking complexities and paradoxes of the medieval legend. The movement in the Roman Catholic Church that is broadly known as the Counter Reformation derived to a large extent from the definitions and reforms laid down by the Council of Trent (1545–1563), which, among other things, reasserted the doctrine of seven sacraments, including that of penance as one of the liturgical rituals deemed to have spiritual effects not simply by faith alone but in virtue of their proper performance (*ex opere operato*). It was at Session 7 of the Council (March 3, 1547) that the institution of all seven sacraments by Christ and their necessity for salvation was affirmed. Further discussions on penance and extreme unction took place later in the Council at Session 14 (November 25, 1551), and Protestant teachings were accordingly repudiated. Although the primary meaning of penance is "punishment" (*poena*), and the practices of the early church did have powerful punitive elements to them, stress was now laid upon the ascetic practice of the penitent in various forms of retirement from the world as a means of controlling and forsaking the passions that resulted in sin. In such teachings and the encouragement of penitential practices, Mary Magdalene was a significant figure.[14]

In addition, it was at the final Session 25 of the Council of Trent (December 3–4, 1563) that decrees were passed relating to the Invocation of Saints, Relics and Images.[15] They were both enabling and restrictive for art.

> Moreover, let the bishops diligently teach that by means of the stories of the mysteries of our redemption portrayed in paintings . . . the people are instructed and confirmed in faith. If any abuses have found their way into these holy and salutary observances, the holy council earnestly desires that they be completely removed . . . so that no representation of false doctrine or occasion of grave error be exhibited. Such zeal and care should be exhibited by the bishops . . . that nothing may appear that is disorderly or unbecoming . . . nothing that is profane. . . . The holy council decrees that no one is permitted to erect . . . any unusual image unless it has been approved by the bishop; also that no new miracles be accepted . . . unless they have been investigated and approved by the same bishop.[16]

Encouraged by the "Rules for Thinking with the Church" in Igna-
tius Loyola's *Spiritual Exercises*, completed in 1541 and published in
1548 with the approval of Paul III, which stated that images may
be venerated "according to what they represent,"[17] artists responded
with paintings that were both naturalistic and expressive in the con-
veyance of their message, even under the terms of decorum as laid
down by the Council.[18] We are a far cry from the mythic excesses of
The Golden Legend. After Trent, and into the baroque period, painters
attempted to create the illusion of the actual presence of their sub-
jects. Seeking verisimilitude, art sought to achieve a space in which
the viewer and the subject come together in a dramatic moment of
time.[19] Art, in other words, brought the viewer, the community of
the faithful, into a moment of real presence in which an experience of
the sacrament of penance and reconciliation can be effected *ex opera
operato* in the contemplative participation with the image. This is a
moment that is at once intensely private and profoundly communal,
drawing all together in the transformative moment of viewing.

In this world of art, southern European Counter-Reformation
baroque painters like Caravaggio in Italy and Velásquez in Spain
developed new iconographic motifs in defense of the teachings of the
Council of Trent and against the criticisms of the Reformers. Under
such influences, the iconography of the penitential Mary Magda-
lene, long having forsaken her lascivious past, flourished afresh as
she became a powerful and particular symbol, and more than that,
for devotion to the sacraments, above all the sacrament of penance.[20]
Furthermore, Mary's traditional iconographic accoutrements, above
all the skull, fitted well with the Catholic Reformers' preoccupation
with death and the transitoriness of life. Amongst the newly estab-
lished Society of Jesus, the Jesuits, and through Ignatius' *Spiritual
Exercises* in particular, a preoccupation with death and the contem-
plation of skulls went as far as actual skulls being made readily avail-
able from cemeteries as aids to devotion. In art, death's-heads were
often depicted with the addition of the cheerful reminder, *Hodie
mihi, cras tibi* (My turn today, yours tomorrow).

✳ ✳ ✳

The deeply enigmatic French realist painter Georges de La Tour
(1593–1652) lived all his life in Lunéville in the duchy of Lorraine,

which was at that time experiencing a religious revival largely associated with the Franciscans. His corpus of work, of which only some thirty-five paintings survive, falls neatly into two categories: there are rather flamboyant and energetic daylight episodes, and then the (more important for us), mysterious night scenes, in all cases except one illuminated by candlelight. These latter paintings clearly show the influence of Caravaggio and his dramatic use of lighting on La Tour's work, the technique probably learnt directly from Utrecht artists, such as Gerrit van Honthorst (1590–1656), since it is unlikely that La Tour ever visited Italy himself. Of these paintings the art historian Anthony Blunt has remarked:

> The forms are generalized to their greatest simplicity and all violence, all movement even, are eliminated, so that the picture takes on the quality of stillness and silence rarely to be found in the visual arts.[21]

They are works, in short, of profound and profoundly still contemplation and meditation. Among them, there are at least four versions of the penitent Magdalene, characterizing as of old the virtues of the *vita contemplativa*, and featuring the motifs of the skull, the traditional flowing hair, the candle, and a mirror. The one with which we are particularly concerned here is a rather late painting by La Tour, executed between 1635 and 1640, and now in the National Gallery of Art in Washington, D.C.

Here Mary Magdalene is portrayed as seated and pensive, her head supported by her right hand, while the fingers of her left hand, thrown into relief by the candle behind them, gently touch the eye sockets of the skull placed on the Bible, the book of life, and one of Mary's customary symbols (see plate 3). But in this instance, she is not reading the Bible. Mary is finely, if simply dressed, yet the light draws us not to the beauty of her form, but rather to her contemplative face, which looks at the mirror that is set before her. In it, we, the viewers of the painting, see reflected not Mary herself, but rather the reflection of the skull. Thus, the mirror, like the skull an emblem of *vanitas* and symbol of the transitoriness of all life, serves two functions: *we*, the community of viewers, see reflected in it the skull, while *Mary* simultaneously contemplates there her own beautiful face, which her right hand touches, even as her left hand touches the skull. In the words of Susan Haskins, "The senses, sight

and touch, are united with the emotions and intellect to meditate upon death and upon what lies beyond."[22]

In the art of the Counter Reformation, and in contrast to the solitary stillness of the painting we have been contemplating, Mary Magdalene, like other saints, could sometimes be enlisted as an instrument of ecclesial propaganda in the celebration of the sacraments: in Francesco Vanni's painting *The Last Communion of Mary Magdalen* (ca. 1600), for example, the legendary Bishop Maximim (who was, according to the *Golden Legend*, one of Christ's original seventy-two disciples to whom Saint Peter had particularly entrusted Mary), administers communion to the dying woman in a visual affirmation of the triumph of the Eucharist and of the Catholic faith over the incursions of Protestantism. In Jacobus de Voragine's medieval description of the death of Mary Magdalene, Maximin is summoned to church "on the day of the Lord's resurrection," there to find Mary in the company of angels as her soul "migrates" to the Lord. In her death, the company of heaven and earth become one.

> Saint Maximin . . . gave fulsome thanks to the Saviour, and on the appointed day, at the appointed hour, went alone into the church and saw blessed Mary Magdalene amidst the choir of angels who had brought her there. She was raised up a distance of two cubits above the floor, standing among the angels and lifting her hands in prayer to God.[23]

The clear implication in his painting is that the artist La Tour gives us something other, and far closer to the heart of the sacred community, than mere religious propaganda of the Counter Reformation. In its deep interiority, it is closer to the vision of Jacobus, as Mary stands suspended between earth and heaven. For in looking at this picture, we literally join with Mary herself in her act of contemplation between life and death, this world and the next. Together we look into the glass, seeing, respectively, her beautiful face and the death skull, each of which she is touching. Life becomes death and death becomes, in Mary, beautiful. Through our commonality with Mary in the watching, we also touch the skull as it literally rests on the very pages of scripture, a real presence, though the skull is in shadow, while her living face is beautifully illuminated. Thus, to see and to contemplate the picture is to enter into it, and as we respond thereby to Mary's beauty, it is not, as it might have been in

her former, unrepentant life, with the erotic gaze fueled by aspects of the sensual, but with a sense of her human beauty already transformed and transfigured in life and through death. Mary herself, in her bodily presence, has taken us through the history of her life, which is ours also in the journey toward salvation and righteousness, and if we see in the mirror the sign of our passage through this fallen life into the next, we see in Mary's face the overcoming of death in her ageless beauty, which is her real presence amongst us. In La Tour's art, the woman of scripture and of fabulous legend has become a reality we may know and respect, and all anecdotal, fabulous, mythic, and extraneous detail is eliminated in that universal stillness that Blunt so well describes. Such still-looking and profound contemplation is itself, I suggest, nothing less for us than a liturgical act, an act of the sacred community.

By way of a very brief conclusion to this chapter, I make a reference to the Second Vatican Council (1962–1965), which was, like the Council of Trent in its day, a watershed in the Roman Catholic Church for the renewal of the sacraments. In its documents on the Sacred Liturgy, Vatican II expresses the need to revise the rite and formulas of the sacrament of penance "so that they give more luminous expression to the nature and effect of the sacrament."[24] But what could be more luminous for us than this iconic Mary Magdalene of Georges de La Tour? Here, and long before the rather ponderous and churchy language of the Vatican Council sought to define the purpose of the sacraments, this artist, with infinite courtesy and gentle privacy, has shown us why Mary has for so long been the gracious symbol of contemplation and of penitence. For if the act of contemplating this picture is itself a celebration, and the work of art is then, in its "proper performance" truly a religious enactment, then it may be that the truth is revealed here that is said of the sacraments by the Council: "They do indeed impart grace, but, in addition, the very act of celebrating them disposes the faithful most effectively to receive this grace in a fruitful manner, to worship God duly, and to practice charity."[25] In contemplating the Mary of La Tour, we stand in a moment suspended between two worlds, as she was in the vision of Maximin at her death, effecting the transfiguration of this world in a moment of forgetting and the deepest participation.

CHAPTER 7

The Artist and the Mind of God

However, if we do discover a complete theory, it should in time be understandable in broad principle by everyone, not just a few scientists. Then we shall all, philosophers, scientists and just ordinary people, be able to take part in the discussion of the question of why it is that we and the universe exist. If we find the answer to that, it would be the ultimate triumph of human reason—for then we would know the mind of God.
—*Stephen Hawking,* A Brief History of Time

If all of us, and it would have to be universal community, for no possible debate could remain, were truly to know the mind of God, then indeed we should know everything and therefore know nothing: for we would then not be in a state of knowing but rather of pure being beyond all consciousness. As we reflect on thinkers like Hawking, we must recall that it has been rightly observed of the scientific mind that "most major scientific theories rebuff common sense. They call on evidence beyond the reach of our senses and overturn the observable world. They disturb assumed relationships and shift what has been substantial into metaphor."[1] Thus, at the furthest reaches of the human mind, science and poetry meet, and beyond that there is indeed—*nothing*, perhaps the mind of God; one doubts it, one can but have faith. In his *Biographia Literaria* (1817), the romantic poet and thinker Samuel Taylor Coleridge, against the background of scripture but drawing on his intellectual immersion in, among others, Kant and Schelling and German

97

idealist philosophy, famously describes the Primary Imagination as "the living Power and prime Agent of all human Perception, and as a repetition in the finite mind of the eternal act of creation in the infinite I AM."[2] If this indeed be the case, then we may say that the poet is at once and at the same time the most holy and the most profane of human beings, being at one, in the finite mind, with the mind and creative activity of God, and thereby trespassing, with ultimate daring, upon territory that is God's alone. Thus, Coleridge can say of the poet in his visionary poem "Kubla Khan":

> Weave a circle round him thrice.
> And close your eyes with holy dread,
> For he on honey-dew hath fed,
> And drunk the milk of Paradise.[3]

Coleridge's contemporary, the madman and genius William Blake, who walked, in his poetic utterance, among the fires of hell— "delighted with the enjoyments of Genius, which to Angels look like torments and insanity"[4]—associated the "poetic genius" entirely with the Creator God, and in such genius the poet participates for this most christocentric of all our English poets. In Blake's "memorable Fancy," Isaiah, Blake's fellow poet, speaks to him:

> I saw no God, nor heard any, in a finite organical perception; but my sense discover'd the infinite in every thing, and as I was then perswaded, & remain confirm'd, that the voice of honest indignation is the voice of God, I cared not for consequences, but wrote.[5]

But few of us would willingly burn with Blake in the fires of hell. At the very most, we might allow ourselves to be led, as the poet Virgil led Dante, as observers on the edge of the incomprehensible, and might be prepared to contemplate the possibility that these poets among us, at the risk of their very souls, might dare impossibly to think the unthinkable and thus to touch upon the region that can be known only in the mind of God. It was the breath of this region that Coleridge experienced when he encountered, in his own way, the aesthetics of incomprehensibility in German romantic thought after the Kant of the Third Critique, *The Critique of Judgement* (1790). In the region of such aesthetics, the poet Novalis, the student of Schiller and friend of Friedrich Schlegel, describes how "Everything Visible cleaves to the Invisible—the Audible to the

Inaudible—the Palpable to the Impalpable. Perhaps the Thinkable to the Unthinkable."[6]

* * *

Now let us change our tone for a moment. The primary sources of Christian theology—Judaism and Hellenism—both contain strong elements of the iconoclastic.[7] The fear of idolatry gives rise to the smashing of images, but there is a deeper, less well-articulated fear also; the fear of ambivalence and of touching with the senses that which can only be profoundly unknowable. And yet, in spite of this fear, Christian theology remains fascinated and inspired by the language of the artist and poet, aware of its deep commitment to the form and realm of thinking that deeply knows the final inadequacy of the propositional frame of mind. In his "Letter on Humanism" (1947), written as a direct refutation of the existentialism of Jean-Paul Sartre, Martin Heidegger provocatively argues for the "multidimensionality of the realm peculiar to thinking. The rigor of thinking, in contrast to that of the sciences, does not consist merely in an artificial, that is, technical-theoretical exactness of concepts. It lies in the fact that speaking remains purely in the realm of Being, and lets the simplicity of its manifold dimensions rule."[8] Such simplicity, however, is also infinitely complex and available only in Heidegger's challenge to what "understanding," "knowing," or "thinking" finally mean.[9] At the heart of poetry is precisely not the capacity to think through and toward some hidden or obscure meaning, but rather through a wisdom characterized by the grace of *gelassenheit*, a serenity and a "letting the unsayable be not said."[10]

We can suggest an example of such knowing presented in Heidegger's reading of the first lines of the German romantic poet Friedrich Hölderlin's hymn "Germania."[11] Stated propositionally, the disappearance and absence of the gods are addressed by the poet.

> Not them, the blessed, who once appeared,
> Those images of gods in the ancient land,
> Them, it is true, I may not now invoke. . . .[12]

But actually the flight and absence of the gods in Hölderlin's poem precisely open up a space in which "knowing" becomes possible—the gods for the first time actually known through their very unknowability.

In the first instance, I want deliberately to separate the epistemological foundations of such poetic "thinking" in the modern world from anything specifically religious or theological, though the connection will later, by implication, be reasserted. But to start with, we need to link it with the intellectual tradition of what S. T. Coleridge describes as the "clerisy," and what in a once-famous and now largely forgotten work, *La Trahison des Clercs* (1927)—*The Treason of the Intellectuals*—the French novelist and critic Julien Benda identifies with the tradition of the "clerks," that is "philosophers, men of religion, men of literature, artists, men of learning."

> I mean [he writes] that class of men whom I shall call the *clercs*, gathering under that title those whose activity does not in its essence aim at practical goals, and who, finding their satisfaction in the practice of art, of science or of metaphysics (in short in the possession of unworldly wealth), announce in one way or another, "My kingdom is not of this world." . . . the action of these *clercs* remained above all theoretical. They did not prevent hatreds or slaughter on the part of the laity. But they did prevent the people at large from making a religion out of its aspirations, from thinking itself important in attempting to realize them. *One can say that, thanks to them, humanity has for two thousand years performed evil but honoured goodness. That paradox is the glory of the human race, and the crack through which civilisation was able to slip.*[13]

One might immediately see why such a form of thinking could be associated with someone like Heidegger and not least in his notorious adherence, despite his philosophical eminence, to the Nazi Party. More broadly, and in a way no less disturbingly, it finds its nineteenth-century embodiment in such works as Coleridge's *On the Constitution of the Church and State* (1830), and Cardinal Newman's *The Idea of a University* (1873), and in forms of romantic conservatism, religious and secular, that were opposed to the vocational and science-based approach to the education of the thinking mind that we should generally identify as Utilitarian. Its project in the promotion of the "clerisy" begins with an abiding sense of the whole and an organic view of society and the human condition, rather than with the individual abstracted from such holistic ways of thought "without which or divided from which," Coleridge remarks in an eerie anticipation of Heidegger's vocabulary, "his Being cannot

even be thought."[14] In the nineteenth century, such thinking was located in what Owen Chadwick has carefully analyzed as the complex and paradoxical relationship between the onset of European secularization and religious faith (a complexity that was, and usually still is, oversimplified in the debates between science and religion, often epitomized in the 1860 argument on the subject of evolution between T. H. Huxley and Bishop Samuel Wilberforce). Actually, we should remember that religious understanding in the Christian tradition has long been accommodated to the task of adjustment, albeit sometimes slow and painful, to new knowledge about the world, and even to the new ways of thinking that such knowledge seems to require. The real issue is approached when the question is asked whether the processes of "secular"—and largely scientific—thinking are "inseparable from an actual *reduction* of Christianity" and the mind is thrust "back upon the foundations of religious faith and practice."[15] It is at this point that the language of religion faces its most serious challenge, for once it begins to anticipate the epistemology and forms of the secular in its own defense, then the rift through which, in the words of Benda, civilization has slipped into the world, and whereby humanity paradoxically continues to do evil yet honors good, is sealed, religion forgets itself, and the poetic language of faith is finally deserted.

We can look at this in two ways. As an admittedly at times rather confused, or perhaps idiosyncratic, disciple of German idealism, Coleridge drew from Kant the distinction between two ways of knowing in the distinction between pure and practical reason. *Vernunft* is the higher way, translated by Coleridge as "reason," "through which truth could be directly apprehended, [and which] freed men from total dependence on naturalistically conditioned knowledge."[16] *Verstand*, on the other hand, called by Coleridge "understanding," is the lower faculty, a form of cognition that draws merely and necessarily from phenomena.

But, and this is the second way, engagement purely with the former and higher way of knowing must necessarily be in a contemplative mode, taking us back to the ancient Christian prioritizing of the *vita contemplativa* over the *vita activa* that has its biblical origins in the story of Jesus' visit to the house of Martha and Mary (Luke 10:38-42) and in later Christianity, in the contemplative traditions

of monasticism which tend to emphasize "being" over "doing." Or, as a poet whose experience turned him against the religion of his fathers wrote of his poems on the First World War (the poet is Wilfred Owen): "these elegies are to this generation in no sense consolatory. They may be to the next. All a poet can do today is warn. *That is why the True Poets must be truthful*."[17] And in being truthful, their task is, in a sense, to do nothing—merely (merely?) to "be."

And so here is the dilemma, or the contradiction: it is thanks to the "clerks" that humanity does evil but honors good. Poets and artists might be said to do nothing, their inutility perhaps at the very heart of the current onslaught on the study of the arts and humanities in universities as unproductive and unprofitable. And so why does Coleridge, himself a poet, fear the poets, and yet defend the clerisy? Plato, fearing the consolations of art,[18] would banish the poets from his Republic, yet their vision is close to the heart of Newman's "idea" of a university—an idea for which we now in our own time must fight tooth and nail. But we have not properly addressed the real rub of Benda's contradiction—that it is *thanks* to the "clerks" (or to the poets, or to those whose "kingdom is not of this world") that humanity does evil—yet honors good. A clue to the heart of this seeming paradox, it may be suggested, lies in the perpetual dilemma in Christianity over the nature of art and the poetic. Without the church, Western art is almost inconceivable, and yet it is precisely the church that has so often deliberately smashed beautiful objects or broken the hearts of poets like Gerard Manley Hopkins, nothing if not a religious man. Saint Augustine, in *The City of God*, suggests that material things

> offer their forms to the perception of our senses, those forms which give loveliness to the structure of this visible world. . . . We apprehend them by our bodily senses, but it is not by our bodily senses that we form a judgement on them. For we have another sense, far more important than any bodily sense, the sense of the inner man, by which we apprehend what is just and what is unjust, the just by means of the "idea" which is presented to the intellect, the unjust by the absence of it. The working of this sense has nothing to do with the mechanism of eye, ear, smell, taste or touch. It is through this sense that I am assured of my existence.[19]

This very loveliness in the structures of the visible world can be a snare and a distraction. In another and more personal work, the *Confessions*, Augustine writes with fine artistry of the dilemma for him:

> I have learnt to love you late, Beauty at once so ancient and so new! . . . You were within me, and I was in the world outside myself. I searched for you outside myself and, disfigured as I was, I fell upon the lovely things of your creation. . . . The beautiful things of this world kept me far from you and yet, if they had not been in you, they would have had no being at all.[20]

Art and the language of poetry may then be signs of the beauty of the divine—but merely to fix our gaze on or give our attention to them is to fail to attend to the "idea" presented to us in them. And so even we may come to see without seeing or to know without knowing.

In what sense, then, may the poet, that most fearful of all creatures, be said to know the mind of God? Not, certainly, as Stephen Hawking might have us think, in the triumph of human reason. Rather, it is in the extraordinary capacity of the human mind to think in words outside and beyond words, to hear and enact an impossibility through a medium that can dare to allow in words the unsayable to remain unsaid. In an earlier book, I wrote about Kant's memorable words in the *Critique of Practical Reason* (1788):[21] "Two things flood the mind with ever increasing wonder and awe [*Bewunderung und Ehrfurcht*], the more often and the more intensely it concerns itself with them: the starry heavens above me and the moral law within me." But, as Arthur C. Danto has pointed out, what is even more awesome than the starry heavens and the moral law is the fact that Kant is aware of them and that his consciousness can reach out into the universe, both external and internal, and is open to that which is, in itself, unpicturable and even unintelligible.[22]

In further exploring this "consciousness," I would wish to move beyond the limits of the argument as set by Tina Beattie, when she turns to "the power of narrative and story-telling to shape our lives" in her published debate with the New Atheists, such as Richard Dawkins and Christopher Hitchens. For in Beattie's arguments, there remains very much the tone of those misguided, and finally naïve, nineteenth-century arguments between science and religion, and from them art (and therefore religion) emerges as too innocent in

the championship of freedom against "every destructive and oppressive force."[23] The matter is actually more complex, more recessed, more ambivalent than that seems to suggest. For art and religion are both two-edged swords, and it is their simultaneous deep love for and profound suspicion of one another that is the key to the mystery. But other words than "suspicion" come to mind—"unease," "contradiction," perhaps "multiplicity"—terms that drive the language of poetry and its ways of knowing, its epistemology.

In his "Stanzas from the Grande Chartreuse" written in 1855, Matthew Arnold famously wrote, with gospel overtones written ironically into his language, of the nineteenth-century dilemma of faith:

> Wandering between two worlds, one dead,
> The other powerless to be born,
> With nowhere yet to rest my head,
> Like these, on earth I wait forlorn.[24]

The "these" refer to the men of faith who have inhabited the Grande Chartreuse, the monks of whose forebears, the Desert Fathers of Egypt, it was once said that "while dwelling on earth in this manner they live as true citizens of heaven."[25] What is driven apart in the dislocated language and culture of the Victorian Age, caught between the seemingly unreconcilable opposites of idealism and utilitarianism, science and religion, faith and materialistic unbelief, is the capacity of poetry to inhabit two (and perhaps more) distinct worlds simultaneously, and thus to move us beyond Arnold's despair (though as a poet he knows this even while he remains abandoned on the darkling plain of martial ignorance).[26] The poetic imagination, as a repetition in the finite mind of the eternal act of creation in the infinite I AM, lies at the very heart of the identity of the sacred community that sings the *Sanctus* simultaneously with the whole company of the faithful both in heaven and here on earth. And it is the identity and being of this community that is sustained by a knowing that is at the same time an unknowing—a contradiction, or, as William Blake would have better described it, a "contrary," without which there is no progression.[27] But as with the monks of old, their worlds utterly inaccessible to Arnold, the true poets do nothing, even while evil persists in the world, yet in their

contemplation, human life becomes a possibility, or, as it is said in the *Historia Monachorum*, the *Lives of the Desert Fathers*, "through them too human life is preserved and honoured by God."[28]

The key to the possibility of "thinking" this in the nineteenth century lies in the dynamic form of idealism we first find fully expressed in the writings of Coleridge. It is dynamic, because it begins with a theory of mind and the world as process, sustained, for Coleridge, by the creative power of God.[29] Coleridge takes the step Kant had failed to take, to the transcendental conclusion—that all is mediated through the oneness of God, "the eternal identity of Allness and Oneness." In this oneness, all is related and interrelated, and we come to God in the contemplation of the interdependence of all particulars, and thus we may perceive, however dimly, the one in the many. For Coleridge, the reality is the One in which alone the particulars can be understood. In a letter to James Gillman he wrote,

> The sum of all . . . is; that in all things alike, great and small; you must seek the *reality* not in any imaginary *elements*. . . . All of which considered as other than elementary relations. . . . Are mere fictions. . . . The Alphabet of Physics no less of Metaphysics, of Physiology no less than of Psychology, is an Alphabet of *Relations* . . .[30]

Such thinking extends to the community in which the particulars can only be perceived and known in the unity of the whole, and it is through poetry alone that this unity can begin to be articulated. Coleridge best describes this in his explanation of the "symbol"—which closely echoes the sense of the sacramental in both its materiality and its particularity. In his "Lay Sermon" of 1816, entitled *The Statesman's Manual*, Coleridge writes,

> A Symbol . . . is characterized by a translucence of the Special in the Individual or of the General in the Especial or of the Universal in the General. Above all by the translucence of the Eternal through and in the Temporal. It always partakes of the Reality which it renders intelligible; and while it enunciates the whole, abides itself as a living part in that Unity, of which it is the representative.

Opposed to the symbol in Coleridge is the "dead letter" of the "present age," among the miseries of which is recognized "no medium between *Literal* and *Metaphorical*" in its "mechanical understanding."[31]

But in the symbol, which is known only through a community that is itself symbolic, the eternal is glimpsed through the temporal in an impossible act of knowing made possible only through the participation of the "being" of the community. In this act of making, or *poiesis*, language renders intelligible that which is beyond comprehension, and it links Coleridge's symbolic, or better sacramental, poetics with Heidegger's sense of what it means to "dwell poetically on the earth as a mortal."[32] James C. Edwards has described such Heideggerian dwelling precisely:

> To dwell poetically on the earth is to live in awareness of the godhead, the clearing, the blank but lightening sky. It is to live so as to measure oneself against that Nothing—that No-thing—that grants the possibility of the presence of and the Being of the things that there are. Within that clearing, as Heidegger puts it, brightness wars with darkness. There we struggle with particular ignorances and incapacities to bring forth truth.[33]

The triumph of reason is to respond to the provocation that what we usually call thinking is merely a protection and therefore a bare maintaining of the status quo, the mere thinking of what the poet describes as "*O curvae in terram animae et celestium inanes*" ("Minds turned to the world and heedless of the heavens").[34] Rarely, though it happens from time to time, in either science or religion, do we encounter thought that is only truly thinking when it measures itself against its own impossibility. Yet such thinking alone facilitates dwelling poetically as a mortal, and allows a nonappropriative understanding of the poetic and a kind of paradoxical knowing, in which the sacred is already at work within the poetic act, that is, an act of pure stillness, an act of being.[35]

In *Biographia Literaria*, Coleridge, with a reference back to Theseus in *A Midsummer Night's Dream*,[36] describes his purpose in contributing to the *Lyrical Ballads* as to "procure for these shadows of imagination that willing suspension of disbelief for the moment, which constitutes poetic faith."[37] He is not playing games here, whereby we might be prepared to believe, for the moment, in the fictional world of the poem, play, or novel. His purpose is much more serious than that, being about the move from the reasonable into a deeper rationality that sustains contradictions requiring a renewed sense of wholeness, and our place in it not as individuals

living alone, "in the sea of life enisl'd,"[38] but as an organic community into which the poet, "diffuses a tone, and a spirit of unity, that blends, and (as it were) *fuses*, each into each, by that synthetic and magical power, to which we have exclusively appropriated the name of imagination."[39] Only then, at this point, can we move on from words as merely instruments of technology and from language as a poor means of reference to recover a sense of words as living things endued afresh with the sense of the sacred and a capacity ever to say more than they appear to say.

Those who have been fortunate enough to experience the recent production of *King Lear* with Derek Jacobi, and its ability to reduce a theatre to utter silence, will have known again the power of language to engender an extraordinary sense of wholeness, a necessary reminder of eternity in a world that is always restlessly moving on. As Marshall McLuhan once expressed it:

> *King Lear* is a kind of elaborate case history of people translating themselves out of a world of roles into the new world of jobs. This is a process of stripping and denudation which does not occur instantly except in artistic vision. But Shakespeare saw that it had happened in his time. He was not talking about the future. However, the older world of roles had lingered on as a ghost.[40]

King Lear tragically follows an ineluctable change from an inclusive to an exclusive sense of the world, from and to Cordelia's "being" with Lear—a form of poetic dwelling—that adds up to "nothing" ("nothing will come of nothing") in a world of emergent "shrill and expansive individualism"[41] that finally results only in mutual destructiveness. More moving even than the final scene of Lear's is the crucial scene when the aged king and Cordelia are led in by Edmund as prisoners, in which Lear—envisaging a community with Cordelia that, even in prison, is not of this world, a way of being and knowing that is finally impervious to the "poor rogues" at court—speaks to Cordelia of their impending captivity. His vision is of an impossible world of mutual blessing and forgiveness, viewed, as it were, from heaven itself, in which in perfect unity they—

> . . . take upon's the mystery of things,
> As if we were God's spies: and we'll wear out,
> In a wall'd prison, pacts and sects of great ones
> That ebb and flow by th' moon.

Upon such sacrifices, my Cordelia,
The Gods themselves throw incense. Have I caught thee?
He that parts us shall bring a brand from heaven,
And fire us hence like foxes. Wipe thine eyes;
The good years shall devour them, flesh and fell,
Ere they shall make us weep: we'll see 'em starv'd first.
Come.[42]

Of course, it is a vision that is never realized on earth, nor could it possibly be, for the world must go on. In a short while, Cordelia lies dead in her father's arms—a new *pieta*—and his heart breaks, never quite convinced of her earthly parting from him. But then the world must go on, sadder and wiser, as Edgar concludes the play.

The weight of this sad time we must obey;
Speak what we feel, not what we ought to say.
The oldest hath borne most: we that are young
Shall never see so much, nor live so long.[43]

In *King Lear*, what E. H. Gombrich in his book *Art and Illusion* (1960) calls the illusion of the third dimension is effected in the art of the stage in the illusory fall of Gloucester from the cliff. But in Lear's vision of the mystery of things, the third dimension is utterly surpassed and transcended, as he imagines looking down on the world—"as if we were God's spies."

The tragedy of *King Lear* marks a shift between two worlds, and it is a shift that drives Lear to madness and others to murderous conflict. But the way of knowing upon which we have been reflecting, the vision of dwelling poetically on earth as a mortal, the vision of the captive and now, perhaps, sane Lear, is yet touched upon in the identity of the sacred community that is the community centered upon the sacrament, the "symbol," in which finite and infinite touch and voices can be raised for a moment on earth in harmony with heaven in the singing of the *Sanctus*. This is a community of poetic voices that pays a heavy price for its necessary contradictions in this world and always has done, for its passion is salvation. It is from this passion alone that the poet writes, even, as Maurice Blanchot has reminded us, one as despairing as Franz Kafka, for "salvation is an enormous preoccupation with him, all the stronger because it is hopeless, and all the more hopeless because it is totally uncompromising."[44] For the poet and sacred community, whose ancient

language is an unutterable poetry, alone know the depths of evil that lie at the root of the tragedy of Lear, and are little known to us for, as Terry Eagleton has recently written:

> On the whole, postmodern cultures, despite their fascination with ghouls and vampires, have had little to say of evil. Perhaps this is because the postmodern man or woman—cool, provisional, laid-back and decentred—lacks the depth that true destructiveness requires. For postmodernism there is nothing really to be redeemed. For high modernists like Franz Kafka, Samuel Beckett, or the early T. S. Eliot, there is indeed something to be redeemed, but it has become impossible to say quite what.[45]

Perhaps in the later Eliot—the social critic of *The Idea of a Christian Society*, published a few months after the outbreak of the Second World War in 1939, though still not altogether in the poet of the *Four Quartets*—this impossible vision becomes caught in a static portrait of a monolithic "Christian world-order," of a society dominated by the church with its "explicit ethical and theological standards."[46] This is quite different from the way of knowing and the community we have been pursuing, which is at once more fragile and contradictory, even given to tragedy, and yet more enduring than anything else in its very inutility and its manner of contemplation. Such a way of knowing celebrates no ultimate triumph of human reason in its conversations with the divine and is even content to be forgotten by the urgent imperatives of the ever-present world order, knowing of it only that in their being human, human beings are mixed creatures striving for wholeness and integrity.[47]

The novelist J. G. Ballard once wrote a brief story entitled "The Life and Death of God."[48] Here, in a declaration signed by three hundred scientists and divines, it is affirmed categorically that "God Exists: Supreme Being Pervades the Universe," an existence proven, it seems, by the observation of a system of "ultra-microwaves." Yet the consequence is not a cause for joy, but it is rather the utter breakdown of all order in human society. Theology is now become a science of certainty—and nothing in society, politics, or religion makes any sense whatsoever. "The term 'deity' was, in any useful sense, meaningless," and it is the United Faith Assembly that proclaims in its Christmas encyclical that *God Is Dead*.[49]

Yet this moment is, in fact, the rebirth of the ultimate contradiction and the resurrection of speech, known for Christianity finally in the Passion Narratives, above all in the narrative of Saint Mark. In the words of the American theologian Thomas J. J. Altizer, though here in rapt attention to the final word of Jesus from the cross—τετέλεσται—from the Fourth Gospel:

> The real ending of speech is the dawning of resurrection, and the final ending of speech is the dawning of a totally present actuality. That actuality is immediately at hand when it is heard, and it is heard when it is enacted. And it is enacted in the dawning of the actuality of silence, an actuality ending all disembodied and unspoken presence. The speech is truly impossible, and as we hear and enact that impossibility, then even we can say: "It is finished."[50]

Art and Communities
of Oppression

If we are in it, we do not stand in it: there is no place there—but we
ourselves are opened up there, parted from ourselves, from all our
places and all our gods.

— *Jean-Luc Nancy, "Of Divine Places"*

In their writing and in their inscriptions, the poet Paul Celan and
the artist Anselm Kiefer are both engaged in the work of mourn-
ing: not mourning for lost friends or severed relationships, but a
deeper mourning of the soul. Born in Romania in 1920, Celan
mourns for a lost generation and a lost community of European
Jewry, and mourns for the German language: his is the mourning
of one who barely survives, articulating and writing at an extreme
in poetry of a steely fragility. Kiefer was born on March 8, 1945, in
Donaueschingen, Germany, and was brought up a Roman Catholic.
His is the mourning of a German who is without personal memory
of the community that has been defeated and is overshadowed by
Nazism and the Holocaust, but still has a profound awareness of
its trauma and loss. For both Celan and Kiefer, dialogue with the
previous generation is blocked, either because it was erased or else
forbidden—expression, verbally or visually, if any form of expression
were still possible, is a coming to terms with exclusion.[1]

The events of the history of the twentieth century, with their
devastating human cost of body and spirit, bleached onto these men's

hearts, minds, and souls as an indelible sensibility. In the words of the late Edith Wyschogrod:

> The holocaust is itself intrinsic to postmodern sensibility in that it forces thought to an impasse, into thinking a negation that cannot be thought and upon which thinking founders.[2]

For Celan and Kiefer, there is indeed the sense of an ending, but there is also a necessary sense of beginning anew. Kiefer explains the repetition of the image of the artist's palette in his paintings, relating it precisely to his vocation as a creative artist: "The palette [he insists] represents the idea of the artist connecting heaven and earth."[3] But the point of connection, which is also the vanishing point, recurs endlessly in his work as also the point at which thinking founders— vanishing in the railway tracks converging on Auschwitz, vanishing in the stairs leading to the closed door of his studio in the converted schoolhouse in the Oden Forest, in the 1973 painting *Resurrexit*, and vanishing in the jagged, mysterious confluence of his 1990 work *Zim Zum* (see plate 4).

"Zim zum" is the name of the point in the Jewish Kabbalah where God withdraws in order that the world may appear—a moment of divine disappearance, but also a point of creation. Yet in Kiefer's canvas, that point, in almost the dead center of the picture, seems rather to be a point of desertion. A scorched and wasted world flows into that space of departure, the point of *chora*, disintegrating into a place of nothingness, in which the viewer stands before the vanishing God, perhaps even the God who has died.

From the twelfth century in Europe it was said of God: *Deus est spaera cuius centrum ubique* (God is the sphere of which the center is everywhere and the circumference is nowhere.).[4] But if God reveals himself at every point in the universe, so too, wherever we are, we are conscious of a presence that is at the same time a vanishing and an absence, and we can no longer finally make any distinction between the divine transcendence and the disappearance of God. God disappears in Auschwitz—God disappears into Auschwitz. Thus, as poets, and as nothing, we sing the praises of the one who is Nothing, as in Paul Celan's "Psalm":

> *Gelobt seist du, Niemand.*
> *Dir zulieb wollen*

wir blühn.
Dir
entgegen.

Ein Nichts
waren wir, sind wir, werden
wir bleiben, blühend:
die Nichts-, die
Niemandsrose.

(Praise be your name, no one.
For your sake
we shall flower.
Towards
you.

A nothing
we were, are, shall
remain, flowering:
the nothing-, the
no one's rose.)[5]

And yet actually our reality is an *experience* of the absence of God, which, as Martin Heidegger said long ago, is "not nothing." Creation and disintegration are opposites that yet, and at the same time, cannot in the end be distinguished, each unendurable. It is Maurice Blanchot who suggests a metaphor for this via a shift in paradigms proposed by Einstein's move to the non-Euclidean geometry of Georg Riemann, and a "manifold with negative curvature, one that forms a hyperbolic rather than a spherical space." From this, we derive a vision of the universe that is not, indeed, a *unity*, but which is incapable of resisting infinite expansion and is "essentially nonfinite, disunited, discontinuous."[6]

Creation, then, is matched by disintegration and fragmentation in equal measure, and therefore there is no interior to any possible reality, as, for Blanchot, we encounter in the work of Kafka "not even one world. For there exists for him only the outside, the glistening flow of the eternal outside."[7] In Kafka's writing there is a profound hopelessness, matched only by his equal obsession with salvation: an obsession that is, it is true, continually extinguished by despair—and yet, and this is the point, he continues to write. Writing never ceases.

And so also Celan *writes* after Auschwitz (despite Adorno's notorious dictum), and Kiefer *paints* and constructs his works, laboring often with the material of lead (once used, *ad maiorem gloriam Dei*, on the roof of Cologne Cathedral), a material that is poisonous, impenetrable, impervious to light and even x-rays, yet still the base metal of alchemy and of the ancient quest for the secret of its transformation into gold. Kiefer also works in the medium of ash, especially in the series of paintings inspired by Celan's great poem *"Todesfuge"* ("Death Fugue"), the ash from the death ovens joining together the golden hair of the Aryan Margarete and the ashen hair of the Jewish Shulamith.[8] For ash is but a trace blown in the wind of that of which nothing now remains—the memorial in Kiefer's art to that which is now no longer—a whole generation obliterated and lost. Jacques Derrida writes in his essay on Celan, "Shibboleth":

> Like the September-roses, no one's rose calls for the blessing of what remains of what doesn't remain and thus for the blessing of the remains that don't remain, the dust or ash. The heart's mouth which comes to bless the dust of ash comes again to bless the date, to say yes, amen, to the nothing that remains and even to the desert in which there would be no one even to bless the ashes.[9]

Gelobt seist du, Niemand ("Praised be your name, no one"). And so the blessing and the praise remain in what does not remain, even (and perhaps especially, above all) in the empty desert.

In the ash, there is total disintegration, a reduction to a mere trace, a nothing (almost), without substance or interiority: and yet in Kiefer's art, that ash itself is offered as a sacrament and a memorial to the forgotten and to those whom he himself had never known, and whom Celan had lost utterly—his family and his community. In the ash, there can be no re-membering, or coming together again in any kind of celebration, and no remembrance, but yet in the ash of Kiefer's canvases, the very vanishing point, the now-familiar confluence of the railway track at the gate of oblivion itself is an opening of another kind, though as incomprehensible as the black holes in space into which all time and matter rushes headlong. Kiefer says: "I tell stories in my pictures to show what's behind the story. I make a hole and go through."[10] To pass through the nonspace of the vanishing point—the absolute beginning and the absolute end—is the reminder of the being of the sacramental moment and its utter

oblivion. To do this—to pass through—is the final thought at the "limit of interiority," and it is to move into what Jacques Derrida terrifyingly describes as "the absolute past—that is, the immemorial or unrememberable, with an archive that no interiorizing memory can take into itself."[11] Within the Christian tradition, there is but one moment of such true art that defies all final interpretation, one moment of utterance in the story that Kiefer's art dares to seek in what Celan calls the "illegibility of this world" (*Unlesbarkeit dieser Welt*).[12] It is Jesus' cry of dereliction from the cross in the Passion Narratives of Mark and Matthew—"*My God, my God, why have you forsaken me*"—his interrogation of the absent deity, and the necessary prelude to the recovery of any possible sacramental—sacred—community, the beginning of all possible memory.

Zim zum: the moment of abandonment, the moment of creation. In his 2003 painting *Am Anfang* (*In the Beginning*), looking back in reference to Albrecht Dürer's *Melencolia I* (1514), Anselm Kiefer throws out his interrogation of the watery wastes of the cosmos: the work's polyhedron is the moment of both formation and despair. He describes this moment in this way: "It is the artist's job to imagine the most impossible things. These are not answers. They are just possible entries into hidden things."[13] Thus, the artist calls us to stand before, to stand at, the vanishing point, the community at once in disintegration and fracture and at the same moment entering into the bliss of all creation: the gates of Auschwitz and the gates of heaven—the darkest of all entries into hidden things. In his 2002 work *Die Himmelspaläste* (*The Heavenly Palaces*), Kiefer draws us again to the same point through an immense pillared hall, reminiscent of the vast Nazi architecture of Albert Speer and Wilhelm Kreis, of which almost nothing now survives, to a distant point under a roof of stars. With an irony that is necessarily present, perhaps, in every moment of true worship as it sanctifies that which destroys, the immediate inspiration of the work is the ancient Jewish book, *Sefer Hechaloth*, which recounts the mystical ascent by chariot (*merkawa*) through the seven heavenly palaces to the palace where the wise are finally united with God.[14]

And so we return to the great work *Zim Zum*, painted twelve years earlier. Here, everything is insistently present, leaden and lifeless, drawn into a presence of nothingness; on the left of the picture,

the heavy suggestion being not so much of the heavenly chariot but rather the square boxcar of the deportees to the death camps. Here, though unseen in this devastated landscape, is the deathly community of the "*Todesfuge*," Celan's great poem—an ode also to the beauty and symmetry of Bach's music, to which Kiefer returns obsessively via the very Nuremberg of Wagner's Hans Sachs and Nazi mythology; the golden hair of Margarete, the victim of Faust's duplicity; and the ashen hair of Shulamith, the woman of legendary beauty who appears but once in the Song of Songs. Celan and Kiefer, in poetry and in art on the aesthetic principle of transgression—of awful beauty heard and seen in death—draw us, before even we are barely aware of it, into the reversal that devours the Jewish people at the vanishing point. Here, the community is lost, drowning—but here alone (as on the cross and at the unbearable center of Elie Wiesel's autobiographical narrative *Night* in the hanging in the death camp of the young boy) we hear the voice of the child at the solemn ceremony of Rosh Hashanah, as recalled by the Roman Catholic François Mauriac in his foreword to Wiesel's work:

> That day I had ceased to plead. I was no longer capable of lamentation. On the contrary, I felt very strong. I was the accuser, and God the accused. My eyes were open and I was alone—terribly alone in a world without God and without man. Without love or mercy. I had ceased to be anything but ashes, yet I felt myself to be stronger than the Almighty, to whom my life had been tied for so long. I stood amid that praying congregation, observing it like a stranger.[15]

It is as if with the eyes of such a child that Kiefer asks us to look, and looking, we are drawn into that ashen solitude that is death and where, alone, in that sacrament of betrayal, there is the only possibility of an inconceivable community, now without memory, one awaiting death, but one that renders all others false, contrived, transgressive. Such an inconceivable community, perhaps, is touched for a moment in the ending of Imre Kertész's work *Fateless*, as the boy Gyuri, having survived the camps though barely, returns to the genuine impossibility of his family in Budapest, yet knowing there will be happiness because Auschwitz and Buchenwald themselves taught him to know its memorable, its remembered possibility even in the darkest of nights.

For even there, next to the chimneys, in the intervals between the torments, there was something that resembled happiness. Everyone asks only about the hardships and the "atrocities," whereas for me perhaps it is that experience which will remain the most memorable. Yes, the next time I am asked, I ought to speak about that, the happiness of the concentration camps.[16]

Even, even beyond good and evil, at the foot of the cross and at the door of the oven there is an impossible laughter, even joy, for it is that which makes us human.

Yet, here we who remain stand, impossibly, the blood of the *Kristallnacht* even now still on our hands, Kiefer forcing our heads around, looking back to Leo von Klenze's Walhalla Temple (1830–1842) in his attic work of 1973, *Germany's Spiritual Heroes*, their names written on the floor in charcoal, the walls of the hall aflame— Joseph Beuys (Kiefer's art teacher), Caspar David Friedrich, Hans Thoma, Arnold Böcklin, Richard Dehmel, Josef Weinheber, Adalbert Stifter, Nikolaus Lenau, Theodor Storm, Robert Musil, Frederick II, Mechthild von Magdeburg, Richard Wagner. They have no common denominator beyond irony, good and evil to an equal degree, disintegrating at the vanishing point at which they are consumed (see plate 5).[17]

<p style="text-align:center">✳ ✳ ✳</p>

Turning our attention now for a moment to another solitary figure of oppressive, impossibly oppressive isolation and confinement from the last century, and to another poet who touches upon the utter logic of that moment, the moment of the unbearable coincidence of opposites: the Nigerian Nobel Prize winner Wole Soyinka, himself once a political prisoner, fears the lonely figure of the imprisoned Nelson Mandela:

> Your logic frightens me, Mandela
> Your logic frightens me. Those years
> Of dreams, of time accelerated in
> Visionary hopes, of savouring the task anew,
> The call, the tempo primed
> To burst in supernovae round a "brave new world."
> Then stillness. Silence. The world closes around
> Your sole reality; the rest is . . . dreams?[18]

It is not the immense passing of the years, moving slowly and quickly, nor is it the hope of the task to be taken up anew that terrifies the poet. It is not even the waiting. It is the still moment, the silence, the "sole reality" and its terrifying logic. That, in another time and in another place, might be the logic of the mystic, the negation of every-thing, the impossibility of knowing nothing without even knowing or of saying what cannot be said: rather here it is *to be* nothing—that is what is so utterly terrifying in its pure logic. As in the vanishing point of Kiefer's paintings, there is only the void—void of all space and time—into which the world falls and from which, in the absence of God, a creation dares to be. Who is the guard and who is the pris-oner—who is good and who is evil?—for we are terrifyingly beyond all distinctions, beyond all ethical claims, everything and nothing, all merging into one.

> From Auschwitz to Durban, and Robben Island.
> Mandela? Mandel . . . Mendel . . . Mengel . . . Mengele!
> It's he! Nazi superman in sneaky blackface![19]

With Soyinka, we retreat in utter confusion and terror—refusing to see, to acknowledge that this alone turns our disintegrating sense of solidarity into unity at the cost of not less than everything. "That night the soup tasted of corpses":[20] "Take and eat—this is my body." Or, finally, Mandela:

> You made them taste sublimity in Blacked-out
> Solitary.[21]

And perhaps only here, in solitariness and absence (Mandela, Der-rida once suggested, was more powerful as an absence, in prison, than he has ever been since as a presence in South Africa), even after the death of God, there is the only beginning of community and total presence, an ending of speech and a dawn of resurrection. Only then can we know, in the final word uttered from the cross in the Fourth Gospel, the end, the completion, the beginning, the dawning of the sacred, the liturgical community, transcending the limitations of creed and tradition.

* * *

Yet, the human capacity to create suffering and oppression is limit-less—in Germany, in South Africa, in China. And so I turn to a very

different culture, one not rooted in the Bible, Jewish or Christian, one in which I currently spend much of my time. Yu Hua's novel *To Live* (1993) is a brutal narrative of the years of China's Cultural Revolution, written by a writer of whom Mo Yan, the author of *Red Sorghum*, remarked: "I've heard that [Yu Hua] was a dentist for five years. I can't imagine what kind of cruel tortures patients endured under his cruel steel pliers."[22] The steel of Yu Hua's pen allows no relief to the reader. To offer such relief would be dishonest, and it would be too kind. In the end—at the vanishing point—the central character of *To Live*, Fugui, a man who is far from innocent, has lost everything in life . . . everything:

> The old man and his ox gradually got further away, but from far off I could still hear the echo of the old man's hoarse and moving voice. It floated through the open night like the wind. The old man sang:
>
>> In my younger days I wandered amuck,
>> At middle age I wanted to stash everything in a trunk,
>> And now that I'm old I've become a monk.
>
> Chimney smoke swirled upward, dancing in the sky above the roof of a small farmhouse as the last rays of evening sunlight broke up and disappeared. . . . And just as a mother beckons her children, so the earth beckoned the coming of night.[23]

This is life stripped to the impossible limit of negation, without hope and without companionship. And here alone for Fugui, as on the cross of Jesus, as under the chimneys of Auschwitz, is the only possibility of utterance in the silence—a terrifying logic that does not ask why. Not to think, not to know, not to hope, not to have faith—but to do only this one thing, to live. Is this a call across human cultures, daring to abandon, for me and us, the lines of biblical logic, of Christian tradition—apophatic and cataphatic? For if Western culture has constructed itself upon the seeming consolations of the linear, extended in time and space (even now we cannot be persuaded otherwise), Chinese culture, infinitely mysterious to me, is about the swirls of water and mist and the exchange of yin and yang.[24] Yet here, the faint echoes of a common community found only at the vanishing point of all dissolution of character, in suffering, on the pure surface—only the surface—of art, its figures rubbed and erased,

are heard and acknowledged, though we have hardly begun to discern them as familiar in translations, in transgressions that cannot be interiorized—any more than the erasures of memory in Kiefer and Celan: we stand consuming and consumed, knowing only "the glistening flow of the eternal outside."[25]

The German word *Nibelung* descends from the Old High German word *Nebal*, meaning "mist," a Nibelung being one who is surrounded by mist. From the German forests, we can look across the abyss of cultures to traditional Chinese painting, which merges the mountainous landscapes with mists that are somehow more material than the rocks themselves. Solid objects dissolve as landscapes of the soul—appearing and disappearing, and rooted also in words, the ancient art of calligraphy. In art, the natural world is not copied, but provides elements for the artist to build other worlds—worlds consuming and consumed.[26] In the work of the contemporary Chinese artist Ding Fang, whose work closely relates to that of the German artist Kiefer, this tradition is taken up and transfigured into landscapes that are "very similar to the bodies struggling to break free from the shackles of chaos of Michelangelo."[27] The echoes of the spiritual in art are universal, across varieties of language and tradition, and it is the artist above all who knows the death of God—that disappearance in which alone renewal is possible, the space and the instant in which vision transcends the material in moments of faith and doubt.

For Ding Fang, as for Kiefer and Celan, art is rooted in violence and oppression, in the struggle of the people and violence in the China of the twentieth century. He was present on June 4, 1989, in Tiananmen Square (the name means "Gate of Heavenly Peace") in Beijing, and all of his work—delicate, humane, violent, cosmic—explores the terrible beauty of violence. A fine and delicate draftsman and painter, his sketches including figures often drawn from the life of the traditional communities of China. But Ding Fang draws his deepest inspiration from the wild and mountainous landscapes of the west of China, the physical, layered fabric of his canvases reproducing their material being.[28] Mountains, abysses, figures human and divine—the suggestion of faces and muscular limbs—and buildings haunt these massive works. Visiting his studio in Beijing, I felt impelled to touch, to feel the weight and depth of

paint, of a cosmos at once dissolving and coming into being. The landscapes are vast and impersonal, as indifferent to life and death as the deserts of the early Christian saints. I asked if the artist began with a picture or an image, but no, the pictures emerge and grow in the slow processes of creation, and in the act of creation dim communities appear from the loneliness and the violence: saintly figures with wings or haloes, visitors from other cultures or other worlds. Reminiscent in some ways of the remote mountains and streams of the art of Guo Xi in the Northern Song Dynasty (960–1127),[29] Ding Fang's landscapes are different in one vital respect. Figures and buildings do not inhabit his landscapes, but emerge from their very being. They are both lost and found, struggling to break free, in violence, in peace. They participate in the community that is both present and absent, silent, haunting bodies; and perhaps, for now and in the memory of literature and art, that is all we can ask, for any more would be too much—to enter the gates into the immemorial silence: the gates of heaven, the gates of Auschwitz, the Gate of Heavenly Peace, Tiananmen:

> The way that can be spoken of
> Is not the constant way;
> The name that can be named
> Is not the constant name.
> The nameless was the beginning of heaven and earth;
> The named was the mother of the myriad creatures.[30]

We see nothing—but that is a start, the barest sacrament, the Tao, the Logos, in the beginning—of the gospel, of the *Tao Te Ching*. So be it.

CHAPTER 9

The Politics of Friendship in the Post-Christian West

After our brief episode in the art of the both the ancient and contemporary culture of China, let us return now to the community in the Western tradition. It is often said that the culture of the West is in our time "post-Christian." If that is the case, then it is a claim that rests upon a profound paradox, or perhaps a number of paradoxes. The Italian philosopher Gianni Vattimo, a deputy in the European Parliament and one of the constructors of the European constitution, resisted the Vatican's concern to establish the idea of Christianity in the constitution. It was not that Vattimo is opposed to the sense of the European tradition as perhaps primarily, though by no means exclusively, Christian, but he objected to the inclusion of the term "Christian values" in the constitution "because," in the words of Santiago Zabala, "it is precisely in order to uphold these same Christian values that Europe is secular: the force of the Gospels and of Jesus' teaching provides the foundation of the secularity of any democratic state today."[1]

Now, we might argue, if the history, and indeed the success, of Western culture and its politics has been largely guided by Christianity, its political durability has resided, on the one hand, in Christianity's passive interiority, its gracious offering of self-emptying love, combined, on the other, with an aggressively metaphysical Platonism, an objectivism that has sustained the power structures of the communities of both church and state in varying degrees of

123

authority and repression across the centuries. The principal architect of this combination was Saint Augustine of Hippo in the fifth century CE. The paradox I will be exploring in this chapter lies in the ultimate and inevitable dissolution of the second element by the first: *if the West is indeed now post-Christian, it is only because Christianity itself has willingly brought this about*—Christian *caritas* (love), with its origins in a supreme act of divine self-giving, offering the possibility of a politics of friendship that effects a dissolution and deconstruction of the metaphysics of the sovereign power, which is so often, perhaps finally always, deeply destructive in its consequences, of the intellect, science, and religious belief structures and dogmas.

Accordingly, we might assert that the "post-Christian" West begins with Immanuel Kant and the European Enlightenment in the eighteenth century but that this would have been impossible without Christianity itself as the very condition for the end of metaphysics. But (and this will not be a central part of our discussion in this chapter), if Kant attempts to replace divinity with reason, reason too has demanded its price since the French Revolution in the establishment of the democratic states of Europe that, in turn, proved too powerful and too divided for the weak philosophy of love and eventually smashed themselves to pieces upon the catastrophes of the two world wars of the twentieth century. Since then (and the key figures in understanding the nature of these catastrophes are Friedrich Nietzsche in the nineteenth century and Martin Heidegger in the twentieth) we must also speak of our *post-Enlightenment* condition, and even of a rediscovery of Christianity in a manner that is as yet barely articulated or even imagined in our nostalgic adherence to the ecclesial ruins of the past, a manner that we will express for now in the term (after the manner of, though rather different from, Jacques Derrida), the Politics of Friendship.[2]

It has recently been affirmed by Santiago Zabala that "Western humanity, in all its relations with beings, is in every respect sustained by metaphysics."[3] At the same time, if this is true, we live in a time of ends, tatters, and remnants—the remnants of metaphysics. The twentieth century was haunted by images of apocalypse—of the end of time, and also by a profound nostalgia for history and the past. We are beings of history, but best illustrated by Paul Klee's tragic *Angel of History*, as seen and described by Walter Benjamin.

Yet it was the philosopher Martin Heidegger who dreamed not of beings, but of being in time, and who, despite his own politics in the context of Nazi Germany, offered us the possibility of a language that is beyond metaphysics and even of a recovery of Christianity at the very heart of European secularity and after the death of God—a language that enabled us to hope in a being-toward, and not only toward death but in a future found nowhere but within the praxis of the present. Furthermore, it was Nietzsche, the philosopher of the death of God, who affirmed long ago that "there are no facts, only interpretations," and Gianni Vattimo goes yet further in stating that even this proposition, too, is "only" an interpretation.[4] But this can only be a matter of regret if we remain addicted to the proffered certainties of the metaphysics of objectivism. For turned around, it offers a hermeneutical world of endless opportunity discovered in discourse and shared discovery—indeed a politics of friendship found in a world in which all is truly before us.

Thus, we begin to learn afresh and in a new way that we are creatures of time. But the time we now begin to know is not spoiled by nostalgia for what is past nor imprisoned or locked into the oppressive seeming certainties of dogmatic assurance. The Christian church, it was once said by Dostoevsky,[5] among others, has protected us for good and ill from the overwhelming demands of reality; and political institutions, in the West and beyond, have been all too quick to learn from it. But as creatures bound together by a friendship that seeks being-toward, of a being discovered only in endless interpretative possibilities, we can once again embrace a belief in infinite openness to the other that has its root in the *kenosis*, or gracious self-emptying of God into the world (Phil 2:6-11). It is we, the children of Adam and Eve, and we together, who are the sad yet hopeful creatures of the end of John Milton's *Paradise Lost*:

> The world was all before them, where to choose
> Their place of rest, and Providence their guide:
> They hand in hand, with wand'ring steps and slow,
> Through Eden took their solitary way.[6]

In the language of the old Christianity, we may indeed be fallen creatures, limited and imperfect—but that now may be, though in a challenging and testing way in our world of contradictions, a matter for which we can be thankful. For it recognizes that without you I

can do nothing, nothing of myself. I, alone, cannot ever be correct outside the sharing of continuous interpretation.[7]

But, it may be asked, after Derrida, on what grounds is a decision ever made, what is a decision, and *who* decides? As long as we remain merely beings of history, addicted to the past, that "who" can only finally be a "what." *What* decides? What institution with its officers and priests decides for us and binds us to its laws and rules, deciding between good and evil, right and wrong? Lacking true courage, we have assumed such decisions to be unquestionable, for they have defined who we are, or choose to think we are—Christian, non-Christian, male, female, white, black, superior, inferior, all images guaranteed for us by the principles of metaphysics. But only when we truly embrace the courage to be,[8] the courage to abandon all such certitudes, do we begin to encounter the risks of freedom, and reaching out in the tentative negotiations of friendship, begin to entertain the consciousness that the person, in Wilhelm Dilthey's term, is not defined by authority but is eternal. Only in my daring to be your friend and in the risk of daring to ask you to be my friend in a hermeneutical openness to the other can we together thankfully begin to admit what Nietzsche in *Human, All-too-Human* (1878) writes of the harmlessness of metaphysics in the future, abandoning their obsession with the purely theoretical problem of the "thing in itself," but now beyond Kant and beyond all the impositions of the will. And Heidegger, beyond the terms good and evil, ushers us back to those two German terms that have been more or less forgotten since the fourteenth century of Meister Eckhart—*gelassenheit* and *geselligkeit*. Let us remind ourselves of them: *gelassenheit*—abandonment, relaxation, serenity, even nonchalance, expressing the ability, or even and perhaps especially the gift, of moving gracefully through all of life's fortunes and accidents: and *geselligkeit*—sociability, a togetherness that is not cloying or impeding, communality. As we grow in friendship, we find them expressing what my old friend Robert Detweiler, on whom I am drawing deeply and thankfully here as he sings with the angels and plays his part in the *Sanctus*, called, describing that most sociable of all acts, reading together, "our dogged insistence on interpretation with a pleasurable interchange made valuable precisely by a refusal to simplify and manipulate the text into something else, another statement."[9] The rabbis of old, and perhaps yet today, are stars at such acts of reading.

But let us go back to Europe. Between February 2002 and June 2004, the European Union established a new constitution. At the heart of its discussions was the issue of Europe's Christian heritage. In a secularized Europe, Christianity is fighting what can only be seen as an increasingly losing battle for its institutional recognition and space in the public sphere. For that, maybe, we can be profoundly thankful, even—especially—I as a priest of the church. For these fragile claims serve only to expose the paradox with which we began, as we begin in the dimness of our vision to perceive that the event, albeit imperfect and debated, of the European Union itself is made possible only in the truth of Christianity as weakness and as heralding the end of the very metanarratives that made inevitable the foundation first of medieval Christendom, and then its political successors, the modern nation-states. Nor is this weakness, which is located in a daring and universal, divine act of self-giving—*soi-même comme un autre* ("oneself as another")[10]—to be mistaken as natural, a "natural base" for civility, but rather as voluntary, willed, and deliberate, a working through of our diversities in totally conscious acts of friendship pursued in love and charity with our neighbors. As such, the European Union has no limits set upon it, for its genuine power and truth are not delimited by central political systems after the manner of Plato's philosopher-kings. (Thus, in the vision of the European Union, the "end of philosophy as metaphysics" may also be identified with the "end of totalitarian governments.") All borders of all kinds remain open, dependent on the goodwill of the citizens—nothing else: a crucial observation.

I have already had occasion at the beginning of this chapter to be mildly critical of the great Saint Augustine of Hippo, but now I return to his writings with more of a degree of charity. In his *Confessions* Augustine famously reflects upon the nature of "time."

> I confess to you . . . that I still do not know what time is. Yet I confess too that I do know that I am saying this in time, that I have been talking about time for a long time, and that this long time would not be a long time if it were not for the fact that time has been passing all the while. How can I know this, when I do not know what time is? Is it that I do know what time is, but do not know how to put what I know into words?[11]

His point here is important in a number of respects. First, and most obviously, that we humans are, indeed, creatures of time. We have come from a past that at once burdens us and enlightens us in varying degrees. We are born into this world, flourish for a time, and then end our mortal span, making way for a new generation to have its moment of time, itself burdened and perhaps occasionally enlightened by our bequests to it. We quantify time as history, and divide it into minutes and hours and days and years, and yet it remains a mystery to us. We are slaves to time—perhaps have made ourselves so, for I do not believe that this is inevitable—always late, fearful of its passage and burdened by time past, terrified of the storm that we call the progress of time. And yet, as Augustine admits, I still do not know what time is. If I were to ask you to define time, you would be lost for words: and precisely to admit this failure would free us from our imprisonment and the anxieties that divide us from one another. With regard to time, we are all like Kafka's K in *The Trial*, unable to admit that our guilt lies in the fact that we cannot admit it. We dare not say that we do not know. "I do not have time for you today," we often sadly say, or "it is too late, the time has passed when we could speak to one another." Away with all such language!

The early vocabulary of Christianity, before it became overconstrained by dogmatism and the structures of metaphysics, drew from its Greek past and offered the possibility of a weakness that would sustain freedom in human companionship, freedom from the Lord of Time and with that a sense of being-toward that arose from the very debris of the remnants of time in new and unanticipated possibilities. The key word in Greek, *pistis* (πίστις), that is the virtue of faith or belief, is a term that is all too human. To the ancient Greeks, it was the gods who possessed knowledge (ἐπιστήμη), while mere human nature has no knowledge but only vaguely approximate belief or opinions—*pistis*, a truly pathetic condition. But then, extraordinarily, we find that Saint Paul, in his First Letter to the Corinthians, turns this around, for humans have tended to count their foolish beliefs as knowledge, while God, in his wisdom, has emptied himself into the human condition and turned "human" weakness and opinion (*pistis*) into strength. In the beautifully economical prose of the King James Bible we read, "Because the foolishness of God is wiser than men; and the weakness of God is stronger than men"

(1 Cor 1:25). We can now not lament our weakness but rejoice in our freedom as creatures of faith (*pistis*) and therefore endlessly negotiating, interpreting, sharing, discovering in a friendship not bound by the old "knowledge" of dogma or unyielding objectivity.

And what is it, also, turning from the Greek to the Latin, to speak of *virtue*? In the classical, pre-Christian culture of the West, virtue has its roots in manly courage, in standing by one's companions in battle and holding to high principles of fearlessness, whatever the cost. Christianity was to humanize the term virtue, perhaps to "empty" it—giving it the qualities of meekness and self-denial, giving to the other—indeed, recognizing oneself precisely in another.[12] In short, virtue now has its home in weakness and the politics of friendship, weakness that is a truly *human* quality that, for Christianity, has its origin in "God's renunciation of his own sovereign transcendence,"[13] but for us flourishes in the common tasks of everyday human interaction and the shared project of interpretation, of being as event, and therefore of being-toward.

"There are no facts, only interpretations." This can only be a cause for celebration: to celebrate—literally, that running together to one place to make festival.[14] Dear reader, dear friends, we join together in a common pragmatism that is at the very heart of Christianity. And the point is that this constrains no one to *be* Christian: not at all. Rather this is to realize the beginning of a freedom to be ourselves, the courage to be. I have referred more than once already in this chapter to the radical Christian Italian philosopher Gianni Vattimo, who enjoyed a close friendship with the American pragmatist thinker Richard Rorty without any desire whatsoever to convert or change him, and perhaps vice versa. Rather, they shared a common view that "does not view knowledge as a matter of getting reality right, but rather as a matter of acquiring habits of action for coping with reality."[15] Those can only be good habits rooted in trust and friendship.

You see where we are heading, I am sure: being as event calls for action, and action can only be effective when it is pursued within a politics of friendship that is a matter of endless, shared possibilities of interpretation, common faith in one another, and the acknowledgement of risk. As friends we are both, indeed, creatures of time, but also of place; for to be friends is, at least now and then and in

spite of the highly questionable conveniences of modern communications and technology, to meet in a particular place, overcoming all the inconveniences and hazards of distance and separation, to make conference and to recognize our being-toward as *liturgical*. We need to be together now and then. Within religious traditions, this term takes on a technical quality—to meet at a specific time to engage in acts of worship. But the liturgical will only become real when it becomes an entire manner of being, a total way of life dedicated to being-together in effective action. It has nothing to do with any exclusiveness in the substance of *what* I believe (which may be different from, and even at odds with, what you believe), but is rather an eradication of that all-too-solid "what" in the embracing of a common task that is greater than all our differences, and indeed, actually celebrates those differences as matters for that strength-in-weakness that seeks, without reserve, to dilute all concentrations of power and therefore constraint; for we are friends and thus anything—all—is possible.

And so, every place can become a place of diversities and freedom without limits, until eventually I am never alone, even when I am on my own. I am always in community. And admitting this, we admit also the crucial importance of *memory*, and a form of memory that is entirely without nostalgia for the past that is past and gone, though conscious of its gifts. For liturgical memory (another Greek word is important here—*anamnesis*—shifted from its Platonic roots to the praxis of Hebrew liturgy) is the bringing of all time into the present, so that our friendship is not limited by the passing of time, but we also are one with our ancestors as we move toward the as yet unrealized future that is to come.[16] Thus, when Christianity truly celebrates the Eucharist, it does not simply remember a Christ who is in the past, but an event that is continually present with us and guiding us forward. And to participate in this event is not a matter of belief or exclusion but is only possible in a potentially universal action. In short, it is a political event that takes the past into itself as a precondition of the future.

In Western literature, there are but two great works of confession. The first is by our old friend and mentor Saint Augustine. Written in the early fifth century of the Christian era, Augustine's *Confessions* is addressed to God, and begins with the assertion, spoken to God, that "you made us for yourself and our hearts find no

peace until they rest in you."[17] The second work is by the French philosopher Jean-Jacques Rousseau and was composed between 1764 and 1770. Rousseau's confessions are concerned entirely with himself, and to present a man "in all the truth of nature." Thus, if Augustine describes the human as an entirely *theocentric* (centered in God) being, Rousseau's image is utterly *anthropocentric* (centered in the human self). Actually, our confessions take us now beyond both of these positions, for we now pursue being only in the losing and finding of the self in the other—a Christianity (if you will) that is entirely secular and universally known in the spirit of *gelassenheit* and *geselligkeit*. And if theology has a place here (and for some it will, for others not at all, yet all are welcome), it can only be under a very loose heading of "negative theology,"[18] and for my part, my friend, without imposing any demands on you to agree or disagree, it may be summed up in the great event described in his sermon *Qui audit me* by the fourteenth-century teacher and mystic, one of the greatest of Western religious thinkers, Meister Eckhart—when, following our highest calling, for God's sake we take our leave of God.[19]

And so, we may be friends again, acknowledging all our differences and with no hard feelings, I hope. Indeed, like Celan and Kiefer, and Ding Fang, we have a task to mourn—that work of mourning, which is the transformation of our understandable reflections on times past from an event of negation into the realization of the gift of death—for death has been swallowed up in victory (1 Cor 15:54)—and the victory of friendship: the death of God and Christianity, the death of Marx and Marxism. For only then can we become responsible heirs in hope, heirs of Marx, and heirs of Christ. Jacques Derrida was obsessed with ghosts, specters, and spirits, and, like him, we are all haunted beings.[20] But to be haunted by the specters of times past and times yet to come can result in two contrasting outcomes. Either, condemned to loneliness, we become addicted to that which is always and forever unobtainable in a nostalgia for what has gone from us, or a perpetual anticipation in fear and trembling of what is not yet. Or else we can join together in a celebration of the past as it bears full responsibility for the present and the present becomes enlivened by a genuine and responsible hope for the future. Thus all is present not in ghostly (*unheimlich*) unreality, which the true community of friendship will always exorcise, but in

the realization of all that to which we are heirs—in hope. We turn to Hamlet as, with his friends, he swears for the third time to the ghost of his father.

> Rest, rest, perturbed spirit!
> So, gentlemen,
> With all my love I do commend me to you,
> And what so poor a man as Hamlet is
> May do t'express his love and friending to you
> God willing shall not lack. Let us go in together,
> And still your fingers on your lips I pray.
> The time is out of joint, O cursed spite,
> That ever I was born to set it right!
> Nay come, let's go together.[21]

Thus speaks Hamlet, with his companions Horatio (who "truly delivers" almost the last word in the play) and Marcellus, to set at rest his father's ghost. In friendship, we may indeed surmise—and with good reason—that our times, too, are out of joint, the world disturbed, disjointed, and fragmented. But we, I hope, as we go together, are no Hamlets. This chapter in this book of meditations has sought to discern and revive the politics of friendship within the sacred, liturgical community in the spirit of questioning and endless interpretations. For the truly transparent society defines the silencing of questions as violence, and knows and fears violence in history as always justified by metaphysical structures and adherence to ultimate truths. And our task is more, much more, important.

In *The Genealogy of Morals* (1887), Nietzsche revisits a theme that had been at the heart of Kant's thinking and that has returned to us in our own time of post-postmodernity: that is, the origin and genesis of *responsibility*. To whom, to what, am I responsible? Not to an idea, not to a creed, not even to God—not in the first instance, at least. I am responsible to you, my friend, and to the absolute demand you lay upon me. Nietzsche wrote: "Fortunately I learned in good time to divorce the theological prejudice from the moral, and no longer to seek the origin of evil *behind* the world."[22] Before we dare to embark upon reflections on the theological, let us first set things right in the celebration of the here and now. The world is indeed all *before* us in its global demands—evil always festering at the roots of power—but yet offering itself to us in all its complex potential,

which it is our task to realize. For now there is nothing else to do: to celebrate the world that is to come, though it is here already if we can but be worthy of it. And so, I conclude this chapter with the concluding, deeply religious, words of Derrida's work *The Politics of Friendship (Politiques de l'amitié)*:

> When will we be ready for an experience of freedom and equality that is capable of respectfully experiencing that friendship, which would at last be just, just beyond the law, and measured up against its measurelessness?[23]

Have I here been preaching to you? If so, then you must forgive me, my friends.

The Sacred Community and the Space of Architecture

For some chapters now we have been considering the place of art and the artist in our reflections upon the possibility of the sacred community. In the last chapter, our thoughts were more political, and, perhaps, social. We now turn to the question of space and the place of community, for even as we sing the *Sanctus* in heavenly harmonies, we are creatures whose bodies occupy a place here on earth as we stand, sit, kneel to pray. So let us begin with a meditation on infinity and eternity by Maurice Blanchot.

> But where has art led? To a time before the world, before the beginning. It has cast us out of power to begin and to end; it has turned us toward the outside where there is no intimacy, no place to rest. It has led us into the infinite migration of error. For we seek art's essence, and it lies where the nontrue admits of nothing essential. We appeal to art's sovereignty: it ruins the kingdom. It ruins the origin by returning to it the errant immensity of directionless eternity.[1]

In his book *The Space of Literature* (1955, French ed.) Blanchot proposes a radical vision of the warfare between religion and the arts, and for us especially the visual arts, after modernity: a vision far beyond the theological irresolutions of the ancient spirit of iconoclasm in the Western church or even the dark abysses of the twentieth century within which, seen with the eyes of Paul Tillich, art alone perhaps reveals.[2] Blanchot's vision is of the art that leads us

to a place and a moment before any possible theological articulation, outside the familiar comforts of time and space, to the nothing that is the end of the vision of the Kingdom. This is the antithesis of any art that submits and functions in servitude, as but the handmaid of religion, and thus invariably falls into the unendurable "petty historicity of our church-sponsored art."[3] At the same time, it is an art that longs to draw us back toward what Mircea Eliade once described as that "cosmic religiosity" that effectively vanished from the West after the cultural and political triumph of Christianity and the church following the time of Constantine. For it was actually Christianity itself, Eliade suggested, that instigated the process of the desacralization of Nature, and in its wake—

> emptied of every religious value or meaning, nature could become the "object" *par excellence* of scientific investigation. From a certain viewpoint, Western science can be called the immediate heir of Judaeo-Christianity. It was the prophets, the apostles, and their successors the missionaries who convinced the Western world that a rock (which certain people have considered to be sacred) was only a rock, that the planets and stars were only cosmic *objects*— that is to say, that they were not (and could not be) either gods or angels or demons.[4]

Admittedly, "from a certain viewpoint" this can indeed be said. For in a context of global violence, which was particularly virulent in the last century, the theory of religion and the idea of the holy or the sacred have become fields of wide debate—sociological, anthropological, phenomenological, and more—engaged in by many, from Durkheim to Otto, and of which the sense of and adherence to the idea of the sacred within the community of the church has been varied, complex, and in some cases quite non-existent.[5] At the same time, and for good and ill, the very recovery in art from the estrangement of the human condition from the divine—a demolition of the contrived distinction between the sacred and the secular that has haunted us at least from the time of the Reformation—renders the sacred itself barely recognizable, hidden not only in the matter of creation but often within forms of seeming profanity that are, perhaps, far distant from the reach of any conventional religious language.[6] The resultant dilemma for the claims of such "conventional" language becomes painfully clear in the development of modern art

from representation to abstraction and formalism and the "progressive surrender to the resistance of its medium."[7] Depth vanishes into two-dimensionality, reference into pure self-reflexivity, brush strokes become physical moments of color and texture, and the timeless essence of art, in Blanchot's words, "lies where the nontrue admits of nothing essential." And yet, in our time, this is also another beginning, the sacred here the merest trace, found only in the primordial whispered conversation between the supreme Yes and the absolute No. This reductive sublime of sacred art can strike us—as in Harris Rosenberg's description of a first experience of the paintings of the Rothko Chapel in Houston, Texas, from which we move to a function outside the painting itself in the greater scheme of the chapel—as an experience that is not simply observed but also felt: "it must hold its shape—i.e. work in itself—by stimulating and conducting eye movement up, down and across the surface, so that the painting is not merely seen but continuously and vividly experienced."[8]

It will be clear, therefore, what a dilemma is presented to contemporary Christian architecture in the Western church. For only with an almost immovable unwillingness and an unreasonably bad conscience, have churches and their congregations surrendered up the architectural distinction between "secular" and "sacred" activity, preferring to maintain, at least in Great Britain, the largely late-Victorian provision of not one but two buildings—the church and the church hall, expressive of a communal division that not only serves to maintain the lack of any sense of the unity of being in community, in an estrangement of the human from the divine, but fails even to admit the possibility of a theological articulation and liturgical embodiment of the sacred, as experienced in the spaces of contemporary art, freed from the dangers of *kitsch* and of deathly nostalgia for an outmoded theology. This is quite different from the proper and healthy sense of the past in the present. Thus, in the uncompromising words of one Roman Catholic theologian, Charles Davis, written in 1962 just prior to the Second Vatican Council: "Unfortunately, it is probably true that our weak nostalgic church architecture reflects well enough the ineffectual fossilized state of our Christian faith."[9]

Perhaps we need to be continually reminded that the first Christians had no holy shrines and that the Christian liturgy of the people

of God is not finally tied to either building or temple. The Eucharist, at the heart of the church's life, is famously described by Dom Gregory Dix, in his great book *The Shape of the Liturgy*—published in 1945 as the buildings and churches of Europe lay in ruin and devastation after the systematic bombing of the Second World War—as an action that "has been done, in every conceivable human circumstance, for every conceivable human need from infancy and before it to extreme old age and after it, from the pinnacles of earthly greatness to the refuge of fugitives in the caves and dens of the earth."[10] Properly, a church building is neither a temple nor a dwelling place for God, but a place for community, and it was actually some four centuries before the practice of dedicating buildings began, and then all that was required, according to Eusebius, Bishop of Caesarea, was the celebration of the Eucharist. The distinction between dedication and consecration, understood properly in a legal sense, was quite unknown in the early church, whose uses and theological understanding were far removed from that form of consecration articulated by Bishop Lancelot Andrewes in 1620 and not untypical in church practice to the present day. Consecration, Andrewes avowed in a prayer to God, is undertaken "to devote and dedicate [this church] for ever to thee, utterly separating it from all former uses common and profane, and wholly and only to consecrate it to the invocation of thy glorious name."[11]

It is important to look back to the New Testament itself, where the building of the Temple in Jerusalem is first dematerialized and then realized anew, in Christ himself as the "living stone" and then in the Christian community itself, which is to be "built, as living stones, into a spiritual temple."[12] Thus, any building is dependent on the nature of the community and its realization in its life, in both worship and work, of the assertion of the truth of Christian belief. It is neither the replication in wood or stone of an ecclesially ordained theological order or practice, nor is it an exclusive space in which such order is found and imposed. Rather, the building is a space that is simultaneously entirely at one with the being of the community, and a place of pure *aporia*, exposed to the unknown heart and errant immensity of all that is both known and unknown.[13]

The twentieth-century German architect Rudolf Schwarz once came close to articulating more precisely this proposal of an

architecture offering the dynamic space, or context, for the human realization in community of the divine presence:

> A meaning is stored up even in that building which is nothing more than an instrument and thus in it, too, the rapidly passing process is embedded in a lastinginess which speaks into the building from out of its remoteness.[14]

The church building is, then, an instrument, a medium into which a "lastingness" or that which is entirely without the movements of both time and space, speaks through a "process"—a passing, though unique, action or event that embraces that which was before the world and before the beginning of all things. Perhaps the sense of this is what Le Corbusier spoke of with regard to his own religious convictions and his work on the church of Notre Dame du Haut at Ronchamp (a building that Schwarz himself, incidentally, dismissed as "trash"): "I have not experienced the miracle of faith, but I have often known the miracle of ineffable space."[15] This is then, perhaps, not so much the place of faith but the space in which faith might become possible through the action of process and event within the living and worshiping community.

Rudolf Schwarz (1897–1961) was a lifelong Roman Catholic, well versed in both theology and liturgy. Dying in the year before the beginning of the Second Vatican Council, he was nevertheless deeply affected by the energies and vision of the Liturgical Movement of the twentieth century. He responded positively to the growing liturgical understanding of the church within the movement as a community that embraced the unity of laity and clergy, and he was closely associated in his formative years with Romano Guardini, whose book *Vom Geist der Liturgie* (*On the Spirit of Liturgy*) (1918) was deeply influenced by the liturgical reformers at the Benedictine monastery of Maria Laach in Germany. Guardini's focus was on contemplation, the *vita contemplativa*, more than action, the *vita activa*, and his sense of both the "playfulness" and "purposelessness" of the liturgy, although deeply theological, resonates in an oblique way with a wider sense of the sacred in contemporary art. Guardini sustains a profound sense of, indeed, both the otherness and separateness of the liturgical, and yet, crucially, its centrality to human life in its unifying of all being:

> In the still depths of man's being there is a region of calm light, and there he exercises the soul's deepest power, and sends up sacrifice to God.
>
>
>
> The altar occupies the holiest spot in the church. The church has itself been set apart from the world of human work, and the altar is elevated above the rest of the church in a spot as remote and separate as the sanctuary of the soul. . . .
>
> The two altars, the one without and the one within, belong inseparably together. The visible altar of the church is but the external representation of the altar at the centre of the human breast.[16]

Guardini's meditation on the altars seems close to the thought of Martin Heidegger on the "sacred" in poetry as that "mystery of the reserving nearness" in the work of art.[17] The closer one approaches, the deeper the mystery and reserve, until at the depth of being is found finally the purity of nonbeing.

In his design of churches, Schwarz is clearly influenced by the principles of the Liturgical Movement, but he moves through them to a point where theological thinking drives his ecclesial architecture, but in such a way that, through such meditations, space itself is resacralized and becomes the only possibility for liturgical action. Far from being governed by the imposed and external authority of the church, the Eucharist is thus rediscovered anew in every celebration of the one event, its form ever a unique discovery, a sacred journey into a desert of ever-receding horizons, and yet a return to a place of a deep familiarity.[18] In his work *The Church Incarnate*, Schwarz offers seven plans of church design, not for actual church buildings, but as visual proposals for contemplations on the nature of church space—ways of thinking and realizing symbols of place and movement. They are entitled, in turn, "the sacred inwardness," "the broken ring," "the chalice of light," "the sacred journey," "the dark chalice," "the dome of light," and "the cathedral of all times." Let us just consider one, "the sacred journey," by way of linking theory to practice, thinking about the liturgical community as it travels to its realization in the shaping of a building. Unlike his other six designs, Schwarz's sacred journey visually presents the community in serried ranks, shoulder to shoulder like a disciplined army foursquare on the march. He gives an extraordinary verbal account

of the sacred journey, thought of in terms of a church building and its ordering of our bodies and our physical being:

> Here no eye looks into another, here no man looks to his fellow—all look ahead. The warm exchange from hand to hand, the surrender from human being to human being, the circuit of heartfelt communion—all are lacking. Here, each human being stands alone within the network of the whole. . . . The bond which binds each one to the others is cool and precisely measured—actually it is only a bond of the pattern and not a bond of the heart. . . . The people cannot feel heartfelt warmth for one another since this pattern has no heart at all.[19]

Clearly looking back to the wanderings of the Israelites in the wilderness, this, at first imagining, would seem a community and a space that is both extraordinarily harsh and cold, a place of erring[20] and a community in failure. Yet how different in contemplation is this from the church of static, straightened pews, all facing forward in strained, individual, and unnatural attention to the pulpit or altar: for in Schwarz's image, it is the journey that consumes all in an iron ascetic discipline, fixed on an as yet unrealized end that is beyond time and space, a form, he says, "richer in love than we at first suppose."[21]

In such thinking, we begin with the experience and language of the sacred that is only then translated into the forms of church space and their function within the liturgy and its sacramental theology. When thinking about stillness and emptiness, Schwarz begins with the sermons of Meister Eckhart. An empty space thus becomes a place for God to fill, its emptiness absolutely necessary as a preparation for "the Guest who may come."[22] Yet Schwarz, in honesty to the twentieth rather than the fourteenth century, goes beyond even Eckhart, anticipating the thought of Jacques Derrida in its avoidance of "that ontological wager of hyperessentiality that one finds at work both in Dionysius and Meister Eckhart."[23] For in any possible realization of such space in a building, fulfillment is perpetually deferred, the actualization of the thought in the building as work of art denying the theological conclusion—the conclusion even Eckhart could not finally resist: as he says in the sermon *Quasi stella matutina*, quoted by Derrida, "But when I say that God is not being and that He is above Being, I have not denied Him being but, rather, I have exalted Being in Him."[24]

Such radical thinking in the writings of Schwarz is very far from the vast majority of writing on contemporary church architecture in the twentieth century in the West, which is, to a large extent, defined by and utterly subservient to the theology and liturgical shaping of the Liturgical Movement from its beginnings in 1832, with the refounding of the Benedictine Abbey of Solesmes, ecumenical but still finally centered upon the *Sacrosanctum Concilium*, the *Constitution on the Sacred Liturgy*, of Vatican II. Here, the liturgy's shape and theology are established under the order of the church, and the spaces in which it is celebrated and engaged with are therefore shaped and ordered accordingly. The documents of Vatican II are perfectly clear: "Regulation of the sacred liturgy depends solely on the authority of the Church, that is, on the Apostolic See and, as laws may determine, on the bishop."[25] In the spirit of the Council, the Swiss architect Justus Dahinden wrote his book *New Trends in Church Architecture* (1967), seeking to implement liturgical reform in church building and decoration. Throughout his work, Dahinden is driven by the principle expressed in Article 128 of the *Constitution on the Sacred Liturgy* concerning the "worthy and well-planned construction of sacred buildings," in the process of which "care should be taken they are suitable for the celebration of liturgical services and for the active participation of the faithful."[26] There is little freedom given that is outside the control of the church.[27]

Discussions of church architecture in the twentieth century tend, invariably, to begin with the authorized theology and performance of liturgy and worship, prompting the design of space in accordance with the theology and practice affected by the ecumenical energies of the Liturgical Movement. Thus, even a scholar as dismissive of our "weak, nostalgic church architecture" as Charles Davis (see above note 9) asserts that "to draw up a programme for a church is not easy, because *the liturgy which the building serves* is complex in structure and in meaning."[28] But historically, the argument for the church as sacred space understood as defined by the shape—subservient to the theology and practice—of the liturgy, eucharistic or otherwise, and set apart solely and specifically for this purpose, is at best weak. True, we have seen how the practice of dedicating buildings began only in the fourth century by the celebration of the Eucharist, though at the same time it was the community (as the "living stones" of a "spiritual

temple") that was shaped by the liturgy and not the building itself. Even before the end of the fourth century, the quite distinct and different role of the new basilicas as *martyria* for the deposition of the relics of the saints and martyrs, and thus centers of pilgrimage, was established. By the seventh century, former pagan temples were appropriated for Christian use by the employment of water—aspersion as a form of exorcism. In other words, the buildings themselves were, in a sense, "baptized," while in the *Gelasian Sacramentary* of the eighth century, it is the elements of the Eucharist that serve to sanctify the building, rather than the building being specifically constructed to serve for their proper celebration: "Send down the Spirit upon this wine mixed with water that, armed with a celestial defence, it may serve for the consecration of this church."[29] It is the liturgy that consecrates the church building, rather than the building being consecrated for the liturgy. And so, as J. G. Davies puts it, "the building ceases to be what it was before and up to this point; there is a kind of transubstantiation of space whereby it becomes holy—holiness being understood as a quality of being."[30]

We have returned, via the early centuries of the church, to a sense of the holy and of sacred space that is actually closer to the experience of art as suggested by Blanchot, a sense, indeed, of the theological that remains potent in a largely post-ecclesial or even post-Christian age—of theology and its articulation in word, deed, and material constructions that, for the first time in the West for almost two thousand years, finds itself outside the boundaries of the church and its order and authority. Modern Christian architecture cannot remain immune from the fascination of contemporary art after modernism with the poetics of space and a return to the mysterious and ancient terms within which even theology itself finds its beginning. It is no accident that the artists of the New York School in the middle years of the last century, above all Rothko, Pollock, and Newman, were fascinated by sacred buildings and their design and adornment, and their fascination was finally no great distance from the contemplative space of Schwarz' thought designs—spaces into which the liturgy must be thought and known, rather than being derivative of and subservient to liturgical theology and order.

Some fifteen years before the magisterial pronouncements of the Vatican Council, Jackson Pollock produced his great drip painting

entitled *Cathedral* (1947; see plate 6).[31] It is "all-over painting," an act of absolute and total immersion in art, with no beginning and no end, spreading infinitely beyond the boundaries of the canvas.[32] The painting offers us a profound and infinite space that refuses to be confined by the limits of the canvas in the "errant immensity of directionless eternity." And yet, like the great stained-glass windows of medieval Gothic cathedrals, Pollock's painting sheds light, refracts it, becomes a window to another world that we can but glimpse through it and which remains utterly beyond our understanding. More than that, it actually *is* that other world in a pure coincidence of opposites—at once pure immanence and pure transcendence in a sacramental moment and space we cannot enter and yet which is entirely present to us. Between the finite and the infinite, this is one with (and yet at the same time utterly removed from) all biblical and theological narratives. Pollock's remarkable, almost architectural lines—thickening, thinning, ending in pools of darkness and space, and making *that* space possible[33]—share an impulse with liturgy itself as fundamental acts of faith in the world. The lines are acts entirely in and for themselves, without reference, and pure sacraments, and just to look at them demands a total suspension of any articulation of belief or disbelief—a pure act, as in the Eucharist we are simply bidden to τοῦτο ποιεῖτε ("do this").[34] We are not so far here from Romano Guardini's understanding of the liturgy itself—without purpose and without even ethical implications. The difference is that while Guardini's gaze is directed toward God, our gaze on *Cathedral*, still deeply religious, is now after the acknowledgement of the death of God—and to the theology of Nietzsche's vision we will briefly return shortly in considering the work of Le Corbusier.

Paintings like *Cathedral* have been compared in American culture to the "free jazz" of Ornette Coleman, which abandons pre-arranged structural limitations and allows the musicians an absolute spontaneity—an individuality in ensemble. Only in the ensemble, or community, are we truly free to be ourselves as individuals. The result in music is "difficult" only because it is an approach to pure music, that is, improvisation is not upon any preordained or dominating "theme," but it is entirely the music itself, a pure, spontaneous, and utterly present act of creation and a total improvisation upon a ground of silence. It is, perhaps, a realization of perfect freedom in

community, for, as Coleman himself has said of his group of musicians: "The most important thing was for us to play together, all at the same time, without getting in each other's way, and also to have enough room for each player to *ad lib* alone."[35] This is, perhaps, a pure music that is the sound equivalent of Pollock's visual art. We might reflect upon the space of *Cathedral* or Coleman's music when re-visioning theological thinking and liturgical act. The space of the painting lies beneath and between the lines of the picture itself; in a sense, what is *not* there is more important than what is—what we see, and in the music what we hear, interrupting and disturbing that which is more deeply (not) seen in the visionary light beyond and within. We move from the attempt to interpret and articulate to a recognition that this is defeated by something far more profound that is still somehow within the act of language and articulation, both heard and seen.

The key question now must be how we shift from this move to its sense within the liturgical and the religious spaces within which the liturgical action is "done." The suggestions here being explored for contemporary art, beginning with Blanchot's question, "But where has art led us?" would not subscribe to the art historian Donald Kuspit's fears for the end of art after the loss of the aesthetic.[36] But they do acknowledge the profound recognition given, after its resounding proclamation by Nietzsche in *The Gay Science* (1882), and following Hegel, of the event of the death of God, which spells not at all the end of religion, or indeed of Christianity, but rather institutes a radical re-visioning that the theological tradition of the church has been deeply unwilling or unable to address or even to know. Nor is this proclamation the end of the church's liturgical practice, but in a strange way, it heralds a return to the thought of the early centuries of theological exploration, in which the slow development of church buildings was itself part of the adventure of worship, rather than a confirmation of ecclesial establishment and authority. The space of the church building becomes, then, an invitation into the mystery, a provocation to community, and a prompting to entertain an ever-new realization of the necessary impossibility of the meeting of the human and the divine, of being and nonbeing, in a sacramental moment that is touched most deeply at a moment of death—on the night that he was betrayed . . .

The theologian and art critic John Dillenberger has thus rightly insisted upon the necessary absence of "safety" in contemporary art[37] and the contrast of this with the banal or safe works of art often associated with the church. Such edginess, provocation, disruption, and deconstruction necessarily contribute to the understanding and experience of community not as that set apart and protected from the world in false isolation, but one built up both corporately and in individual freedom in the uncanny no-place that conjoins the transcendent and the immanent at the necessary moment of dissolution and reconstruction—the no-place of a profound reality and yet the place of nontouching, of the *noli me tangere*.[38] The dangers of refusing such a reality in either art or religion were expressed long ago by Paul Tillich, in terms of an estrangement:

> the estrangement of the actual human situation from the essential unity of the human with the divine, the reality of the Cross which critical realism shows in its whole empirical brutality, and which expressionism shows in its paradoxical significance. Because this is lacking even in the greatest works under the predominance of the idealistic style, it can become the other source of *Kitsch* in religious art.[39]

The sacred found in contemporary art uncompromisingly acknowledges the reality of the human situation—a genuine though often uncomfortable humanism that in one recent theological discussion has been termed a "theological humanism" that resists the opposite extremes of "overhumanization" and "hypertheism."[40] It is the church that too often falls into the latter, into hypertheism, withdrawing thereby in its almost obsessively "religious" practices and liturgies from the necessary impossibilities of the real. Devotion to too much religion, as to most things, can be a very bad thing, separating us from what is most real.

Perhaps the closest realization and instantiation of such impossibilities in twentieth-century church building, closest to the vision of art in Blanchot, is in Le Corbusier's designs for the monastery La Tourette and the Chapel of Notre Dame du Haut, Ronchamp (see plate 7). From his early reading of Nietzsche's *Thus Spoke Zarathustra* and Ernest Renan's *The Life of Jesus*, Le Corbusier identifies the architect with both Zarathustra and Jesus, leading the community of the people from chaos to the impossible Pythagorean purity of

the New Age, and, in Mark C. Taylor's words, "since the build-ing re-presents the plan, the construction *incarnates* the idea."[41] The church building itself is an incarnation, not simply a response to established and traditional liturgical practice, but a space that itself necessitates the liturgy and alone prompts and interprets the action, the origins of which are found only in a time before the world and before the beginning of all things. The space of the Eucharist thus actually emerges from the incarnation in stone of the narrative of the first eighteen verses of Saint John's Gospel, grounded in the will of God (John 1:13). The sense of this, experienced in the liturgical community, is described by Le Corbusier himself in a manner oddly resonating with Blanchot's words and looking back to Wassily Kan-dinsky's theory of color:

> At the basis of us, beyond our senses, a resonance, a sort of table of harmony begins to vibrate. Traces of indefinable, pre-existing Absolute that establishes our being. This table of harmony that vibrates in us is our criterion of harmony. This must be the axis on which man is organized in accord with nature and, probably, the universe; this axis of organization must be the same as that on which all phenomena and all objects of nature are aligned; this axis leads us to suppose a unity of gestation in the universe, to admit a unique will at the origin.[42]

It was in the Dominican monastery of La Tourette, designed by Le Corbusier, that Anselm Kiefer spent his profoundly formative period of retreat in 1966, almost, it might be said, a wilderness period before truly embarking on his vocation as an artist.[43] In its vast space and in its deep asceticism, La Tourette has been described as "one of the most haunting, numinous buildings of the twentieth century,"[44] being at once rooted in the ancient monastic tradition of worship and yet also inescapably of its own time. Le Corbusier's sacred space continues to inform the work of Kiefer in its evocation of the simul-taneous terrifying presence and equally terrifying absence of the divine, the necessary primal moment for any sense of the sacred.

As Le Corbusier seeks the "miracle of ineffable space" in his church buildings and follows Pythagoras in noting that "number is the base of all beauty,"[45] the American video artist Bill Viola has linked the great medieval European gothic cathedral with the same tradition when he writes,

> To the European mind the reverberant characteristics of the interior of the Gothic cathedral are inextricably linked with a deep sense of the sacred and tend to evoke strong associations with both the internal private space of contemplation and the larger realm of the ineffable. . . .Cathedrals such as Chartres in France, embody concepts derived from the rediscovery of the works of the ancient Greeks, particularly those of Plato and Pythagoras and their theories of the correspondence between the macrocosm and the microcosm, expressed in the language of sacred number, proportion and harmony, and that manifest themselves in the science of sound and music. These design concepts were not considered to be the work of man, or merely functions of architectural practice, but represented the divine underlying principles of the universe itself.[46]

Viola's video artwork, *The Messenger* (1996) was made specifically for installation in Durham Cathedral, its then-contemporary video technology reaching out in conversation to the massive medieval technology of the building, a space built, as it were, from the inside outward. From its place at the great west door of the church, Viola's figure slowly rising and sinking in the water, expands its presence into the space of the building, not imposing on it any established theology or Christian liturgy of baptism or initiation (as has been wrongly suggested), but growing into the place of worship as a possibility or invitation that symbolically embraces the sacred and becomes the context for a possible liturgical community.

Viola's art engages with the Christian architecture of Durham cathedral (which is itself deeply ambivalent in its expression of earthly power and divine majesty, of the secular and sacred community[47]), bringing with it not only the symbolism of the Christian tradition, but Viola's own deep sense of the religious, which is variously drawn from the mysticism and the *via negativa* of both the East and the West and the influence on him of sources as different as Jalaluddin Rumi, Chuang Tzu, Saint John of the Cross, and Meister Eckhart. All these, even those outside the Christian tradition, in a sense, the building of the cathedral "knows," and it is upon this enriched and universal spirituality that the liturgy of the church deeply feeds and thereby grows. Sacred space grows outward from the "intimate immensity"[48] of the work of art, and is not dictated to by any established theological order of liturgical

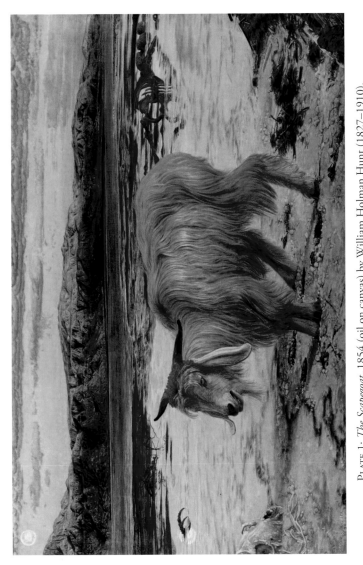

PLATE 1: *The Scapegoat*, 1854 (oil on canvas) by William Holman Hunt (1827–1910). © Lady Lever Art Gallery, National Museums Liverpool / The Bridgeman Art Library.

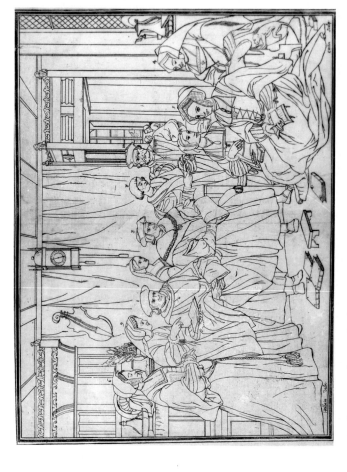

PLATE 2: *The Family of Thomas More (1478–1535), Chancellor of England*, engraved by Christian de Mechel (1737–1817) (engraving) (b/w photo) after Hans Holbein the Younger (1497/8–1543). Private Collection / The Bridgeman Art Library.

PLATE 3: Georges de La Tour, *The Repentant Magdalen*. Ailsa Mellon Bruce Fund. Image courtesy of the National Gallery of Art, Washington, D.C., ca. 1635/1640.

PLATE 4: Anselm Kiefer, *Zim Zum*. Gift of the Collectors' Committee. Image courtesy of the National Gallery of Art, Washington, D.C., 1990. ©Anselm Kiefer.

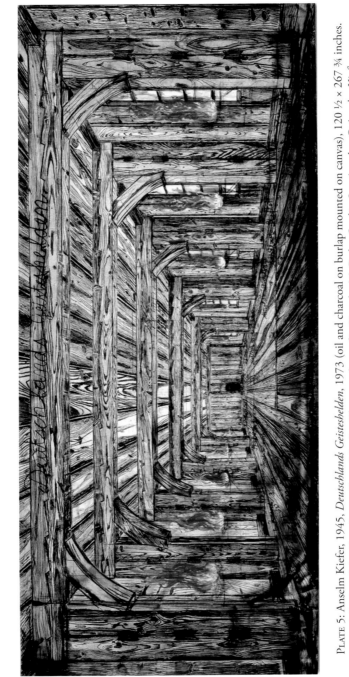

PLATE 5: Anselm Kiefer, 1945, *Deutschlands Geisteshelden*, 1973 (oil and charcoal on burlap mounted on canvas), 120 ½ × 267 ¾ inches. The Broad Art Foundation, Santa Monica. Photography credit: Douglas M. Parker Studio, Los Angeles. © Anselm Kiefer.

PLATE 6: Jackson Pollock, *Cathedral*, 1947 (enamel and aluminum paint on canvas). Image courtesy of the Dallas Museum of Art. © The Pollock-Krasner Foundation / Artists Rights Society (ARS), New York.

PLATE 7: Le Corbusier, The Chapel of the Monastery of La Tourette.
Photograph courtesy of Kellie Cole.

PLATE 8: *The Embarkation of Regulus, Ancient Carthage*, engraved by Daniel Wilson (1816–92), 1838–52 (etching) after Joseph Mallord William Turner (1775–1851). Yale Center for British Art, Paul Mellon Collection, USA / The Bridgeman Art Library.

practice. For, as Gaston Bachelard has observed, "isn't imagination alone able to enlarge indefinitely the images of immensity," and does that immensity not begin within ourselves? Prompted by the indefatigable imagination of the artist, even (and perhaps even above all) through the abstractions and deconstructions of modernity and postmodernity, such immensity, in a meeting of finite and infinite, realizes an expansion of being that too often life, and even the life of the church and its order, curbs, and caution arrests.[49]

Into such a universal immensity, the eucharistic liturgy leads us, prompted by the ineffable immensity of sacred spaces. As in Le Corbusier and others, these are by no means always spaces of comfort or repose, and they are often far removed from the nostalgia and conformity of much contemporary ecclesiastical architecture, straightened as it is by habit and a narrowed vision, even if sometimes splendidly so. Their motion is centrifugal rather than centripetal (though the two movements may be ultimately one). Gaston Bachelard draws on the mystical poetry of Oscar V. de Lubicz Milosz (1877–1939) in his meditation on the two movements of concentration and dilation and the exaltation of space beyond all frontiers: "Away with boundaries, those enemies of horizons! Let genuine distance appear!"[50] Building from the inside, finitude meets the infinite in an instant of eternity.

Has art led us to return again to Blanchot and to this impossible, sacramental instant, though rooted in history, from which alone the liturgy of the Eucharist emerges? In our present Western society, it is futile to pretend that we can re-create, even if that were desirable, the public drama of the Eucharist under the immense and broad authority of the church of medieval Christendom—and yet the artist can draw us back, even in the vast spaces of Durham Cathedral itself, to a eucharistic realization that now requires new and different exercises in the imagination for both the architect and the worshiping, celebratory community. As Philip Sheldrake has commented in his book *Spaces for the Sacred*:

> There is another side to the theology and practice of the Eucharist that moves us beyond immediate issues of the public presentation of the ritual and we often overlook this. Does eucharistic theology only allow the Eucharist to be "Church space" or do we have a theology that permits the Eucharist to be, more broadly, a space

for the world? What is really being enacted when the Eucharist is celebrated in the midst of the human city?[51]

Here, the challenge is laid down to the church, returning it again to something like its early condition without holy shrines or buildings and the paradoxical admission that "it is very important for a proper appreciation of the meaning of a church to realize that churches are not strictly necessary to Christianity. A basic trait of the Christian religion is that it is not tied to any sacred buildings."[52] And yet the importance of sacred space in which the *community*, the Body of Christ, is realized, remains within the radical, complex, and diverse contemporary context of the sense of the sacred and its explorations of the universal. Theology has offered its voice to such explorations, not so much in a great deal of the possibly necessary but finally unimaginative and often even banal writing on the church and the city, but in the broader poetic reaches of the now rather neglected work of one such as Pierre Teilhard de Chardin—a voice worthy to be heard again in our post-Heideggerian and critical age. That voice may be easy to dismiss as something approaching pantheistic self-indulgence, nevertheless de Chardin's insistence on eucharistic corporeality—*Hoc est Corpus meum*—on the final unity of the one and the many in the mystical body of the Christian community,[53] finds its echoes deep in the meditations of the contemporary continental thought of Jean-Luc Nancy, and afterward, of Jacques Derrida himself. Nancy's essay "Corpus" was a work of the early 1990s, a kind of *summa* of his previous thought on body and soul, and finally published in English with other papers in 2008:

> we're obsessed with showing a *this*, and with showing (ourselves) that *this*, here, *is* the thing we can't see or touch, either here or anywhere else—and that *this* is *that*, not just in any way, but *as its body*. The body of *that* (God, or the absolute, if you prefer)— and the fact that "that" *has a body*, or that "that" *is* a body (and so we might think that "that" is *the* body, absolutely): that's our obsession. The presentified "this" of the Absentee par excellence: incessantly, we shall have called, convoked, consecrated, policed, captured, wanted, absolutely wanted it. We shall have the assurance, the unconditional certainty of a *THIS IS: here it is*, nothing more, absolutely, here it is, here, this one, *the same thing*.

Hoc est enim . . . challenges, allays all our doubts about appearances, conferring, on the real, the true final touch of its pure Idea.[54]

Nancy's essay, and after it Derrida's response in his book *On Touching—Jean-Luc Nancy* (2000, English translation, 2005), can be read as a complex postmodern meditation from which the celebration of the Eucharist again becomes possible, necessary as an act and an utterance within at least one strand of the Western tradition. Although, predictably, neither the church nor its liturgical practice has given it any serious attention, Nancy's voice is an echo and a call from what now remains of the monotheistic spirit, minimalist perhaps, but sounding from the ground of the image and responding to Blanchot's simultaneous refusal of the "question of God" and insistence on the recovery, or the "nomination" of the unnameable, even the absent God.[55] Thus, we return, finally, to our point of departure in Blanchot's *The Space of Literature*.

How to translate this space into the space of architecture—the place of gathering for worship? Perhaps we are left, as a beginning, in the minimalism, the reductive sublime, of the Rothko Chapel in Houston, Texas. For the vision of contemporary Christian architecture, the Chapel presents immense problems and questions on numerous levels. The Rothko Chapel is indeed a spiritual sanctuary, but open to all faiths and to nonbelievers alike, without distinction, while being a venue also for many different occasions from the cultural and musical to a wide range of occasions of social concern. In 1981 and 1986, for example, it was the place for the awards given to human rights activists known as the Rothko Chapel Awards for Commitment to Truth and Freedom. Thus, it is a spiritual place very much of and in the world. Its very planning was not without incident. The original architect, Philip Johnson, working with Rothko himself and John and Dominique de Menil, withdrew from the work in 1969, and it was completed by the architects Howard Barnstone and Eugene Aubry.[56] The resultant octagonal building is based upon the design of Russian Orthodox churches (looking back, perhaps, to Kandinsky and other early avant-garde artists), while Rothko's fourteen dark panels in this, his penultimate project before his suicide in February 1970, pulsate with a tragic luminosity—stations of the cross that both prompt and dismay meditation in their

instigations and disruptions. Mark C. Taylor has written of them: "Sacred or secular . . . presence or absence . . . fullness or emptiness . . . satisfaction or deferral? It remains uncertain. Nearly a decade earlier, Rothko anticipated the uncertainty he would eventually embody in the chapel: 'If people want sacred experiences, they will find them here. If they want profane experiences, they'll find those too. I take no sides.'"[57]

Is this, perhaps, the proper place for the beginning of the worship of the Christian community, the realization of the Eucharist, *le milieu divin*? It is what the artist and the architecture grant to the community as a gift of grace: not a place of predetermination and the dissolution of the sacred and secular into one, but a place of uncertainty, in which all exists uncomfortably in unresolved tension. The tragedy for Rothko was that he did take sides and deeply desired the sacred within that tragic uncertainty, between concealment and revelation, which finally proved too much for him, even unto death. His art is at once uncompromising in its angularity and uncertain in its attachment to surface. In 1958, Rothko had commented in a lecture:

> I want to mention a marvellous book, Kierkegaard's *Fear and Trembling/Sickness unto Death*, which deals with the sacrifice of Isaac by Abraham. Abraham's act was absolutely unique. There are other examples of sacrifice. . . . But what Abraham was prepared to do was beyond understanding. There was no universal that condoned such an act. This is like the role of the artist.[58]

Those artists and architects who seek to give us church buildings cannot be exempt from this awful call. There is no universal precedent to condone their acts. For the one Eucharist that will be celebrated within their structures, the voice which is heard there is unique, unrepeatable, and without precedent. In each age, according to the vision of the sacred found there, albeit always resounding with the echoes of the past in human history, the starting place for the sacred community must be sought once again, without nostalgia and with courage for the future. The words, and even the ritual actions, may remain the same—which is why there is an echo of Rothko's words heard faintly but firmly and distinctly even in de Chardin's *Hymn of the Universe* and the liturgical documents of Vatican II, and vice versa—but always darkly, in Blanchot's "primordial Yes and No."[59] It

is that reminder that the words of the Eucharist begin with an act of betrayal and transgression—"on the night that he was betrayed"— and it is this betrayal the artist, above all, endures—seen for us most starkly in the lives and violent, self-inflicted deaths of Rothko, Vincent van Gogh, the poet Paul Celan. We continue to demand a harsh realism that alone makes possible the hope of a new dawning, and we end with the words of George Steiner at the conclusion of his book *Real Presences*:

> We also know about Sunday. To the Christian, that day signifies an intimation, both assured and precarious, both evident and beyond comprehension, of resurrection, of a justice and a love that have conquered death. If we are non-Christians or non-believers, we know of that Sunday in precisely analogous terms. We conceive of it as the day of liberation from inhumanity and servitude. We look to resolutions, be they therapeutic or political, be they social or messianic. The lineaments of that Sunday carry the name of hope (there is no word less deconstructible).[60]

As art, poetry, and theory in the last century have taught us the absolute unavoidability of the deconstructive turn, we conclude, impossibly and even perversely, with that hope that is immune to deconstruction. Where is this to be found? The builders of sacred spaces are called, repeatedly, to bring the community to a place of new birth from the ashes of the old, with eyes wide open to the contemporary, in memory of the past, and in firm and hopeful anticipation of that which is to come.

The Church and the Sacred Community in Contemporary Society

Although in the Sanctus we sing with the angels of heaven, yet we remain on earth as ones bereaved of those who have gone before us into glory.

> They are all gone into the world of light!
> And I alone sit lingring here;
> Their very memory is fair and bright
> And my sad thoughts doth clear.
>
> I see them walking in an Air of glory,
> Whose light doth trample on my days:
> My days which are at best but dull and hoary,
> Meer glimmerings and decays.[1]

In the beginning, before time itself began, God said let there be light and there was light. By the divine Word all things come into being. This divine creative word is different from any human word, for as the Lord says in Isaiah, "it shall not return unto me void, but it shall accomplish that which I please, and it shall prosper in the thing whereto I sent it" (55:11). In this Word are contained all the secrets of creation; from chaos is brought order, an order brought into being by the will of God and the distinction is made between Creator and creature.

The material is formed from the immaterial, not first in the shapes of nature, but in the distinction between light and darkness, a distinction in which the most profound and mysterious of

meanings resides. From the beginning of creation, the light shines in the darkness and the darkness has not overwhelmed or even understood it. It has not penetrated it. This mystery is most truly and perhaps only known to us in the vocation of the artist, which is at once the most sacred and the most profane of all callings. In the eyes of Vincent van Gogh in the last and greatest of his self-portraits,[2] painted in the near-madness of his final months, before his suicide in 1890, we see him, in his own words in his last letter to his brother, "risking his life" to reveal to us the deepest abyss of his eyes, which at once see everything and nothing. In the depths of van Gogh's seeing, the natural and the supernatural are one, nature and grace, and he sees with horror the moment of God's words, "Let there be light" for then, too, darkness itself is revealed. In the passion of the eyes of van Gogh, there is a meeting of all opposites and a new totality that is at once the darkness of death and a vision that is the sanctification even of darkness itself, a darkness visible and transfigured, as in Christ's passion on the cross. In such a vision, which in European art is revealed most fully in the fourteenth-century gothic art of Giotto, we see Christ portrayed as at once fully human and fully divine, a mystery proclaimed in the doctrines of theology, but finally beyond all theological understanding, except in what is seen in the eyes of the artist.

In the art of Rembrandt and van Gogh, the light shines in an absolute *depth*; in cubist and modern abstract painting it moves across the absolute *surface* of the deep. Light at once reveals and hides, for the deepest mystery and glory of God's creative word is at once known and utterly unknown. In the art of J. M. W. Turner, such absolute light both blinds and unveils, as the forms of nature are the signs of divine order and yet are consumed by the radiance of God's glory. In 1828 Turner painted the legend of Regulus, the Roman consul whose suffering Saint Augustine in *The City of God* compares to Christian martyrdom, and whose punishment was to be forced to look into the glare of the setting sun until blinded by it (see plate 8).

In Turner's work, we, the viewers of the painting, look as if we were Regulus himself, blinded by light. It is a theme taken up even more radically almost twenty years later by Turner in his late painting, *The Angel Standing in the Sun*, which draws on Revelation 19:17:

"And I saw an angel standing in the sun; and he cried with a loud voice, saying to all the fowls that fly in the midst of heaven, Come and gather yourselves together unto the supper of the great God." A contemporary reviewer in *The Spectator* for May 9, 1846, described it as a "*tour de force* that shows how nearly the gross materials of the palette can be made to emulate the source of light." (The artist as creator is thus, as it were, a mirror image of the divine creator in the beginning of all things, the one who "speaks" light into being to reveal the materials of the creation.)

In Turner's painting, the angel with raised sword emerges from a vortex of dazzling light that begins as white, gradually shading to yellow and finally red. The angel and the light are one. Around the rim of the vortex flit, indistinctly, the birds of prey of the verse in Revelation. In the foreground, and equally indistinct, are various biblical and apocryphal figures, among whom may be identified Judith holding aloft the severed head of Holofernes, and perhaps Adam and Eve lamenting the death of Abel. Like van Gogh, as he approached death, Turner saw into the very abyss that is both the beginning and the end of all things, seeing with the eyes of the artist that are at once all light and all darkness.

But who heard the voice of God as he spoke the world and all that is in it into being? Just as van Gogh and Rembrandt know most deeply the light that is within an absolute darkness, even the darkness of God, so the poet and the musician alone truly hear the word and the music within the deepest silence. Thus, the Egyptian poet Edmond Jabès can write,

> You do not go into the desert to find identity but to lose it, to lose your personality, to become anonymous. You make yourself void. You become silence. It is very hard to live with silence. The real silence is death and this is terrible. It is very hard in the desert. You must become more silent than the silence around you. And then something extraordinary happens: you hear silence speak.[3]

The voice of God, which brought all things into being through light, is also the silence that speaks. It is hard for us to hear such silence, which is the fullness of all language and from which everything and nothing emanates. But the poet, the maker in language, is absorbed in the silence that is both the beginning and the end of all speech, the silent text that is the blueprint of all creation. Such is the silence

of Elijah's still small voice in the wilderness, which is truly the voice of God (1 Kgs 19:12): a sound without sound, a wind without a stir, and that which is wholly present only as an absence. Silence, too, is at the very heart of music, as in Beethoven's extraordinary late string quartets, above all Opus 132, no. 15. For this is music Beethoven himself never actually heard, except within his inmost being, trapped in a profound physical deafness to which his conversation books and battered piano bear tragic witness. It is music also born out of the practical chaos of Beethoven's life—the all too common and familiar cares of financial worries, illness, and his concern for an errant ward and nephew. As from the chaos before creation, God brings all things into being, so from the mess and muddle of our fallen lives, lived alone and together, the artist hears the silence of God and speaks of it out of an inner silence few of us can even imagine or dare to contemplate. It is no accident that this Quartet no. 15 was written not long after Beethoven had completed his great work the *Missa Solemnis*, for which he had made a close study of liturgical music, the results of which are deeply apparent in the quartet's sublimely mystical third movement, the *Molto adagio*, which he entitled, "A convalescent's Hymn of Thanksgiving to God, in the Lydian mode."

The artist ever seeks the hymn of thanksgiving, that which in the Christian tradition (and it is a hymn present in its own way also in Islam, Judaism, and the great religions of the East) lies, as we have seen repeatedly in this book, at the heart of the Eucharist and therefore at the heart of the sacred community. And at the very heart of this hymn of thanksgiving is the silence in which we come to know, though however faintly, in the greatest of all miracles, the unknowable, the total presence of God. For, as Tom Altizer notes in *The Self-Embodiment of God*, the end of speech is but the dawn of resurrection—a present actuality that is glimpsed and heard in the sacramental enactment of the liturgy as a miraculous impossibility.[4] But this is an actuality known also to the poet—as the dying King Lear, slipping into eternity with Cordelia in his arms, speaks his version of Christ's last words from the cross, "It is finished," the five repeated "nevers," one of the most moving lines in English literature, capable of bringing a whole theatre to silence. The past is past, into it Cordelia has slipped, and for Lear there is only the vision of the future—the call to *see* and to look (as with the eyes of van Gogh):

Thou'lt come no more,
Never, never, never, never, never!
Pray you, undo this button: thank you, Sir.
Do you see this? Look on her, look, her lips,
Look there, look there![5]

Through the unseeing eyes of the aged Lear, we see into that abyss, though, as Edgar says in the play's final lines, "we that are young / Shall never see so much, nor live so long." But even we might glimpse the light and catch the word of total presence that we can never fully grasp: in the words of the poet Wallace Stevens, those "evanescent symmetries," sacraments of the harmonious whole.

The poet, the musician, and the artist are never more needed by the community that is the church than today, the church whose religion so often can become the place of what E. M. Forster describes in *A Passage to India* as "poor little talkative Christianity." We chatter, but in our idle chattering, we fail to listen and we lose the sense of true communion with one another and with God. But the artist, as the romantic poets knew full well, exists perilously on the edge of the utterly sacred and the absolutely profane, speaking the word into silence and seeing in the moment of the transfiguration of darkness into pure light—"Beware! Beware! / . . . / For he on honey-dew hath fed / And drunk the milk of Paradise."[6] Thus, to dwell poetically on earth is to live in awareness of the godhead, in the face of the nothing, that, as has been said, "grants the possibility of the presence of and the Being of the things that there are."[7] And so to dwell in this way moves finally beyond the formalities of theology and even our actual practices of worship (though it lies at the very heart of the liturgy), and it is to risk reason and even, as for van Gogh, life itself. Yet, as art above all is utterly truthful, its poetry is what tries to make music and harmony of what occurs in life. Those words are not mine, but were said by the French poet Yves Bonnefoy of his own book of poetry, which is beautifully entitled *Ce qui fut sans lumière*, and in the English translation, *In the Shadow's Light*:[8] again, the light that shines in the darkness. Now let us read and contemplate this poem by a contemporary English poet who is also a priest, David Scott—a brief poem of pure understatement and the silence that heals and enlightens, and I move deliberately from the vast to the beauty and tragedy of common, everyday experience and the pastoral. The poem is called "Parish Visit":

Going about something quite different,
begging quiet entrance
with nothing in my bag, I land
on the other side of the red painted step
hoping things will take effect.
The space in the house is ten months old
and time has not yet filled it up,
nor is the headstone carved.
He died when he was twenty
and she was practised at drawing
him back from the brink
cajoling in spoons of soup.
We make little runs at understanding
as the winter afternoon
lights up the clothes on the rack;
we make so many
the glow in the grate almost
dips below the horizon,
but does not quite go out.
It is a timely hint
and I make for the door and the dark yard,
warmed by the tea,
talking about things quite different.[9]

Scott catches perfectly in this poem the profound truth that the words of care embrace a greater silence in which it is profoundly necessary both to speak and not to speak, just as no one heard God's creative Word in the beginning, that which brought order from chaos. The poet knows, then, that the text of the poem, as with the word of pastoral care, is precisely *not* a matter of getting at some hidden meaning, but rather, as was said by Heidegger, a "letting the unsayable be not said," and a being before the salving mystery.[10] Another form of this is the knowing when to let go and to let being simply "be" before God. Perhaps the only moment of pure poetry in the writings of that most intellectual of creatures, C. S. Lewis, is on the final page of his moving meditation on his experience of the loss of his wife to death, *A Grief Observed*, a moment of transcendence in the letting be of the other:

I have come to misunderstand a little less completely what a pure intelligence might be, lean over too far. There is also, whatever it

means, the resurrection of the body. We cannot understand. The best is perhaps what we understand least.

Didn't people dispute once whether the final vision of God was more an act of intelligence or of love? That is probably another of the nonsense questions.

How wicked it would be, if we could call the dead back! She said not to me but to the chaplain, "I am at peace with God." She smiled, but not at me. *Poi si tornò all' eternal fontana.*[11]

We stand over the abyss, and even there we can smile. The poet knows what the novelist Valdimir Nabokov has called "the marvel of consciousness—that sudden window swinging open to a sunlit landscape amid the night of non-being."[12] It is that very sunlit landscape that van Gogh sees, and paints for us in the countryside around Saint-Rémy, even as he looks deeply into the night of death. In our church's liturgy, it is that strange and now familiar moment that has been with us throughout this book in so many circumstances, the moment in the Great Thanksgiving prayer when we lose ourselves in that multitude of angels and archangels and the whole church past and present, a supremely timeless moment when we, the least of all that company, dare to sing in community with them the anthem to God's glory, the *Sanctus*, even as we stand at the edge of betrayal and death itself—"on the night when he was given up to death." Thus, we shift from all eternity to the supreme moment of nonbeing in human time when Christ was given up to death.

Time and again, the poet and the artist risk everything to bring us to the brink of the mystery, inviting us to see the unseeable and to hear the word of silence as it speaks. At their most daring, artists have suffered deeply, as have the greatest of saints—Saint John of the Cross, Meister Eckhart, and all those others abused and despised, many forgotten, even by the church itself. Artists and those whom genius touches traditionally are not necessarily the best or the most sociable of people, though they may be, and even the sublime John Milton was once described as "a true poet and of the Devil's party without knowing it."[13] But that is written in a work by Milton's fellow poet William Blake entitled *The Marriage of Heaven and Hell*: and is that perhaps the true and sacred vocation of the poet, to see into the abyss in which finally heaven and hell are one and reconciled in that peace that passes all human understanding? It is very hard

for the church to look into this abyss, for, except at moments of pure transcendence in its liturgy, it is still too preoccupied with fighting, rightly and wrongly, its battles against sin, the world, and the devil. That is why it is too often easy to criticize the artist for being impractical, for inutility, for doing nothing and for failing to be useful, for, it might be said, the artist is the only one who fully believes, who dares, impossibly, to shed doubt, though perhaps at the cost of everything. Thus, the greatest artists are deeply christocentric, in their own way, and one with the creator God in their daring to be even within the creative and visionary Logos, and this is why van Gogh and Beethoven and Turner each suffered their own passions of suffering in this world. For, in the words of the so-called "Father of Canadian Poetry," Charles Sangster (1822–1893), writing of Moses, perhaps the greatest of all poets (for who knows if Moses did not in fact write the first books of the Bible as Turner thought?)—

> Here he stands
> Enthroned above the world; and with the eye
> Of full Belief looks through the smiling sky
> Into the Future, where the Sacred Lands
> Of Promise . . .
> . . . are brought nigh,
> And he beholds their beauty.[14]

But Moses himself never entered the Promised Land of Canaan—he merely beheld it from afar, from Pisgah's height: and so it is with the artist. In the eighteenth century, poetry could be described as the handmaid of religion, but nothing could be further from the truth: for creativity cannot be commissioned nor can the reproduction of appearances finally do more than replicate our theological shortcomings. Over fifty years ago, before the deep-seated rot of the institutions of our churches had taken a firm hold in the West (a process that ultimately may be profoundly liberating for religion), the American theologian Paul Tillich remarked that the "sentimental, beautifying naturalism . . . the feeble drawing, the poverty of vision, the petty historicity of our church-sponsored art is not simply unendurable, but *incredible* . . . it calls for iconoclasm."[15] Now, of course, iconoclasm, as we know, has ever been part of the Christian church, which in its early days took over the Jewish prohibition of idolatry, summed up in the Second Commandment, more or less wholesale.

And the fear of idolatry propelled the Protestant reformation of the image[16] into images as little more than illustrations of the already proclaimed theology of the church, and thus toward that poverty of vision of which Tillich speaks. The fact is that there never has been in the church what the theologian Jeremy Begbie has identified as a direct and ultimately harmonious relationship between its theology and the arts, but rather one far more edgy and more problematic, the vision of the latter always seeing further, both more darkly and more brightly than ever the necessary compulsions of the former.

But this is not to say that theology and the arts within the sacred community do not have much in common, at the very least a three-fold commonality. For in this community, both the theologian and the artist have a calling to the *prophetic*; they have a responsibility to the *sacramental*; and they understand the fundamental importance of the art of *memory*. But the theologian, it may be, carries a responsibility from which the artist is free—though his or hers may be, in the end, the far darker and heavier tragedy. For Moses, after the vision of the Pisgah height, was lost in eternity and buried in an unknown grave in the wilderness, and he did not go on to bear the burdens of settlement in the Promised Land. In Arnold Schoenberg's unfinished opera *Moses und Aron* (1932), Moses, the supreme architect of the vision of the people, finally sinks to the ground in despair in silence: "*O Wort, du Wort, das mir felt!*" ("O word, thou word, that I lack!"). But in his silence, he saw from afar the land for the people to which he had led them, and the world was all before them, though nothing there could be taken for granted. Our version of the Pisgah vision, which challenges all inherited speech and image, is perhaps described by the late Peter Fuller in his book *Images of God*, when he writes:

> Even if we have ceased to believe in God, nature can provide it [the symbolic order] for us; the answer lies not in the reproduction of appearances, but in an *imaginative perception* of natural form, in which its particularities are not denied, but grasped and transfigured.[17]

This shift from the "reproduction of appearances" to "imaginative perception" is both challenging and deeply uncomfortable, especially for those of us who would prefer to keep up appearances and pretend that things in the community of the church are as they always have

been, and that, perhaps, the repetition of ancient formularies and the imposition of established disciplines will suffice to make everything better again, to go back to what we always were.

But neither the poet nor the artist of themselves can make things better. As the First World War poet Wilfred Owen wrote, "All a poet can do today is warn. That is why the true Poets must be truthful."[18] The poet reminds us that ugliness will continue to exist despite art and despite the church, that humanity will continue to do evil despite honoring the good,[19] but yet poetry never allows us to install the unreasoning of ugliness in our institutions. In the words of one contemporary art critic: "artistic form mediates ugliness without socially and metaphysically reifying it, which allows it to give birth to beauty. Art in fact strips ugliness of the social and metaphysical overlay that obscures and sanitizes its insanity. Art does not rationalize ingrained irrationality but lets it stand forth in all its inevitability."[20] In what then can we believe, if the irrational is inevitable? But, does this not precisely describe the scandal of the cross, a supreme moment in art beyond all reason in all its ghastly ugliness and sublime beauty, supremely a new space for exploration, a space indeed for the sacred, placing us where now, perhaps, we even have little wish to be and where we have no language to interpret the mystery. Then, in this space, as in all art, we, together, have to do the impossible.

In the creative power of the word and in the power of images and music the impossible does not cease to be impossible, but can present itself to us in all its impossibility in moments of utter beauty, or awe and terror; in those moments of searing consciousness in a world in which we too often prefer to pretend, to close our eyes and not to see the ugly and disfigured. But finally, in that marvel of consciousness—that sudden window swinging open to a sunlit landscape amid the night of nonbeing—we are prompted to dare to be what we have not been, transfigured in a radical re-vision of the ethical, the aesthetic, and finally the spiritual. The poet and the artist draw us together to behold that which God saw in the beginning, and saw that it was good—the beauty in the particularities of the commonplace, the world in a grain of sand, the ever new glories of the natural and the sublime. The greatest of artists—Rembrandt, Velásquez, van Gogh, Beethoven, and Dostoevsky—draw

us to contemplate the profound beauty in the faces of those worn by age and toil and in the commonplace things we take for granted, prompting us afresh to contemplate the questions of most profound importance.

Throughout the ages of Christianity in the West, the church has been one of the greatest of patrons of the arts. But it has also too often patronized the artist in the midst of the community, whose greatest works have frequently been too edgy, too difficult, too impossible for the church to tolerate. Van Gogh stares into an abyss that even he cannot bear, suffering for his art even to death. The greatest art, poetry, and music is that which lets the unsayable be unsaid, so that silence may speak and we hear and glimpse the God whom we dare and rejoice to worship in the *Sanctus*. In the icons of Christ's face in the Eastern church, it has been said that the image of Christ is empty of His presence and full of His absence. "What could be more faithful to the Incarnation (it has been remarked), which the Greek Fathers also called *kenosis*, evacuation or emptying? To incarnate. To empty. When the Word became flesh, divinity did not fill up with matter nor did matter fill up with divinity."[21] And so, finally, we return to where we began—with the Word that links matter with divinity.

Allow me to end this last chapter on a personal note. Some years ago, I undertook a solitary retreat for some time in the deserts of West Texas.[22] It was there, in a very faint manner, that I knew for the first time what it is to be at once solitary and to be in communion with all being, and to begin to hear the words of silence, and see in nature the images beyond image that lie at the heart of all true art. I saw, perhaps, ever so faintly, with the eyes of van Gogh and heard the music in the silence of Beethoven: impossible, fearful—but it is possible if we take care enough. Then I realized what the monk Thomas Merton meant when he wrote these words, and I thought of van Gogh:

> It is only when the solitary dies and goes to heaven that he sees clearly that this possibility was already actualized in his life and he did not know it for his solitude consisted above all in the "possible" possession of God and of nothing else but God, in pure hope.[23]

To see this possibility in the world of light, and to see that it is good, is the deepest work of the artist and the artist's gift to the sacred community in the church, in a moment suspended in time, in equilibrium, in all things: "One with One, one from One, one in One and one in One in all eternity. Amen."[24]

CHAPTER 12

Afterword

In the year that king Uzziah died I saw also the Lord sitting upon a throne, high and lifted up, and his train filled the temple. Above it stood the seraphims: each one had six wings; with twain he covered his face, and with twain he covered his feet, and with twain he did fly. And one cried unto another, and said, Holy, holy, holy, is the Lord of Hosts: the whole earth is full of his glory. And the posts of the door moved at the voice of him that cried, and the house was filled with smoke. Then said I, Woe is me! for I am undone; because I am a man of unclean lips, and I dwell in the midst of a people of unclean lips: for mine eyes have seen the King, the Lord of hosts. Then flew one of the seraphims unto me, having a live coal in his hand, which he had taken with the tongs from off the altar: And he laid it upon my mouth, and said, Lo, this hath touched thy lips; and thine iniquity is taken away, and thy sin purged. Also I heard the voice of the Lord, saying, Whom shall I send, and who will go for us? Then said I, Here am I; send me. And he said, Go, and tell this people, Hear ye indeed, but understand not; and see ye indeed, but perceive not.

—Isaiah 6:1-9

Finally we return to where we began in the Introduction, to the origin of the *Sanctus* and to Isaiah's vision in the Temple in Jerusalem, which to the medieval pilgrims, in community with some of whom we have traveled, was the very center of the world. Before the heavenly throne and in God's presence, even as they sing their praises, the seraphims who are the guardians of the Temple, the bearers of

the live coal that purges away iniquity, cover their faces, and Isaiah alone sees the Lord, and before him that which the Temple represents comes alive in smoke and movement. Only Isaiah sees the glorious vision of the divine that to witness is fatal, for "no man shall see me and live" (Exod 33:20).

Yet, by the fire of the burning coal of the seraphim, Isaiah's sins are purged and burnt away, just as God had revealed himself to Moses in the burning bush, to Israel in the fires of Sinai, and to Elijah in the fire on Mount Carmel.[1] Yet the prophet's sins are forgiven not for himself alone but so that he might speak to the whole community of the people, and that by an act of obedience to the call of God. But this mission will be fruitless, it seems, for the people will not understand him and the city will be laid waste as a tree felled, except that the "holy seed," the remnant, will remain in the stump, from which new growth will spring (Isaiah 6:13).[2]

The fate of Isaiah's apparently profitless ministry spoken in the light of his vision of the worship before the throne is taken up in the Gospel of Mark in its account of Jesus' explanation of the parables to his uncomprehending disciples.

> Unto you it is given to know the mystery of the kingdom of God: but unto them that are without, all these things are done in parables: That seeing they may see, and not perceive; and hearing they may hear, and not understand; lest at any time they should be converted, and their sins should be forgiven them. (Mark 4:11-12)

This statement stands, it would appear, as a terrible barrier to readers and interpreters of the Gospel.[3] Saint Matthew in his Gospel, seems to have tried to iron out the bleak and exclusive enigma of Mark (Matt 13:15), and biblical commentators ever since have largely sought to avoid its seeming impossibility: that the words of Jesus, like those of the prophet before him, are intended to guard their secrets from our comprehension; to prevent us from understanding.

What, then, is it to "know the mystery of the kingdom of God"? In the pages of this book, we have traveled in many and distant times and places, through texts and through art, poetry, drama, and architecture, with the sacred community who celebrate the Christian Eucharist and who, together with the great prophet of Israel, Isaiah, the seraphim, and cherubim, sing the great hymn of praise both in heaven and on earth in the celebration of the Eucharist.

On one level, and it is not an unimportant one, the constitution of this community can be found in the mystery of text and narrative, wherein the human spirit reaches out in words to a "common sense" that common sense would deny, to something that is more than words themselves can say.[4] The members of this community are the inheritors of an ancient and often harsh prophetic tradition that the indomitable and often sceptical traveler in the Middle East, Gertrude Bell, found still in the wilderness of the Judaea in the early years of the twentieth century.

> Out of it strode grim prophets, menacing with doom a world of which they had neither part nor understanding; the valleys are full of the caves that held them, nay, some are peopled to this day by a race of starved and gaunt ascetics, clinging to a tradition of piety that common sense has found it hard to discredit.[5]

The literary critic Frank Kermode, writing of Mark's Gospel in his discussion of the grim "secrecy" of the gospel narrative suggests that

> Mark is a strong witness to the enigmatic and exclusive character of narrative, to its property of banishing interpreters from its secret places. He could say *hina* ["lest"—Mark 4:12], even though his ostensible purpose, as declared in the opening words of his book, was the proclamation of good news to all.[6]

Another literary critic, Brian Wicker, in his sadly neglected book *The Story-Shaped World*, suggests that it is "narratives which once again combine the empirical and the fictional in a mode of narration more complex than either of these can be by itself."[7] Within this mysterious and secretive complexity, the sacred community dares to be, for like narratives, it exists in faith and between, or rather and more precisely, within, two worlds—the actual and the imagined, earth and heaven, the immanent and the transcendent. Furthermore, its manner of being can only be known to those who, by an act of the willing suspension of disbelief,[8] can enter worlds that are simultaneously interior and universal, revealed only to the eyes of faith.

The community of which we have been writing follows in company with Isaiah, Ezekiel, and Jeremiah. It is a prophetic, a pilgrim, and a sacramental community. It is also a poetic community, singing in harmony with angels and archangels through time and space, in celebration and in oppression, at once and in friendship and

solitariness before God. In a sense, it is not a community that cares for recognition in this world—as Gertrude Bell described, with a degree of perplexity, the poor Russian pilgrims to the Holy Land in her day, followers of Egeria and Felix Fabri.

> Many die from exposure and fatigue and the unaccustomed climate; but to die in Palestine is the best of favours that the Divine hand can bestow, for their bones rest softly in the Promised Land and their souls fly straight to Paradise.[9]

As William Blake dines with Isaiah and Ezekiel in his "memorable Fancy" in *The Marriage of Heaven and Hell*, he asks the question: "Does a firm persuasion that a thing is so, make it so?" Isaiah replies: "All poets believe that it does, and in ages of imagination the firm persuasion removed mountains; but many are not capable of a firm persuasion of anything."[10] And yet the poets and the sacred community remain with us, frequently hidden and as often, as Saint Augustine knew full well, quite distinct from the public community of the church and its assemblies. In that most fabulous and riddling of texts, the *Travels of Sir John Mandeville*, to which we have returned from time to time in these pages, the attack on Western Christendom by this most pious (and most mysterious) of Christian pilgrims can take the form of the acknowledgment of the presence of the sacred community in lands that are precisely not Christian, where, as in the Isle of Bragman, the Land of Faith, folk "live a commendable life, are folk of great virtue, flying away from all sins and vices and malice, and they keep the Ten Commandments well."[11] And the fruits of such lives can usher in the presence of the divine at unexpected moments, even in the midst of the things of this world. One of Sir John Mandeville's modern admirers, Giles Milton, records how the modern visitor to Jerusalem can begin to trace the faith of those who in earlier ages placed a more literal sense upon the sacred places and the *via dolorosa* than modern scepticism and literalism might find it easy to tolerate.

> I, like most, had signed up for the tour with considerable scepticism but as we weaved our way through the narrow streets of Jerusalem I became aware that something had begun to change in our group. Despite the commotion and noise around us, we moved quietly along our slow, inevitable path—a path worn smooth by

centuries of pilgrims—and as we did so we became our own little community, cut off from the bustle just inches from our faces. Slowly, imperceptibly, a hushed silence had descended.[12]

And so the community can be found by God, as Isaiah hears the voice of the God who has found him and who calls him. In the celebration of the Eucharist in word and sacrament, the community that sings the *Sanctus* has already heard and been instructed in the words of scripture. It has made its prayers of intercession, in which all things are brought into the divine presence. It has made confession and been absolved by God (as was Isaiah through the living coal of the seraphim), and its members have made their peace in love one with another. In the Liturgy of St. John Chrysostom, which has been the principal eucharistic liturgy of the Eastern church for over a thousand years, the anaphora then begins with the priest drawing all together in the grace of Jesus Christ, the love of God the Father, and the fellowship of the Holy Spirit.

> It is fitting and right to hymn you, (to bless you, to praise you,) to give you thanks, to worship you in all places of your dominion. For you are God, ineffable, inconceivable, invisible, incomprehensible, existing always and in the same way, you and your only-begotten Son and your Holy Spirit. You brought us out of non-existence in existence; and when we had fallen, you raised us up again, and did not cease to do everything until you had brought us up to heaven, and granted us the kingdom that is to come. For all these things we give thanks to you and to your only-begotten Son and to your Holy Spirit, for all that we know and do not know, your seen and unseen benefits that have come upon us.[13]

Then the ministry of the gathered community is offered through the words of the *Sanctus*, sung by all the people.

> Holy, holy, holy, Lord God of Sabaoth; heaven and earth are full of your glory. Hosanna in the highest. Blessed is he who comes in the name of the Lord. Hosanna in the highest.

After this, the priest privately acknowledges the glory of God, known above all in the *kenosis*, the self-emptying and hiddenness that is the mystery of the incarnation which was entered into for our salvation: "for you so loved the world that you gave your only-begotten Son

that all who believe in him may not perish, but have everlasting life." In the grammar of the liturgy, it is as a result of this act of self-emptying that the sacred community of the Eucharist, like Isaiah of old, sees the glory of the Lord—the vision that prompts its endless hymn of praise.

Notes

Introduction

1 See *The Alternative Service Book, 1980. A Commentary by the Liturgical Commission* (London: CIO Publishing, 1980), 56. R. C. D. Jasper and Paul F. Bradshaw, *A Companion to the Alternative Service Book* (London: Society for Promoting Christian Knowledge, 1986) speak of the adoption of "a structure which owed much to the researches of Gregory Dix into the primitive pattern of the Eucharist in his book *The Shape of the Liturgy*, published in 1945," 172.

2 This is fundamentally what it means in the writings of, for example, St. Maximus the Confessor (580–662). Maximus also uses the term φυσική θεωρία ("natural contemplation").

3 Ian T. Ramsey, *Religious Language* (London: SCM Press, 1957), 180.

4 Philip H. Pfatteicher, *Liturgical Spirituality* (Valley Forge, Pa.: Trinity Press International, 1997), ix, xi.

5 See further, P. F. Bradshaw, "Celebration," in *The Eucharist Today: Studies on Series 3*, ed. R. C. D. Jasper (London: Society for Promoting Christian Knowledge, 1974), 133–34.

6 St. Augustine, quoted in Bradshaw, "Celebration," 136.

7 Joseph A. Jungmann, S.J., *The Mass of the Roman Rite: Its Origins and Development*, rev. and abridged ed., trans. Francis A. Brunner (New York: Benziger Brothers, 1959), 381–82. E. C. Ratcliff, "The Sanctus and the Pattern of the Early Anaphora," *Journal of Ecclesiastical History* 1 (1950): 29–36, 125–34. Jasper and Bradshaw, *Companion to the Alternative Service Book*, 216–17.

8 Jungmann, *The Mass of the Roman Rite*, 382.

9 "The Liturgy of St. Mark," in *Prayers of the Eucharist, Early and Reformed*, ed. R. C. D. Jasper and G. J. Cuming, 3rd ed. (New York: Pueblo Publishing, 1987), 64.

10 "Liturgy of St. Mark," 64.

11 Dom Gregory Dix, *The Shape of the Liturgy* (Westminster: Dacre Press, 1945), 744.

Chapter 1

1 Jean-Yves Lacoste, *Experience and the Absolute: Disputed Questions on the Humanity of Man*, trans. Mark Raftery-Skeban (New York: Fordham University Press, 2004).

2 See Maurice Blanchot, *The Space of Literature*, trans. Ann Smock (Lincoln: University of Nebraska Press, 1982). I felt acutely the truth of Blanchot's words as I sat in my temporary office in Renmin, thousands of miles from home and my own community. "The work of the writer requires that he lose everything he might construe as his own 'nature,' that he lose all character and that, ceasing to be linked to others and to himself by the decision which makes him an 'I,' he becomes the empty space where the impersonal emerges. This is a requirement which is no requirement at all, for it demands nothing; it has not content. It does not oblige anyone to do anything; it is only the air one has to breathe, the void on which one has to get a footing, daylight worn thin where the faces one loves best become invisible" 55–56.

3 See further below, chap. 9, p. 125.

4 On such an understanding of "being" in literature, see Blanchot, *The Space of Literature*. "The poem—literature—seems to be linked to a spoken word which cannot be interrupted because it does not speak; it is" 37.

5 Lacoste, *Experience and the Absolute*, 39.

6 Maurice Blanchot, *The Unavowable Community*, trans. Pierre Joris (New York: Station Hill Press, 1988), 56.

7 Plato, *Republic*, ix, 592, a.b., trans. H. D. P. Lee (Harmondsworth, U.K.: Penguin, 1955), 369.

8 See R. J. McElvey, *The New Temple: The Church in the New Testament* (Oxford: Oxford University Press, 1969), 38–39.

9 See Martin Heidegger, "Building, Dwelling, Thinking," in *Poetry, Language, Thought*, trans. Albert Hofstadter (New York: Harper & Row, 1975), 145–62. See also James C. Edwards, "Poetic Dwelling on Earth as a Mortal," in *The Plain Sense of Things: The Fate of Religion in an Age of Normal Nihilism* (University Park: Pennsylvania State University Press, 1997), 151–94.

10 Lacoste, *Experience and the Absolute*, 173.

11 Georges Bataille, quoted in the introduction to *Deconstruction in Context: Literature and Philosophy*, ed. Mark. C. Taylor (Chicago: University of Chicago Press, 1986), 1.

12 Maurice Blanchot, "How Is Literature Possible?" in *The Blanchot Reader*, ed. Michael Holland (Oxford: Blackwell, 1996), 40.

13 See, e.g., Sander van Maas, *The Reinvention of Religious Music: Oliver Messiaen's Breakthrough toward the Beyond* (New York: Fordham University Press, 2009).

14 Friedrich Hölderlin, "As on a Holiday . . .," in *Poems and Fragments*, trans. Michael Hamburger (London: Anvil Press Poetry, 1994), 399.

15 Romans 3:4. Paul's response to his question, "For what if some did not believe? Shall their unbelief make the faith of God without effect?"

16 See the art of Anselm Kiefer, chap. 8, p. 112.

17 Helen Gardner, ed., *The Faber Book of Religious Verse* (London: Faber & Faber, 1972), 56. See further chap. 4, p. 64.

18 See also chap. 2, "The Sacrificial Praise of the Eucharist," p. 27.

19 *The First and Second Prayer Books of King Edward the Sixth* (London: J. M. Dent & Sons, 1910), 225.

20 Lacoste, *Experience and the Absolute*, 191.

21 The phrase is taken from M. A. Screech, *Laughter at the Foot of the Cross* (London: Allen Lane, 1997).

22 *Francis and Clare: The Complete Works*, trans. Regis J. Armstrong and Ignatius C. Brady (New York: Paulist Press, 1982) 165–66. See also Lacoste, *Experience and the Absolute*, 193–94; David Jasper, *The Sacred Body: Asceticism in Religion, Literature, Art and Culture* (Waco, Tex.: Baylor University Press, 2009), 171–72.

23 The English translation of the title of Yves Bonnefoy's book of poems *Ce qui fut sans lumière* (1987).

24 Quoted in Timothy Rosendale, *Liturgy and Literature in the Making of Protestant England* (Cambridge: Cambridge University Press, 2007), 142.

Chapter 2

1 Isaiah 1:11-17. Terry Eagleton reads these verses as political rather than religious. "Yahweh is forever having to remind his pathologically cultic people that salvation is a political affair, not a religious one. He himself is a non-god, a god of the 'not yet,' one who signifies a social justice which has not yet arrived, and who cannot even be named for fear that he will turn into just another fetish by his compulsively idolatrous devotees. He is not to be bound to the pragmatic needs of the status quo. He will be known for what he is, so he informs his people, when they see the stranger being made welcome, the hungry filled with good

things, and the rich being sent empty away," in *After Theory* (London: Allen Lane, 2003), 175.

2 *The Lives of the Desert Fathers* (*Historia Monachorum in Aegypto*), trans. Norman Russell (Kalamazoo, Mich.: Cistercian Publications, 1980), 50.

3 For further discussion of *The Scapegoat*, see David Jasper, "The Desert in Biblical Art," in *Bible, Art, Gallery*, ed. Martin O'Kane (Sheffield, U.K.: Sheffield Phoenix Press, 2011), 54–66.

4 The fullest account remains that of Joachim Jeremias, *The Eucharistic Words of Jesus*, trans. Norman Perrin (London: SCM Press, 1966).

5 Formally known as the Egyptian Church Order, this work was established as the work of St. Hippolytus in the early years of the twentieth century. It professes to reflect "the tradition which has remained until now." See Josef A. Jungmann, S.J., *The Early Liturgy to the Time of Gregory the Great*, trans. Francis A. Brunner (London: Darton, Longman & Todd, 1960), 52–73; Bard Thompson, *Liturgies of the Western Church* (Cleveland, Ohio: Meridian Books, 1961), 13–24.

6 Tertullian satirizes the reaction of outsiders to Christian acts of "cannibalism." "No doubt [the Christian] would say, 'You must get a child still very young, who does not know what it means to die, and can smile under your knife; and bread to collect the gushing blood. . . . Come, plunge your knife into the infant . . . or, if that is someone else's job, simply stand before a human being dying before it has really lived. . . . Take the fresh young blood, saturate your bread with it, and eat freely.'" *Apology*, 8. Quoted in Elaine Pagels, *Beyond Belief: The Secret Gospel of Thomas* (London: Macmillan, 2003), 18.

7 Augustine of Hippo, *The Confessions*, trans. R. S. Pine-Coffin (Harmondsworth, U.K.: Penguin, 1961). At the beginning of his work, Augustine defines "man" as a being whose life is properly rooted in the praise of God. "The thought of you stirs him so deeply that he cannot be content unless he praises you, because you made us for yourself and our hearts find no peace until they rest in you," 21.

8 "Glory" is in Greek δόξα, with its root meaning of appearance—to appear in glory is to appear in one's true self.

9 Palladius, *The Lausiac History*, trans. Robert T. Myer (New York: Newman Press, 1964), 110. See also Michel de Certeau, *The Mystic Fable*, vol. 1, *The Sixteenth and Seventeenth Centuries*, trans. Michael B. Smith (Chicago: University of Chicago Press, 1992), 32–34; David Jasper, *The Sacred Desert: Religion, Literature, Art, and Culture* (Oxford: Blackwell, 2004), 11–12.

10 Mark 16:8.

11 "If my being is ever to be decisively attached to yours, there must first die in me not merely the monad ego but also the world: in other words

I must first pass through an agonizing phase of diminution for which no tangible compensation will be given me. That is why, pouring into my chalice the bitterness of all separations, of all limitations, and of all sterile fallings away, you then hold it out to me. 'Drink ye all of this.'" Pierre Teilhard de Chardin, *Hymn of the Universe* (London: Collins, 1965), 31.

12 See Anna Harrison, "Community among the Dead: Bernard of Clairvaux's *Sermons for the Feast of All Saints*," in *Last Things: Death and the Apocalypse in the Middle Ages*, ed. Caroline Walker Bynum and Paul Freedman (Philadephia: University of Pennsylvania Press, 2000), 191–204.

Chapter 3

1 Immanuel Kant, *Religion within the Limits of Reason Alone* (1793), trans. Theodore M. Greene and Hoyt T. Hudson (New York: Harper Torchbooks, 1960), 15.

2 Evelyn Abbott and E. D. Mansfield, *A Primer of Greek Grammar: Accidence* (London: Rivingtons, 1933), iii. From the preface by the Right Rev. John Percival.

3 James Hope Moulton, *A Grammar of New Testament Greek*, vol. 1, *Prolegomena*, 3rd ed. (Edinburgh: T&T Clark, 1908), 165.

4 C. F. D. Moule, *An Idiom-Book of New Testament Greek*, 2nd ed. (Cambridge: Cambridge University Press, 1971), 23.

5 The second edition of the *Oxford English Dictionary* (2004) remarks of the word "wistful": "with a reminiscence of wishful"; its early use was predominantly poetic.

6 Aristotle, "Poetic Truth and Historical Truth," in *On the Art of Poetry*, trans. T. S. Dorsch (Harmondsworth, U.K.: Penguin, 1965), 43–45.

7 σκανδαλισθήσεσθε is the verb used. The noun σκάνδαλον is a later form for σκανδάληθρον, thus defined in Henry George Liddell and Robert Scott, *A Greek–English Lexicon*, 5th ed. (Oxford: Clarendon, 1864), 1326.

8 Joseph Conrad, *The Heart of Darkness* (1902) (Toronto: Bantam Books, 1969), 119.

9 Paul Ricoeur, *Evil: A Challenge to Philosophy and Theology*, trans. John Bowden (London: Continuum, 2007), 38.

10 See further Douglas A. Templeton, *The New Testament as True Fiction: Literature, Literary Criticism, Aesthetics* (Sheffield: Sheffield Academic Press, 1999).

11 Fyodor Dostoevsky, "The Grand Inquisitor," in *The Brothers Karamazov* (1879–1880), vol. 1, trans. David Magarshack (Harmondsworth, U.K.: Penguin, 1958), 308.

12 Frank Kermode, *The Genesis of Secrecy: On the Interpretation of Narrative* (Cambridge, Mass.: Harvard University Press, 1979), 63 (emphases added).

13 Jacques Rancière, *The Flesh of Words: The Politics of Writing*, trans. Charlotte Mandell (Stanford: Stanford University Press, 2004), 87–89.

14 Miguel de Cervantes, *The Adventures of Don Quixote* (1604/1615), trans. J. M. Cohen (Harmondsworth, U.K.: Penguin, 1950), 27.

15 Cervantes, *Don Quixote*, 28. "Evil thoughts come from the heart." See Mark 7:15.

16 Rancière, *Flesh of Words*, 88 (emphases added).

17 The image is from E. M. Forster, *Aspects of the Novel* (Harmondsworth, U.K.: Penguin, 1962), 21–22.

18 Jorge Luis Borges, *Labyrinths: Selected Stories and Other Writings* (Harmondsworth, U.K.: Penguin, 1970), 278. Compare John 1:1: "In the beginning was the Word."

19 Stephen D. Moore, *Mark and Luke in Poststructuralist Perspective: Jesus Begins to Write* (New Haven: Yale University Press, 1992), 71.

20 James Joyce, *Finnegans Wake* (1939), (Harmondsworth, U.K.: Penguin, 2000), 54.21.

21 Quoted in Richard Ellmann, *James Joyce* (London: Oxford University Press, 1966), 546.

22 Mary Ann Tolbert, *Sowing the Gospel: Mark's World in Literary-Historical Perspective* (Minneapolis: Fortress, 1989), 282.

23 Moore, *Mark and Luke in Poststructuralist Perspective*, 70–71.

24 Timothy Hilton, *The Pre-Raphaelites* (London: Thames & Hudson, 1970), 107–8.

25 Harold Bloom, *The Western Canon: The Books and School of the Ages* (London: Macmillan, 1995), 10–11.

26 Susan Neiman, *Evil in Modern Thought: An Alternative History of Philosophy* (Princeton: Princeton University Press, 2002), 250.

27 Rancière, *Flesh of Words*, 93 (emphases added).

28 Georges Bataille, *Literature and Evil*, trans. Alastair Hamilton (London: Marion Boyers, 1985), vii.

29 The Latin of the *Apostolic Tradition* has no verb here.

30 Hippolytus, *The Apostolic Tradition*, in Jasper and Cuming, *Prayers of the Eucharist*, 34.

Chapter 4

1 Victor W. Turner, *The Ritual Process: Structure and Anti-Structure* (Harmondsworth, U.K.: Penguin, 1974), 83. See also Victor W. Turner, "Pilgrimages as Social Processes," in *Dramas, Fields, and Metaphors* (Ithaca: Cornell University Press, 1974), 166–230.

2 See Eamon Duffy, *The Stripping of the Altars: Traditional Religion in England, c. 1400–1580* (New Haven: Yale University Press, 1992), 407.

3 Thomas à Kempis, *The Imitation of Christ*, trans. Leo Sherley-Price (Harmondsworth, U.K.: Penguin, 1952), 186.

4 John Heywood, "The Play Called the Four PP," in *Medieval and Tudor Drama*, ed. John Gassner (New York, Bantam Books, 1968), 233.

5 *The Book of Margery Kempe*, ed. S. B. Meech and H. E. Allen (Early English Text Society, 1940), 79.

6 A recent and popular book on Mandeville, Giles Milton's *The Riddle and the Knight: In Search of Sir John Mandeville* (London: Sceptre,1996), concludes that he probably did exist and actually traveled to Constantinople, Cyprus, and then, by one of the pilgrim routes, to Sinai and Jerusalem.

7 C.W.R.D. Moseley, *The Travels of Sir John Mandeville* (Harmondsworth, U.K.: Penguin, 2005), 15.

8 "The place where Jesus was crucified was near the city . . ." John 19:20.

9 *Lives of the Desert Fathers*, 50.

10 Peter Brown, *The Cult of the Saints: Its Rise and Function in Latin Christianity* (Chicago: University of Chicago Press 1981), 42.

11 Prudentius, *Peristephanon*, trans. M. C. Eagan. The Fathers of the Church 7 (New York: Fathers of the Church, 1949), 11, 191–2, 199–202. Quoted in Brown, *The Cult of the Saints*, 42.

12 Brown, *The Cult of the Saints*, 93–6.

13 Ian Bradley, *The Celtic Way*, new ed. (London: Darton, Longman & Todd, 2003), 70–75.

14 *Lives of the Desert Fathers*, 50.

15 David Adam, *The Cry of the Deer* (London: Society for Promoting Christian Knowledge, 1987), 28.

16 *Sancti Columbani Opera*, ed. G. S. M. Walker (Dublin Institute for Advanced Studies, 1957), 97.

17 For Egeria, we are bound in our mortal body by the inevitability of death, yet the Christian has already entered into the path of eternal life through the waters of baptism. See also Adam G. Cooper, "Corporeality and the Christian," in *The Body in St. Maximus the Confessor: Holy Flesh, Wholly Deified* (Oxford: Oxford University Press, 2005), 206–50.

18 See further John Wilkinson, ed., *Egeria's Travels* (London: Society for Promoting Christian Knowledge, 1971), 3–88.

19 Janet Soskice, in her book *Sisters of Sinai* (London: Vintage, 2010), remarks, without any references to her sources, "Sylvia of Aquitaine, sometimes misnamed as St. Egeria, had travelled to Sinai in the early 380s. . . . Egeria followed what was clearly an already well-established physical and spiritual itinerary," 128.

20 Wilkinson, *Egeria's Travels*, 91.

21 Wilkinson, *Egeria's Travels*, 107.

22 Wilkinson, *Egeria's Travels*, 133.

23 Wilkinson, *Egeria's Travels*, 134.

24 Wilkinson, *Egeria's Travels*, 137.

25 E.g., Brown, *Cult of the Saints*; Ronald C. Finucane, *Miracles and Pilgrims: Popular Beliefs in Medieval England* (London: J. M. Dent, 1977), 25–38.

26 Wilkinson, *Egeria's Travels*, 146.

27 Their journey and sixth-century account of the monks of the desert has been recently revisited in William Dalrymple's *From the Holy Mountain* (London: Flamingo, 1997).

28 For both texts, see John Wilkinson, *Jerusalem Pilgrims before the Crusades* (Warminster: Aris & Phillips, 2002).

29 Wilkinson, *Jerusalem Pilgrims*, 131. Stories of Jesus learning his alphabet begin in the late second century *Infancy Gospel of Thomas*. See M. R. James, *The Apocryphal New Testament* (Oxford: Clarendon, 1953), 50–51.

30 In his *Catechetical Lectures* (14.5–829), Cyril of Jerusalem links the nut garden in the Song of Songs with the garden in which the risen Lord appears.

31 Wilkinson, *Jerusalem Pilgrims*, 139.

32 Wilkinson, *Jerusalem Pilgrims*, 137.

33 Wilkinson, *Jerusalem Pilgrims*, 144.

34 Wilkinson, *Jerusalem Pilgrims*, 145.

35 Wilkinson, *Jerusalem Pilgrims*, 139.

36 The modern reinventor of the game was, of course, A. A. Milne's Winnie-the-Pooh.

37 Julian of Norwich, *Revelations of Divine Love*, trans. Clifton Wolters (Harmondsworth, U.K.: Penguin, 1966), 66.

38 Wilkinson, *Jerusalem Pilgrims*, 146.

39 The monastery on Mount Sinai dates from 527, about forty years before the visit of the Piacenza pilgrim and his company. It was nearly three hundred years before it was connected with St. Catherine of Alexandria, whose body was said to have been transported by angels to Mount Sinai ca. 800.

40 Sophronius of Jerusalem, *Anacreonticon* 19, 13–36. Translation by Jeff Hunt.

41 See A. A. Anderson, *The Book of Psalms*, vol. 2, New Century Bible (London: Oliphants, 1972), 854. Anderson suggests that this psalm was sung by pilgrims of the postexilic period as they entered Jerusalem, depicting the pilgrims' joy at being able to visit their city once more.

42 Wilkinson, *Jerusalem Pilgrims*, 162n6.

43 "Labadie the Nomad," in Certeau, *Mystic Fable*, 271–93.

44 Certeau, *Mystic Fable*, 299.

45 Finucane, *Miracles and Pilgrims*, 40.

46 See further Andrew Jotischky, *Crusading and the Crusader States* (London: Pearson Longman, 2004), 259–60; Geoffrey Chaucer, *The Works of Geoffrey Chaucer*, ed. F. N. Robinson (London: Oxford University Press, 1957), 17.

47 Jotischky, *Crusading and the Crusader States*, 258.

48 H. F. M. Prescott, *Jerusalem Journey: Pilgrimage to the Holy Land in the Fifteenth Century* (London: Eyre & Spottiswoode, 1954), 115. It was only in the nineteenth century, and with a wholly different and modern sense of geography, that the site of the crucifixion and entombment of Christ was identified as outside the Damascus Gate. In 1883, General Charles Gordon (later of Khartoum fame) wrote to a friend: "You have the ordnance map of Jerusalem. Look at the shape of the contour Number 2459—Jeremiah's Grotto, near Damascus Gate. It is the shape of a skull; near it are gardens and caves, and close to it are the shambles of Jerusalem. . . . To me, this Jeremiah Grotto area was the site of the Crucifixion." Quoted in Giles Milton, *The Riddle and the Knight*, 190.

49 *Wanderings of Felix Fabri*, vol. 7, trans. A. Stewart (Palestine Pilgrims' Text Society, 1892–1897), 299.

50 Graham Jones, *Saints in the Landscape* (Stroud: Tempus Publishing, 2007), 121.

51 Prescott, *Jerusalem Journey*, 128.

52 Prescott, *Jerusalem Journey*, 129.

53 *Wanderings of Felix Fabri*, vol. 9, 86–88.

54 Hannah Arendt, *The Human Condition*, 2nd ed. (Chicago: University of Chicago Press, 1998), 240.

55 His journey is recorded in H. F. M. Prescott, *Once to Sinai: The Further Pilgrimage of Felix Fabri* (London: Eyre & Spottiswoode, 1957).

56 Prescott, *Once to Sinai*, 77.

57 Wilkinson, *Egeria's Travels*, 93.

58 Prescott, *Once to Sinai*, 86. See also *Nicolai de Marthono Liber Peregrinationis ad Loca Sancta*, ed. Leon de Grand, *Revue de l'Orient Latin*, vol. 3 (Paris: Ernest Leroux, 1895), 566–669.

59 Wilkinson, *Egeria's Travels*, 98.

60 Quoted in Prescott, *Once to Sinai*, 89.

61 Prescott, *Once to Sinai*, 89.

62 Agnes Smith Lewis and Margaret D. Gibson, *How the Codex was Found: a narrative of two visits to Sinai, from Mrs. Lewis's journals, 1892–1893* (Cambridge: Macmillan & Bowes, 1893), 3.

63 Soskice, *Sisters of Sinai*, 298–99.
64 It was, in a way, somewhat recovered in the art and spirituality of the Counter Reformation. See chap. 6.
65 Helen Gardner, ed., *The Faber Book of Religious Verse* (London: Faber & Faber, 1972), 56. See also Prescott, *Jerusalem Journey*, 117.

Chapter 5

1 Henry Littlehales, ed., *The Prymer, or, Prayer-Book of the Lay People in the Middle Ages*, vol. 1 (London: Longmans, Green, 1891), 17. The manuscript is dated about 1400.
2 "As the so-called People of the Book, Christians and Jews, along with Magians, Samaritans, and later Zoroastrians and others, were treated as minorities under the protection of Islam (*dhimmis*), believers in God." Jane I. Smith, "Islam and Christianity," in *The Oxford History of Islam*, ed. John L. Esposito (Oxford: Oxford University Press, 1999), 306.
3 This *Primer* is printed in William Maskell, ed., *Monumenta Ritualia Ecclesiae Anglicanae*, vol. 2 (London: W. Pickering, 1846), 1–178. See also G. J. Cuming, *A History of Anglican Liturgy*, 2nd ed. (London: Macmillan, 1982), 8.
4 Littlehales, *The Prymer*, vol. 2, ix–x.
5 For example, William Marshall's *A Goodly Primer in English* (1534) and John Hilsey's (Bishop of Rochester) *The Manual of Prayers* (1539), which draws on the Sarum Primer, both of which were approved of and were decidedly Lutheran in tone. See G. J. Cuming, *History of Anglican Liturgy*, 30–32.
6 P. L. Hughes and J. F. Larkin, ed., *Tudor Royal Proclamations*, no. 158, vol. 1 (New Haven: Yale University Press, 1967–1969), 231. See Eamon Duffy, *Marking the Hours* (New Haven: Yale University Press, 2006), 149.
7 Duffy, *Marking the Hours*, 33.
8 *Book of Curtesye* (1477–1478), Early English Text Society. Quoted in Littlehales, *The Prymer*, vol. 2, xvi.
9 In Cullum's *History and Antiquities of Hawsted*. Quoted in Littlehales, *The Prymer*, vol. 2, x.
10 See Duffy, *Marking the Hours*, 54–55, on private pews within parish churches. "[H]istorians disagree as to whether such structures were a sign of retreat from parish religion into elite privacy, or an assertion of presence (and power) in the parish community." Duffy firmly subscribes to the latter view.
11 Stanley Fish, "Is There a Text in This Class?" in *Is There is Text in This Class? The Authority of Interpretive Communities* (Cambridge, Mass: Harvard University Press, 1980), 303–21.

12 Jonathan Hughes, *The Religious Life of Richard III: Piety and Prayer in the North of England* (Stroud, U.K.: Sutton Publishing, 1997), 132.

13 William Shakespeare, *I Henry VI*, Act 3, Scene 6. Cf. Duffy, *Marking the Hours*, 69–80.

14 Stanley Fish, "Is There a Text in This Class?," 321.

15 Quoted in Duffy, *Marking the Hours*, 114.

16 Cuming, *History of Anglican Liturgy*, 9.

17 Duffy, *Marking the Hours*, 113–14.

18 Irena Ratushinskaya, *Pencil Letter* (Newcastle-upon-Tyne: Bloodaxe Books, 1988), 13. See also Ratushinskaya's autobiography, *Grey Is the Colour of Hope*, trans. Alyona Kojevnikov (London: Hodder & Stoughton, 1988).

19 "The Translators to the Reader," in *The Bible: Authorized King James Version*, ed. Robert Carroll and Stephen Prickett (Oxford: Oxford University Press, 1997), lvi.

20 Carroll and Prickett, "The Translators to the Reader," liii.

21 See, for example, Thomas Hobbes, "Of the Signification in Scripture of Kingdome of God," in *Leviathan*, ed. C. B. Macpherson (Harmondsworth, U.K.: Penguin, 1968), 445. See also Melvyn Bragg, *The Book of Books: The Radical Impact of the King James Bible, 1611–2011* (London: Hodder & Stoughton, 2011), 51.

22 See "W. T. unto the Reader," in *Tyndale's New Testament (1534)*, ed. David Daniell (New Haven: Yale University Press, 1989), 3–12; David Daniell, *The Bible in English: Its History and Influence* (New Haven: Yale University Press, 2003), 133–59.

23 William Tyndale, *The Obedience of a Christian Man*, ed. David Daniell (Harmondsworth, U.K.: Penguin, 2000), 24–25. See also George Steiner, *After Babel: Aspects of Language and Translation*, 2nd ed. (Oxford: Oxford University Press, 1992), 258.

24 Tyndale, *Obedience of a Christian Man*, 19.

25 C. S. Meyer, ed., *Cranmer's Selected Writings* (London: Society for Promoting Christian Knowledge, 1961), 2.

26 See Adam Nicolson, *Power and Glory: Jacobean England and the Making of the King James Bible* (London: Harper Collins, 2003), 73, 77.

27 Melvyn Bragg, *Book of Books*, 44–45.

28 William Shakespeare, *A Midsummer Night's Dream*, Act 4, Scene 1, lines 211–12. The New Shakespeare, ed. Sir Arthur Quiller-Couch and John Dover Wilson (Cambridge: Cambridge University Press, 1969), 58.

29 Meyer, *Cranmer's Selected Writings*, 90. See also David L. Frost, *The Language of Series 3*. Grove Booklet on Ministry and Worship 12 (Bramcote, U.K.: Grove Books, 1973), 5–6.

30 Helen Wilcox, ed., *The English Poems of George Herbert* (Cambridge: Cambridge University Press, 2007), 594.

31 David Martin and Peter Mullen, ed., *No Alternative: The Prayer Book Controversy* (Oxford: Blackwell, 1981). Brian Morris, ed., *Ritual Murder: Essays on Liturgical Reform* (Manchester: Carcanet Press, 1980).

32 Roger Beckwith, "Doctrine and Devotion in the Book of Common Prayer," in Martin and Mullen, *No Alternative*, 76–77.

33 David Scott, "The Book of Common Prayer 1549," in *A Quiet Gathering* (Newcastle-upon-Tyne: Bloodaxe Books, 1984), 36.

34 Quoted in the preface to David Jasper, *The Study of Literature and Religion*, 2nd ed. (London: Macmillan, 1991), xix.

35 See further "Sanctified Whingeing?" in Duffy, *Marking the Hours*, chap. 6, esp. 98–99.

36 "Love III," in Wilcox, *The English Poems of George Herbert*, 661.

37 "The H. Scriptures I," in Wilcox, *The English Poems of George Herbert*, 208.

38 "Lidger" is a term for a resident ambassador—as well as the "ledger," the book that keeps accounts straight.

39 See David Lyle Jeffrey, ed., *A Dictionary of Biblical Tradition in English Literature* (Grand Rapids: Eerdmans, 1992), 184.

40 See also Bragg, "From Shakespeare—The Bible and Literature (1)," in *Book of Books*, chap. 13. David Jasper and Stephen Prickett, ed, *The Bible and Literature: A Reader* (Oxford: Blackwell, 1999). Andrew Hass, David Jasper, and Elisabeth Jay, eds., *The Oxford Handbook of English Literature and Theology* (Oxford: Oxford University Press, 2007). A useful small anthology is Ruth Etchells, *Praying with the English Poets* (London: Society for Promoting Christian Knowledge, 1990).

41 John Hollander, "Psalms," in *Congregation: Contemporary Writers Read the Jewish Bible*, ed. David Rosenberg (San Diego: Harcourt Brace Jovanovich, 1987), 305.

42 "The Elixir," in Wilcox, *The English Poems of George Herbert*, 641.
> This is the famous stone
> That turneth all to gold:
> For that which God doth touch and own
> Cannot for lesse be told.

43 For parallel texts of the Exhortations in the 1549, 1552, and 1661 forms of Holy Communion, see F. E. Brightman, *The English Rite,* vol. 2 (London: Rivingtons, 1915), 650–681.

44 Marshall McLuhan, *The Gutenberg Galaxy: The Making of Typographic Man* (Toronto: University of Toronto Press, 1962).

45 Duffy, *Marking the Hours*, 124–27.

46 Duffy, *Marking the Hours*, 23.

Chapter 6

1 E.g., 1 Samuel 15:29; Numbers 23:19. See C. E. B. Cranfield, *The Gospel According to Saint Mark* (Cambridge: Cambridge University Press, 1972), 68.

2 *The Apostolic Tradition of Hippolytus*, trans. Burton Scott Easton (Cambridge: Cambridge University Press, 1934), 42–43.

3 *Ecclesiastical History*, 7.16. Quoted in Margaret Hebblethwaite and Kevin Donovan S.J., *The Theology of Penance* (Dublin: Mercier Press, 1979), 21–22.

4 St. Ambrose, *De Elia et Ieiunio*, 21.79. Quoted in Edward Yarnold, *The Awe Inspiring Rites of Initiation: Baptismal Homilies of the Fourth Century* (Slough, U.K.: St. Paul Publications, 1971), 14.

5 See further *"Beata Peccatrix,"* in Susan Haskins, *Mary Magdalen: Myth and Metaphor* (London: Harper Collins, 1993), 134–91.

6 Quoted in Haskins, *Mary Magdalen*, 288.

7 Jacobus de Voragine, *The Golden Legend: Readings on the Saints*, vol. 1, trans. William Granger Ryan (Princeton: Princeton University Press, 1993), 375.

8 Voragine, *The Golden Legend*, 376.

9 Voragine, *The Golden Legend*, 375.

10 Benedicta Ward, S.L.K.G., *Harlots of the Desert: A Study of Repentance in Early Monastic Sources* (Kalamazoo, Mich.: Cistercian Publications, 1987), 26. For St. Mary of Egypt, see also Jasper, *Sacred Body*, 69–80.

11 In the East, she was said to have been buried in Ephesus, and there the English St. Willibald saw her supposed tomb while on pilgrimage in the eighth century.

12 See Haskins, *Mary Magdalen*, 240.

13 See Owen Chadwick, *The Reformation* (Harmondsworth, U.K.: Penguin, 1972), 304.

14 See further Hebblethwaite and Donovan, *Theology of Penance*, 50–55.

15 B. J. Kidd, *The Counter Reformation, 1550–1600* (London: Society for Promoting Christian Knowledge, 1933), 111–13.

16 The Council of Trent, quoted in Peter Murray and Linda Murray, *The Oxford Companion to Christian Art and Architecture* (Oxford: Oxford University Press, 1996), 542.

17 St. Ignatius Loyola, *The Spiritual Exercises*, ed. Halcyon Backhouse (London: Hodder & Stoughton, 1989), 119.

18 It was as a result of this that Pius V required many of Michaelangelo's figures in the Sistine Chapel to be provided with loincloths. See also N. Pevsner, "The Counter Reformation and Mannerism," in *Studies in Art, Architecture and Design*, vol. 1 (London: Thames & Hudson, 1968).

19 See further "Baroque," in *The Oxford Companion to Art*, ed. Harold Osborne (Oxford: Clarendon, 1970), 108–9.

20 See Diane Apostolos-Cappadona, *Dictionary of Christian Art* (Cambridge: Lutterworth, 1994), 51–53, 237.

21 A. Blunt, *Art and Architecture in France. 1500–1700* (1988). Quoted in *The Oxford Companion to Western Art*, ed. Hugh Brigstocke (Oxford: Oxford University Press, 2001), 408.

22 Haskins, *Mary Magdalen*, 269–70.

23 Voragine, *The Golden Legend*, vol. 1, 381.

24 Walter M. Abbott, S.J., ed., *The Documents of Vatican II* (London: Geoffrey Chapman, 1966), 161.

25 Abbott, *Documents of Vatican II*, 158.

Chapter 7

1 Gillian Beer, *Darwin's Plots* (London: Routledge & Kegan Paul, 1983), 3.

2 S. T. Coleridge, *Biographia Literaria* (1817), vol. 7 of *The Collected Works*, part 1, ed. James Engell and W. Jackson Bate (Princeton: Princeton University Press, 1983), 304.

3 S. T. Coleridge, "Kubla Khan" (1798), in *Poetical Works*, ed. Ernest Hartley Coleridge (Oxford: Oxford University Press, 1969), 298.

4 William Blake, "The Marriage of Heaven and Hell" (c. 1790–1793), in *Complete Writings*, ed. Geoffrey Keynes (Oxford: Oxford University Press, 1966), 150.

5 Blake, "A memorable Fancy," in *Complete Writings*, 153.

6 Novalis, "Studies in the Visual Arts." Quoted in *German Aesthetic and Literary Criticism: The Romantic Ironists and Goethe*, ed. Kathleen Wheeler (Cambridge: Cambridge University Press, 1984), 14.

7 See, e.g., George Pattison, *Art, Modernity and Faith: Restoring the Image* (London: Macmillan, 1991), 10–11.

8 Martin Heidegger, "Letter on Humanism," reprinted in *From Modernism to Postmodernism: An Anthology*, ed. Lawrence Cahoone (Oxford: Blackwell, 1996), 276. Written as a response to a letter from a young philosopher, Heidegger's letter argues for the abandonment of traditional forms of philosophical thinking and for a humanism that "would make man the 'shepherd' of Being rather than its engineer or overseer" 274.

9 See Martin Heidegger, *What Is Called Thinking?* trans. J. Glenn Gray (New York: Harper & Row, 1968).

10 Quoted in Timothy Clark, *Martin Heidegger* (London: Routledge, 2002), 118. *Gelassenheit* is a term used in the fourteenth century by the mystic Meister Eckhart, and taken up by Heidegger, sometimes

translated as "releasement." See Robert Detweiler, *Breaking the Fall: Religious Readings of Contemporary Fiction* (San Francisco, Harper & Row, 1989), 35–36.

11 Martin Heidegger, *Elucidations of Hölderlin's Poetry*, trans. Keith Hoeller (New York: Humanity Books, 2000).

12 Friedrich Hölderlin, *Poems and Fragments*, trans. Michael Hamburger (London: Anvil, 1994), 423.

13 Julien Benda, *The Treason of the Intellectuals*, trans. Richard Aldington (New Brunswick, N.J.: Transaction Publishers, 2009), 43–44 (emphases added). The gender-specific language of the original has been retained.

14 S. T. Coleridge, as quoted in the introduction to the Dent edition of *On the Constitution of the Church and State* (1830), ed. John Barrell (London: J. M. Dent, 1972), ix.

15 Owen Chadwick, *The Secularization of the European Mind in the Nineteenth Century* (Cambridge: Cambridge University Press, 1975), 16.

16 Ben Knights, *The Idea of the Clerisy in the Nineteenth Century* (Cambridge: Cambridge University Press, 1978), 20.

17 Wilfred Owen, preface to *War Poems*, ed. C. Day Lewis (London: Chatto & Windus, 1963), 31 (emphases added).

18 Iris Murdoch, the Romanes Lecture, 1976, in *The Fire and the Sun: Why Plato Banished the Artists* (Oxford: Oxford University Press, 1977), 88.

19 St. Augustine, *The City of God*, trans. Henry Bettenson (Harmondsworth, U.K.: Penguin, 1972) 462. See also Pattison, *Art, Modernity and Faith*, 14–15.

20 St. Augustine, *Confessions*, 231–32.

21 Jasper, *Sacred Body*, xii.

22 Arthur C. Danto, *The Abuse of Beauty: Aesthetics and the Concept of Art* (Chicago: Open Court, 2003), 148.

23 Tina Beattie, *The New Atheists: The Twilight of Reason and the War in Religion* (London: Darton, Longman & Todd, 2007), 163.

24 Matthew Arnold, *The Poems of Matthew Arnold, 1849–1867*, Oxford World Classics (Oxford: Oxford University Press, 1924), 260.

25 *Lives of the Desert Fathers*, 50.

26 I refer, of course, to the final lines of "Dover Beach":

> And we are here as on a darkling plain
> Swept with confused alarms of struggle and flight,
> Where ignorant armies clash by night.

Arnold, *The Poems*, 368.

27 "Without contraries there is no progression. Attraction and Repulsion, Reason and Energy, Love and Hate, are necessary to Human existence." Blake, *Complete Writings*, 149. One thinks again of Benda—of the performance of evil and the honoring of good.

28 *Lives of the Desert Fathers*, 50.

29 See Knights, *Idea of the Clerisy*, 43.

30 S. T. Coleridge, *The Collected Letters*, vol. IV, ed. E. L. Griggs (Oxford: Clarendon, 1956–1971), 688.

31 S. T. Coleridge, *Lay Sermons*, vol. 6 in *The Collected Works*, ed. R. J. White (Princeton: Princeton University Press, 1972), 30.

32 See Martin Heidegger, "Being, Dwelling, Thinking," in *Basic Writings*, ed. David Farrell Krell, rev. ed. (London: Routledge, 1993), 344–63.

33 Edwards, *Plain Sense of Things*, 184. See also Jasper, *Sacred Body*, xiii.

34 Julien Benda, *Treason of the Intellectuals*, 43.

35 See further Clark, *Martin Heidegger*, 120.

36 "The best in this kind are but shadows; and the worst are no worse, if imagination amend them." William Shakespeare, *A Midsummer Night's Dream*, Act 5, Scene 1, lines 211–12. The New Shakespeare, 67.

37 Coleridge, *Biographia Literaria*, part 2, 6.

38 "Isolation," in Arnold, *The Poems*, 121.

39 Coleridge, *Biographia Literaria*, part 2, 16.

40 McLuhan, *Gutenberg Galaxy*, 14.

41 McLuhan, *Gutenberg Galaxy*, 15.

42 William Shakespeare, *King Lear*, Act 5, Scene 3, lines 16–26. *The Arden Shakespeare*, ed. Kenneth Muir (London: Methuen, 1972), 188–89.

43 Shakespeare, *King Lear*, Act 5, Scene 3, lines 322–25. *The Arden Shakespeare*, 206.

44 Blanchot, *Space of Literature*, 57.

45 Terry Eagleton, *On Evil* (New Haven: Yale University Press, 2010), 15.

46 "Religion and Literature" (1935), in T. S. Eliot, *Selected Essays*, 3rd ed. (London: Faber & Faber, 1951), 388.

47 See further David E. Klemm and William Schweiker, *Religion and the Human Future: An Essay on Theological Humanism* (Oxford: Blackwell, 2008).

48 J. G. Ballard, *Low-Flying Aircraft and Other Stories* (London: Triad/Panther, 1978), 136–47.

49 Ballard, *Low-Flying Aircraft*, 147.

50 Thomas J. J. Altizer, *The Self-Embodiment of God* (New York: Harper & Row, 1977), 96.

Chapter 8

1 Andrea Lauterwein, *Anselm Kiefer/Paul Celan: Myth, Mourning and Memory* (London: Thames & Hudson, 2007), 20–21.

2 Edith Wyschogrod, "Hasidism, Hellenism, and Holocaust: A Postmodern View." Unpublished paper quoted in Mark C. Taylor, *Disfiguring:*

Art, Architecture and Religion (Chicago: University of Chicago Press, 1992), 299.

3 Anselm Kiefer, *Heaven and Earth*. Organized by Michael Auping (Fort Worth: Modern Art Museum of Fort Worth, 2006), 171.

4 See Kevin Hart, *The Dark Gaze: Maurice Blanchot and the Sacred* (Chicago: University of Chicago Press, 2004), 1–2. See also Georges Poulet, *The Metamorphoses of the Circle*, trans. Carley Dawson and Elliott Coleman (Baltimore, Md.: Johns Hopkins University Press, 1966), xi.

5 Paul Celan, "Psalm," in *Selected Poems*, trans. Michael Hamburger (Harmondsworth, U.K.: Penguin, 1990), 174–75.

6 See Hart, *Dark Gaze*, 7. See also, Maurice Blanchot, "Interruption (as on a Riemann surface)," in *The Infinite Conversation*, trans. Susan Hanson (Minneapolis: University of Minnesota Press, 1993), 106–12.

7 Blanchot, *Space of Literature*, 83.

8 The paintings are entitled *Your Blond Hair, Margarete* (1981), *Your Ashen Hair, Shulamite* (1981), *Your Golden Hair, Margarete* (1981), and *Shulamite* (1983).

9 Jacques Derrida, "Shibboleth," in *Midrash and Literature*, ed. Geoffrey Hartman and Sanford Budick (New Haven: Yale University Press, 1986), 334.

10 Quoted in Steven Madoff, "Anselm Kiefer: A Call to Memory," *ArtNews* 86, no. 8 (1987): 128.

11 Jacques Derrida, *Memoires for Paul de Man*, trans. Cecile Lindsay, Jonathan Culler, and Eduardo Cadava (New York: Columbia University Press, 1986), 67, 71.

12 "Illegibility," in Celan, *Selected Poems*, 320–21. Celan's brief poem ends with the words:

> *Du, in dein Tiefstes geklemmt,*
> *entsteigst dir*
> *für immer.*

> (You, clamped
> into your deepest part,
> climb out of yourself
> for ever.)

See also, Harold Bloom, *Kabbalah and Criticism* (New York: Continuum, 1993).

13 Kiefer, *Heaven and Earth*, 134.

14 See Kiefer, *Heaven and Earth*, 118.

15 François Mauriac, foreword to Elie Wiesel, *Night* (Harmondsworth, U.K.: Penguin, 1981), 10.

16 Imre Kertész, *Fateless*, trans. Tim Wilkinson (London, Vintage Books, 2006), 262.

17 See also Lauterwein, *Myth, Mourning and Memory*, 40–43.

18 "Your Logic Frightens Me, Mandela," in Wole Soyinka, *Mandela's Earth and Other Poems* (London: Methuen, 1990), 3.

19 "Like Rudolf Hess, the Man Said!" in Soyinka, *Mandela's Earth*, 6.

20 Wiesel, *Night*, 77.

21 "Like Rudolf Hess, the Man Said!" in Soyinka, *Mandela's Earth*, 6–7.

22 Mo Yan, "The Awakened Dream Teller: Random Thoughts on Yu Hua and His Fiction," in *Yu Hua 2000 Collection: Contemporary China Literature Reader* (Hong Kong: Ming Pao, 1999), 1.

23 Yu Hua, *To Live*, trans. Michael Berry (New York: Anchor Books, 2003), 235. Typically, in the film version, the ending is much softened for the wider cinema audience.

24 Xia Kejun, *Painting of Remnant Image*, trans. Cen Yixuan (Beijing, 2009), 26.

25 Blanchot, *Space of Literature*, 83.

26 See Lin Ci, *Chinese Painting: Capturing the Spirit of Nature with Brushes*, trans. Yan Xinjian and Ni Yanshuo (Beijing: China Intercontinental Press, 2010), 7.

27 Ding Fang, quoted in David Jasper, "The Spiritual in Contemporary Art," *Art and Christianity* 65 (2011): 6.

28 See, *Ding Fang's Pictucre* [*sic*] *Album* (Beijing: Oriental Light Art Development, 1994); *Ding Fang* (Hubei: Hubei Fine Arts Publishing House, 2007); *Ding Fang. Twenty Artists of Chinese Oil Painting* (2004). (All these texts are published in Chinese.)

29 See Lin Ci, *Chinese Painting*, 104–7.

30 Lao Tzu, *Tao Te Ching*, trans. D. C. Lau (Harmondsworth, U.K.: Penguin, 2009), 3.

Chapter 9

1 Santiago Zabala, "Gianni Vattimo and Weak Philosophy," in *Weakening Philosophy: Essays in Honour of Gianni Vattimo*, ed. Santiago Zabala (Montreal: McGill-Queen's University Press, 2007), 28.

2 Jacques Derrida, *The Politics of Friendship*, trans. George Collins (London: Verso, 2005).

3 Santiago Zabala, *The Remains of Being: Hermeneutic Ontology after Metaphysics* (New York: Columbia University Press, 2009), 2.

4 Gianni Vattimo, "The Age of Interpretation," in Richard Rorty and Gianni Vattimo, *The Future of Religion*, ed. Santiago Zabala (New York: Columbia University Press, 2004), 43.

5 See "The Parable of the Grand Inquisitor," in Dostoevsky, *The Brothers*

Karamazov (1880), trans David Magarshack (Harmondsworth, UK: Penquin, 1958), 1:288–311.

6 John Milton, *Paradise Lost* (1667), book XII, lines 646–49. *Poetical Works*, ed. Douglas Bush (London: Oxford University Press, 1966), 459.

7 See also David Daiches, *God and the Poets* (Oxford: Clarendon, 1984). As the pair leave Eden at the end of the poem, solitary yet hand in hand "such is the mixed texture of our experience; such are the difficulties, contradictions, challenges, and rewards that await purposive man in the world. It is not the effortless peace of the Garden of Eden. It is something more interesting and more testing" (49).

6 The phrase is, of course, Paul Tillich's.

9 Detweiler, *Breaking the Fall*, 35.

10 Paul Ricoeur, *Oneself as Another*, trans. Kathleen Blamey (Chicago: University of Chicago Press, 1992). The deeply theological foundations of Ricoeur's argument in this book are rooted in a necessary and self-conscious hiddenness and withdrawal from the theological. "I have presented to my readers arguments alone, which do not assume any commitment from the reader to reject, accept, or suspend anything with regard to biblical faith. It will be observed that this asceticism of the argument . . . leads to a type of philosophy from which the actual mention of God is absent and in which the question of God, as a philosophical question, itself remains in a suspension that could be called agnostic . . ." (24).

11 St. Augustine, *Confessions*, 273.

12 See further "Virtue: A Short History," in Warner Berthoff, *Literature and the Continuances of Virtue* (Princeton: Princeton University Press, 1986), 45–88.

13 Gianni Vattimo, *After Christianity*, trans. Luca D'Isanto (New York: Columbia University Press, 2002), 38.

14 See Introduction, p. 5.

15 Richard Rorty, *Objectivity, Relativism, and Truth*, Philosophical Papers, vol. 1 (Cambridge: Cambridge University Press, 1991), 1.

16 Of *anamnesis*, W. Jardine Grisbrooke writes, "A Greek word expressing a Semitic concept . . . all but untranslatable into English. Memorial, commemoration, remembrance—all these suggest that the person or deed commemorated is past and absent, whereas anamnesis signifies exactly the opposite: it is an objective act, in and by which the person or event commemorated is actually made present, is brought into the realm of the here and now." "Anaphora," in J. G. Davies, *A New Dictionary of Liturgy and Worship* (London: SCM Press, 1986), 18.

17 St. Augustine, *Confessions*, 21.

18 See Jacques Derrida's discussion of this "looseness" in his essay "How

to Avoid Speaking: Denials," in *Languages of the Unsayable: The Play of Negativity in Literature and Literary Theory*, ed. Sanford Budick and Wolfgang Iser (New York: Columbia University Press, 1989), 3–70.

19 See further, by another friend with whom at least one should discuss and argue, Don Cupitt, *Taking Leave of God* (London: SCM Press, 1980).

20 See Jacques Derrida, *The Work of Mourning*, ed. Pascale-Anne Brault and Michael Naas (Chicago: University of Chicago Press, 2001); idem, *Specters of Marx: The State of the Debt, the Work of Mourning, and the New International*, trans. Peggy Kamuf (New York: Routledge, 1994).

21 William Shakespeare, *Hamlet*, Act 1, Scene 5, lines 182–90. *The New Shakespeare*, ed. John Dover Wilson (Cambridge: Cambridge University Press, 1971), 33.

22 Friedrich Nietzsche, *The Genealogy of Morals*, trans. Francis Golffing (New York: Doubleday Anchor Books, 1956), 151.

23 Derrida, *Politics of Friendship*, 306.

Chapter 10

1 Blanchot, *Space of Literature*, 244.

2 See George Pattison, *Crucifixions and Resurrections of the Image: Christian Reflections on Art and Modernity* (London: SCM Press, 2009), 2.

3 See Paul Tillich, "Art and Ultimate Reality," in *Art, Creativity and the Sacred: An Anthology in Religion and Art*, ed. Diane Apostolos-Cappadona (New York: Continuum, 1995), 219–35.

4 Mircea Eliade, "The Sacred and the Modern Artist," in Apostolos-Cappadona, *Art, Creativity and the Sacred*, 182. Compare this with the political arguments relating to Christianity and the European Union in the previous chapter.

5 See, e.g., Emile Durkheim, *The Elementary Forms of the Religious Life*, 2nd ed., trans. Joseph Ward Swain (London: George Allen & Unwin, 1976); Georges Bataille, *Theory of Religion*, trans. Robert Hurley (New York: Zone Books, 1989); Rudolf Otto, *The Idea of the Holy*, trans. John W. Harvey, 2nd ed. (Oxford: Oxford University Press, 1958); René Girard, *Violence and the Sacred*, trans. Patrick Gregory (Baltimore, Md.: John Hopkins University Press, 1977).

6 It has been suggested that this "recovery" of the divine in art extends even to opera, as it developed a concern for biblical and religious themes in the twentieth century in composers as diverse as Schoenberg, Poulenc, and Taverner.

7 Clement Greenberg, "Towards a Newer Laocoon," in *Pollock and After: The Critical Debate*, ed. Francis Frascina (New York: Harper & Row, 1985), 43. See also Taylor, *Disfiguring*, 3–4.

8 Quoted in Walter Hopps, "The Rothko Chapel," in *The Menil Collection: A Selection from the Paleolithic to the Modern Era*, newly updated ed. (New York: Harry N. Adams, 1997), 314.

9 Charles Davis, "Church Architecture and the Liturgy," in *Towards a Church Architecture*, ed. Peter Hammond (London: Architectural Press, 1962), 115.

10 Dix, *Shape of the Liturgy*, 744.

11 Quoted in J. G. Davies, *The Secular Use of Church Buildings* (London: SCM Press, 1968), 249.

12 1 Peter 2:5. Also Ephesians 2:20ff.

13 See also, Gilbert Cope, "Function and Symbolism in Church Buildings," in *Christianity and the Visual Arts*, ed. Gilbert Cope (London: Faith Press, 1964), 77–88.

14 Rudolf Schwarz, *Vom Bau der Kirche* [*The Church Incarnate*] (Chicago: Regnery, 1938), quoted in Cope, "Function and Symbolism in Church Buildings," 77.

15 Quoted in William J. R. Curtis, *Le Corbusier: Ideas and Forms* (New York: Rizzoli, 1986), 178–79. See also Richard Kieckhefer, *Theology in Stone: Church Architecture from Byzantium to Berkeley* (Oxford: Oxford University Press, 2004), 229ff.

16 Romano Guardini, *Sacred Signs*, rev. ed., trans. Grace Branham (Wilmington: Michael Glazer, 1979), 73–75.

17 Heidegger, *Elucidations of Hölderlin's Poetry*, 43, 47.

18 Rudolf Schwarz, *Vom Bau der Kirche*, 132–33.

19 Rudolf Schwarz, *Vom Bau der Kirche*, 116.

20 The term is deliberately drawn from Mark C. Taylor, *Erring: A Postmodern A/theology* (Chicago: University of Chicago Press, 1984).

21 Rudolf Schwarz, *Vom Bau der Kirche*, 119, 135.

22 Rudolf Schwarz, "The Eucharistic Building," trans. V. Hoecke, *Faith and Form* 2 (1969), 21.

23 Derrida, "How to Avoid Speaking: Denials," 8.

24 Derrida, "How to Avoid Speaking: Denials," 8.

25 *Sacrosanctum Concilium*, in ed. Walter M. Abbott, S.J., *Documents of Vatican II*, 146.

26 *Sacrosanctum Concilium*, 176; and Justus Dahinden, *New Trends in Church Architecture*, trans. Brother Cajetan (London: Studio Vista, 1967), 58–59.

27 Some slight freedom is given to art in Article 126: "When passing judgment on works of art, local ordinaries must listen to the opinions of the Diocesan Commission on Sacred Art and—in those instances which call for it—also to those of others who are specially expert." In his commentary on this, Donal O'Sullivan, S.J., very cautiously

observes: "Amongst the 'specially expert' may we not legitimately hope to find those whose lives are dedicated to art?" "Sacred Art," in *Vatican II: The Liturgy Constitution*, ed. Austin Flannery, O.P. (Dublin: Scepter Publishers, 1964), 80.

28 Davis, "Church Architecture and the Liturgy," 108 (emphases added). There is also the volume edited by Gilbert Cope, which gives itself away in its title, *Making the Building Serve the Liturgy* (London: A. R. Mowbray, 1962).

29 H. A. Wilson, ed., *The Gelasian Sacramentary* (Oxford: Clarendon, 1894), 285.

30 Davies, *Secular Use of Church Buildings*, 253.

31 The following discussion is largely drawn from my earlier work, *The Sacred Desert*, 119–21.

32 See Irving Sandler, *The Triumph of American Painting: A History of Abstract Expressionism* (New York: Harper & Row, 1970), 110–11.

33 Frank O'Hara notes Pollock's "amazing ability to quicken a line by thinning it, to slow it by flooding, to elaborate that simplest of elements, the line, to change, to reinvigorate." Quoted in *Modern Art: Impressionism to Post-Modernism*, ed. David Britt (London: Thames & Hudson, 1989), 265. Pollock's art reduces all to a minimum, and then explores that condition in all its extraordinary complexity.

34 1 Corinthians 11:24.

35 Ornette Coleman, from notes to the LP *Free Jazz* (Atlantic SD 1364, 1961).

36 Donald Kuspit, *The End of Art* (Cambridge: Cambridge University Press, 2004).

37 John Dillenberger, "Artists and Church Commissions: Rubin's *The Church at Assy* Revisited," in Apostolos-Cappadona, *Art, Creativity, and the Sacred*, 193–95.

38 John 20:17: "Jesus saith unto her, Touch me not, for I am not yet ascended to my Father."

39 Tillich, "Art and Ultimate Reality," 234–35.

40 On these terms, which are not my own, see further Klemm and Schweiker, *Religion and the Human Future*.

41 Taylor, *Disfiguring*, 109.

42 Le Corbusier, quoted in Taylor, *Disfiguring*, 109.

43 See above pp. 111–17.

44 Jonathan Glancey, "Divine Inspiration," *The Guardian*, January 14, 2002.

45 Charles Edouard Jeanneret and Amédée Ozenfant, *Après le cubisme* (Torino: Bottega d'Erasmo, 1975), 28.

46 Bill Viola, *Reasons for Knocking at an Empty House: Writings, 1973–1994*

(London: Thames & Hudson, 1995), 154–55. See also David Jasper, "Screening Angels," in *The Art of Bill Viola*, ed. Chris Townsend (London: Thames & Hudson, 2004), 181–95.

47 Sir Walter Scott famously described Durham Cathedral as "half Church of God, half fortress 'gainst the Scot."

48 Gaston Bachelard, *The Poetics of Space*, trans. Maria Jolas (Boston: Beacon Press, 1994), 183–210.

49 See Bachelard, *Poetics of Space*, 184.

50 Oscar V. de Lubicz Milosz, *L'amoureuse initiation*. Quoted in Bachelard, *Poetics of Space*, 189–90.

51 Philip Sheldrake, *Spaces for the Sacred: Place, Memory and Identity* (London: SCM Press, 2001), 169–70.

52 Davis, "Church Architecture and the Liturgy," 113.

53 Pierre Teilhard de Chardin, *Le Milieu Divin: An Essay on the Interior Life* (London: Fontana Books, 1964), 143

54 Jean-Luc Nancy, *Corpus*, trans. Richard A. Rand (New York: Fordham University Press, 2008), 3–5.

55 Jean-Luc Nancy, *Dis-Enclosure: The Deconstruction of Christianity*, trans. Bettina Bergo, Gabriel Malenfant, and Michel B. Smith (New York: Fordham University Press, 2008), 85–88; "The Name *God* in Blanchot," in Jean-Luc Nancy, *The Ground of the Image*, trans. Jeff Fort (New York: Fordham University Press, 2005).

56 See Walter Hopps, in *Menil Collection*, 314.

57 Taylor, *Disfiguring*, 94.

58 Quoted in Anna C. Chave, *Mark Rothko: Subjects in Abstraction* (New Haven: Yale University Press, 1989), 197.

59 Blanchot, *Space of Literature*, 244.

60 George Steiner, *Real Presences* (London: Faber & Faber, 1989), 232.

Chapter 11

1 Henry Vaughan, "They are all gone into the world of light!" from *Silex Scintillans, or Sacred Poems and Private Ejaculations* (1650), in *Poetry and Selected Prose of Henry Vaughan*, ed. L. C. Martin (London: Oxford University Press, 1963), 318.

2 For a fuller discussion of this painting, see Jasper, *Sacred Body*, 101–3.

3 I have never been able to trace the original source of this quotation. I discovered it printed on a conference programme in the context of a discussion of Meister Eckhart.

4 Altizer, *Self-Embodiment of God*, 96.

5 William Shakespeare, *King Lear*, Act 5, Scene III, lines 306–10 (emphasis added). The Arden Shakespeare, 205.

6 "Kubla Khan," in Coleridge, *Poetical Works*, 298.

7 Edwards, *Plain Sense of Things*, 184.

8 Yves Bonnefoy, *In the Shadow's Light*, trans. John Naughton (Chicago: University of Chicago Press, 1991). The original French publication was 1987.

9 Scott, *A Quiet Gathering*, 77.

10 See Clark, *Martin Heidegger*, 118.

11 C. S. Lewis, *A Grief Observed* (London: Faber & Faber, 1961), 63–64.

12 See Jasper, *Sacred Body*, 1–13.

13 Blake, *Complete Writings*, 150.

14 Charles Sangster, "Faith," in "*The St. Lawrence and the Saguenay*": *And Other Poems* (New York: John Creighton & John Duff, 1856), 216. See George P. Landow, *Victorian Types, Victorian Shadows: Biblical Typology in Victorian Literature, Art and Thought* (Boston: Routledge & Kegan Paul, 1980), 204.

15 Paul Tillich, *Theology of Culture* (Oxford: Oxford University Press, 1959), 74. See also Graham Howes, *The Art of the Sacred: An Introduction to the Aesthetics of Art and Belief* (London: I. B. Tauris, 2007), 24–28.

16 The phrase is taken from the title of Joseph Leo Koerner's fine book *The Reformation of the Image* (London: Reaktion Books, 2004).

17 Peter Fuller, *Images of God: The Consolations of Lost Illusions* (London: Hogarth Press, 1990), 16.

18 Wilfred Owen, preface to the *Collected Poems*, ed. C. Day Lewis (London: Chatto & Windus, 1963), 31.

19 See also Romans 7:15: "For that which I do I allow not: for what I would, that do I not; but what I hate, that I do."

20 Kuspit, *End of Art*, 186.

21 Marie-José Baudinet, "The Face of Christ, the Form of the Church," in *Fragments for a History of the Human Body*, part 1, ed. Michel Feher, with Ramona Naddaff and Tadia Tazi (New York: Zone Books, 1989), 151.

22 For a fuller account of this experience, see Jasper, *Sacred Desert*.

23 Thomas Merton, "Thoughts in Solitude" (1958), in *Thomas Merton: Spiritual Master. The Essential Writings*, ed. Lawrence S. Cunningham, (New York: Paulist Press, 1992), 241–2.

24 Meister Eckhart, "On the Noble Man," in *Selected Writings*, trans. Oliver Davies (Harmondsworth, U.K.: Penguin, 1994), 108.

Chapter 12

1 John Mauchline, *Isaiah 1–39* (London: SCM Press, 1962), 91.

2 Perhaps significantly, the hopeful note sounded in the second part of verse 13 is textually highly problematic, and it is omitted in the

Septuagint version. J. A. Emerton's study of the verse runs to 34 pages and apologizes for its superficiality! "The Translation and Interpretation of Isaiah vi. 13." in *Interpreting the Hebrew Bible: Essays in Honour of E. I. J. Rosenthal*, ed. J. A. Emerton and Stefan C. Reif (Cambridge: Cambridge University Press, 1982), 85–118.

3 For detailed literary discussions, see David Jasper, "On Reading the Scriptures as Literature," *History of European Ideas* 3, no. 3 (1982): 311–34; Kermode, *Genesis of Secrecy*, 28–34. The literature on this problem is vast.

4 Edward Robinson, *The Language of Mystery* (London: SCM Press, 1987).

5 Gertrude Bell, *The Desert and the Sown* (1907). Reprinted with an introduction by Rosemary O'Brien (New York: Cooper Square Press, 2001), 10.

6 Kermode, *Genesis of Secrecy*, 33–34. In Mark's Gospel, parables are thus told to those "outside" *lest* (Gr. ἵνα) they turn, repent, and are forgiven.

7 Brian Wicker, *The Story-Shaped World: Fiction and Metaphysics: Some Variations on a Theme* (London: Athlone Press, 1975), 105.

8 Coleridge, *Biographia Literaria* (1817), 2:6.

9 Gertude Bell, *The Desert and the Sown*, 8.

10 Blake, *Complete Writings*, 153.

11 *Travels of Sir John Mandeville*, 178.

12 Milton, *The Riddle and the Knight*, 179.

13 Jasper and Cuming, *Prayers of the Eucharist*, 132.

Bibliography

Abbott, Evelyn, and E. D. Mansfield. *A Primer of Greek Grammar: Accidence.* London: Rivingtons, 1933.

Abbott, Walter M., S.J., ed. *The Documents of Vatican II.* London: Geoffrey Chapman, 1966.

Adam, David. *The Cry of the Deer.* London: Society for Promoting Christian Knowledge, 1987.

The Alternative Service Book, 1980. A Commentary by the Liturgical Commission. London: CIO Publishing, 1980.

Altizer, Thomas J. J. *The Self-Embodiment of God.* New York: Harper & Row, 1977.

Anderson, A. A. *The Book of Psalms.* 2 vols. New Century Bible. London: Oliphants, 1972.

Apostolos-Cappadona, Diane. *Dictionary of Christian Art.* Cambridge: Lutterworth, 1994.

———, ed. *Art, Creativity and the Sacred: An Anthology in Religion and Art.* New York: Crossroad, 1984.

Arendt, Hannah. *The Human Condition,* 2nd ed. Chicago: University of Chicago Press, 1998.

Aristotle, *On the Art of Poetry.* Translated by T. S. Dorsch. Harmondsworth, U.K.: Penguin, 1965.

Arnold, Matthew. *The Poems of Matthew Arnold, 1849–1867.* Oxford World Classics. Oxford: Oxford University Press, 1924.

Augustine of Hippo. *The City of God.* Translated by Henry Bettenson. Harmondsworth, U.K.: Penguin, 1972.

————. *The Confessions.* Translated by R. S. Pine-Coffin. Harmonds-worth, U.K.: Penguin, 1961.

Bachelard, Gaston. *The Poetics of Space.* Translated by Maria Jolas. Boston: Beacon Press, 1994.

Ballard, J. G. *Low-Flying Aircraft and Other Stories.* London: Triad/Panther, 1978.

Bataille, Georges. *Literature and Evil.* Translated by Alastair Hamilton. London: Marion Boyers, 1985.

————. *Theory of Religion.* Translated by Robert Hurley. New York: Zone Books, 1989.

Baudinet, Marie-José. "The Face of Christ, the Form of the Church." In *Fragments for a History of the Human Body*, part 1, edited by Michel Feher, with Ramona Naddaff and Tadia Tazi, 148–59. New York: Zone Books, 1989.

Beattie, Tina. *The New Atheists: The Twilight of Reason and the War in Religion.* London: Darton, Longman & Todd, 2007.

Beer, Gillian. *Darwin's Plots.* London: Routledge & Kegan Paul, 1983.

Bell, Gertrude. *The Desert and the Sown.* 1907. Reprinted with an introduction by Rosemary O'Brien. New York: Cooper Square Press, 2001.

Benda, Julien. *The Treason of the Intellectuals.* Translated by Richard Aldington. New Brunswick, N.J.: Transaction Publishers, 2009.

Berthoff, Warner. *Literature and the Continuances of Virtue.* Princeton: Princeton University Press, 2002.

Blake, William. *Complete Writings.* Edited by Geoffrey Keynes. Oxford: Oxford University Press, 1966.

Blanchot, Maurice. *The Infinite Conversation.* Translated by Susan Hanson. Minneapolis: University of Minnesota Press, 1993.

————. *The Space of Literature.* Translated by Ann Smock. Lincoln: University of Nebraska Press, 1982.

————. *The Unavowable Community.* Translated by Pierre Joris. New York: Station Hill Press, 1988.

Bloom, Harold. *Kabbalah and Criticism.* New York: Continuum, 1993.

————. *The Western Canon: The Books and School of the Ages.* London: Macmillan, 1995.

Bonnefoy, Yves. *In the Shadow's Light.* Translated by John Naughton. Chicago: University of Chicago Press, 1991.

The Book of Margery Kempe. Edited by S. B. Meech and H. E. Allen. London: Early English Text Society/Oxford University Press, 1940.

Borges, Jorge Luis. *Labyrinths: Selected Stories and Other Writings*. Harmondsworth, U.K.: Penguin, 1970.

Bradley, Ian. *The Celtic Way*. New ed. London: Darton, Longman & Todd, 2003.

Bradshaw, Paul F. "Celebration." In *The Eucharist Today: Studies on Series 3*, edited by R. C. D. Jasper, 133–34. London: Society for Promoting Christian Knowledge, 1974.

Bragg, Melvyn. *The Book of Books: The Radical Impact of the King James Bible, 1611–2011*. London: Hodder & Stoughton, 2011.

Brightman, F. E. *The English Rite*. 2 vols. London: Rivingtons, 1915.

Brigstocke, Hugh, ed. *The Oxford Companion to Western Art*. Oxford: Oxford University Press, 2001.

Britt, David, ed. *Modern Art: Impressionism to Post-Modernism*. London: Thames & Hudson, 1989.

Brown, Peter. *The Cult of the Saints: Its Rise and Function in Latin Christianity*. Chicago: University of Chicago Press, 1981.

Carroll, Robert, and Stephen Prickett, eds. *The Bible: Authorized King James Version*. Oxford: Oxford University Press, 1997.

Celan, Paul. *Selected Poems*. Translated by Michael Hamburger. Harmondsworth, U.K.: Penguin, 1990.

Certeau, Michel de. *The Mystic Fable*. Vol. 1, *The Sixteenth and Seventeenth Centuries*. Translated by Michael B. Smith. Chicago: University of Chicago Press, 1992.

Cervantes. Miguel de. *The Adventures of Don Quixote*. 1604/1615. Translated by J. M. Cohen. Harmondsworth, U.K.: Penguin, 1950.

Chadwick, Owen. *The Reformation*. Harmondsworth, U.K.: Penguin, 1972.

———. *The Secularization of the European Mind in the Nineteenth Century*. Cambridge: Cambridge University Press, 1975.

Chardin, Pierre Teilhard de. *Hymn of the Universe*. London: Collins, 1965.

———. *Le Milieu Divin: An Essay on the Interior Life*. London: Fontana Books, 1964.

Chaucer, Geoffrey. *The Works of Geoffrey Chaucer*. Edited by F. N. Robinson. London: Oxford University Press, 1957.

Chave, Anna C. *Mark Rothko: Subjects in Abstraction*. New Haven: Yale University Press, 1989.

Clark, Timothy. *Martin Heidegger*. London: Routledge, 2002.

Coleman, Ornette. *Free Jazz*, Atlantic SD 1364, 1961, LP.

Coleridge, S. T. *Biographia Literaria*. 1817. Vol. 7 of *The Collected Works*, edited by James Engell and W. Jackson Bate. Princeton: Princeton University Press, 1983.

———. *The Collected Letters*. Vol. IV. Edited by E. L. Griggs. Oxford: Clarendon, 1959.

———. *Lay Sermons*. Vol. 6 of *The Collected Works*, edited by R. J. White. Princeton: Princeton University Press, 1972.

———. *On the Constitution of the Church and State*. 1830. Edited by John Barrell. London: J. M. Dent, 1972.

———. *Poetical Works*. Edited by Ernest Hartley Coleridge. Oxford: Oxford University Press, 1969.

Conrad, Joseph. *The Heart of Darkness* (1902). Toronto: Bantam Books, 1969.

Cooper, Adam G. *The Body in St. Maximus the Confessor: Holy Flesh, Wholly Deified*. Oxford: Oxford University Press, 2005.

Cope, Gilbert. *Making the Building Serve the Liturgy*. London: A. R. Mowbray, 1962.

———, ed. *Christianity and the Visual Arts*. London: Faith Press, 1964.

Cranfield, C. E. B. *The Gospel According to Saint Mark*. Cambridge: Cambridge University Press, 1972.

Cuming, G. J. *A History of Anglican Liturgy*. 2nd ed. London: Macmillan, 1982.

Cunningham, Lawrence S., ed. *Thomas Merton: Spiritual Master. The Essential Writings*. New York: Paulist Press, 1992.

Cupitt, Don. *Taking Leave of God*. London: SCM Press, 1980.

Curtis, William J. R. *Le Corbusier: Ideas and Forms*. New York: Rizzoli, 1986.

Dahinden, Justus. *New Trends in Church Architecture*. Translated by Brother Cajetan. London: Studio Vista, 1967.

Daiches, David. *God and the Poets*. Oxford: Clarendon, 1984.

Dalrymple, William. *From the Holy Mountain*. London: Flamingo, 1997.

Daniell, David. *The Bible in English: Its History and Influence*. New Haven: Yale University Press, 2003.

———, ed. *Tyndale's New Testament (1534)*. New Haven: Yale University Press, 1989.

Danto, Arthur C. *The Abuse of Beauty: Aesthetics and the Concept of Art*. Chicago: Open Court, 2003.

Davies, J. G., ed. *A New Dictionary of Liturgy and Worship*. London: SCM Press, 1986.

———. *The Secular Use of Church Buildings*. London: SCM Press, 1968.

Derrida, Jacques. "How to Avoid Speaking: Denials." In *Languages of the Unsayable: The Play of Negativity in Literature and Literary Theory*, edited by Sanford Budick and Wolfgang Iser, 3–70. New York: Columbia University Press, 1989.

———. *Mémoires for Paul de Man*. Translated by Cecile Lindsay, Jonathan Culler, and Eduardo Cadava. New York: Columbia University Press, 1986.

———. *The Politics of Friendship*. Translated by George Collins. London and New York: Verso, 2005.

———. "Shibboleth." In *Midrash and Literature*, edited by Geoffrey Hartman and Sanford Budick, 307–47. New Haven: Yale University Press, 1986.

———. *Specters of Marx: The State of the Debt, the Work of Mourning, and the New International*. Translated by Peggy Kamuf. New York: Routledge, 1994.

———. *The Work of Mourning*. Edited by Pascale-Ann Brault and Michael Naas. Chicago: University of Chicago Press, 2001.

Detweiler, Robert. *Breaking the Fall: Religious Readings of Contemporary Fiction*. San Francisco: Harper & Row, 1989.

Ding Fang [in Chinese]. Hubei, China: Hubei Fine Arts Publishing House, 2007.

Ding Fang's Pictucre [*sic*] *Album* [in Chinese]. Beijing: Oriental Light Art Development, 1994.

Ding Fang. Twenty Artists of Chinese Oil Painting [in Chinese]. Beijing: n.p., 2004.

Dix, Dom Gregory. *The Shape of the Liturgy*. Westminster: Dacre Press, 1945.

Dostoevsky, Fyodor. *The Brothers Karamazov*. 1879–1880. Translated by David Magarshack. Harmondsworth, U.K.: Penguin, 1958.

Duffy, Eamon, *Marking the Hours*. New Haven: Yale University Press, 2006.

———. *The Stripping of the Altars: Traditional Religion in England, c. 1400–1580*. New Haven: Yale University Press, 1992.

Durkheim, Emile. *The Elementary Forms of the Religious Life*. 2nd ed. Translated by Joseph Ward Swain. London: George Allen & Unwin, 1976.

Eagleton, Terry. *After Theory*. London: Allen Lane, 2003.

———. *On Evil*. New Haven: Yale University Press, 2010.

Easton, Burton Scott, trans. *The Apostolic Tradition of Hippolytus*. Cambridge: Cambridge University Press, 1934.

Eckhart, Meister. *Selected Writings*. Translated by Oliver Davies. Harmondsworth, U.K.: Penguin, 1994.

Edwards, James. C. *The Plain Sense of Things: The Fate of Religion in an Age of Normal Nihilism*. University Park: Pennsylvania State University Press, 1997.

Eliot, T. S. *Selected Essays*. 3rd ed. London: Faber & Faber, 1951.

Ellmann, Richard. *James Joyce*. London: Oxford University Press, 1966.

Emerton, J. A. "The Translation and Interpretation of Isaiah vi. 13." In *Interpreting the Hebrew Bible: Essays in Honour of E. I. J. Rosenthal*, edited by J. A. Emerton and Stefan C. Reif, 85–118. Cambridge: Cambridge University Press, 1982.

Etchells, Ruth. *Praying with the English Poets*. London: Society for Promoting Christian Knowledge, 1990.

Finucane, Ronald C. *Miracles and Pilgrims: Popular Beliefs in Medieval England*. London: J. M. Dent, 1977.

The First and Second Prayer Books of King Edward the Sixth. London: J. M. Dent & Sons, 1910.

Fish, Stanley. *Is There a Text in This Class? The Authority of Interpretive Communities*. Cambridge, Mass.: Harvard University Press, 1980.

Flannery, Austin O.P., ed. *Vatican II: The Liturgy Constitution*. Dublin: Scepter Publishers, 1964.

Forster, E. M. *Aspects of the Novel*. Harmondsworth, U.K.: Penguin, 1962.

Francis and Clare: The Complete Works. Translated by Regis J. Armstrong and Ignatius C. Brady. New York: Paulist Press, 1982.

Frascina, Francis, ed. *Pollock and After: The Critical Debate*. New York: Harper & Row, 1985.

Frost, David L. *The Language of Series 3*. Grove Booklet on Ministry and Worship 12. Bramcote, U.K.: Grove Books, 1973.

Fuller, Peter. *Images of God: The Consolations of Lost Illusions*. London: Hogarth Press, 1990.

Gardner, Helen, ed. *The Faber Book of Religious Verse*. London: Faber & Faber, 1972.

Gassner, John, ed. *Medieval and Tudor Drama*. New York: Bantam Books, 1968.

Girard, René. *Violence and the Sacred*. Translated by Patrick Gregory. Baltimore, Md.: Johns Hopkins University Press, 1977.

Glancey, Jonathan. "Divine Inspiration." *The Guardian*, January 14, 2002.

Guardini, Romano. *Sacred Signs.* rev. ed. Translated by Grace Branham. Wilmington: Michael Glazer, 1979.

Hammond, Peter, ed. *Towards a Church Architecture.* London: Architectural Press, 1962.

Harrison, Anna. "Community among the Dead: Bernard of Clairvaux's *Sermons for the Feast of All Saints*." In *Last Things: Death and the Apocalypse in the Middle Ages*, edited by Caroline Walker Bynum and Paul Freedman, 191–204. Philadephia: University of Pennsylvania Press, 2000.

Hart, Kevin. *The Dark Gaze: Maurice Blanchot and the Sacred.* Chicago: University of Chicago Press, 2004.

Haskins, Susan. *Mary Magdalen: Myth and Metaphor.* London: Harper Collins, 1993.

Hass, Andrew, David Jasper, and Elisabeth Jay, eds. *The Oxford Handbook of English Literature and Theology.* Oxford: Oxford University Press, 2007.

Hebblethwaite, Margaret, and Kevin Donovan, S.J. *The Theology of Penance.* Dublin: Mercier Press, 1979.

Heidegger, Martin. *Basic Writings.* rev. ed. Edited by David Farrell Krell. London: Routledge, 1993.

———. *Elucidations of Hölderlin's Poetry.* Translated by Keith Hoeller. New York: Humanity Books, 2000.

———. "Letter on Humanism." In *From Modernism to Postmodernism: An Anthology*, edited by Lawrence Cahoone, 274–308. Oxford: Blackwell, 1996.

———. *Poetry, Language, Thought.* Translated by Albert Hofstadter. New York: Harper & Row, 1975.

———. *What Is Called Thinking?* Translated by J. Glenn Gray. New York: Harper & Row, 1968.

Hilton, Timothy. *The Pre-Raphaelites.* London: Thames & Hudson, 1970.

Hobbes, Thomas. *Leviathan.* Edited by C. B. Macpherson. Harmondsworth, U.K.: Penguin, 1968.

Hölderlin, Friedrich. *Poems and Fragments.* Translated by Michael Hamburger. London: Anvil Press Poetry, 1994.

Holland, Michael, ed. *The Blanchot Reader.* Oxford: Blackwell, 1996.

Howes, Graham. *The Art of the Sacred: An Introduction to the Aesthetics of Art and Belief.* London: I. B. Tauris, 2007.

Hughes, Jonathan. *The Religious Life of Richard III: Piety and Prayer in the North of England*. Stroud, U.K.: Sutton Publishing, 1997.

Hughes, P. L., and J. F. Larkin, eds. *Tudor Royal Proclamations*. New Haven: Yale University Press, 1967–1969.

Ignatius Loyola. *The Spiritual Exercises*. Edited by Halcyon Backhouse. London: Hodder & Stoughton, 1989.

James, M. R. *The Apocryphal New Testament*. Oxford: Clarendon, 1953.

Jasper, David. "The Desert in Biblical Art." In *Bible, Art, Gallery*, edited by Martin O'Kane, 54–66. Sheffield, U.K.: Sheffield Phoenix Press, 2011.

———. "On Reading the Scriptures as Literature." *History of European Ideas* 3, no. 3 (1982): 311–34.

———. *The Sacred Body: Asceticism in Religion, Literature, Art and Culture*. Waco, Tex.: Baylor University Press, 2009.

———. *The Sacred Desert: Religion, Literature, Art, and Culture*. Oxford: Blackwell, 2004.

———. "Screening Angels." In *The Art of Bill Viola*, edited by Chris Townsend, 181–95. London: Thames & Hudson, 2004.

———. "The Spiritual in Contemporary Art." *Art and Christianity* 65 (2011): 2–6.

———. *The Study of Literature and Religion*. 2nd ed. London: Macmillan, 1991.

———, and Stephen Prickett, eds. *The Bible and Literature: A Reader*. Oxford: Blackwell, 1999.

Jasper, R. C. D., ed. *The Eucharist Today: Studies on Series 3*. London: Society for Promoting Christian Knowledge, 1974.

———, and Paul F. Bradshaw. *A Companion to the Alternative Service Book*. London: Society for Promoting Christian Knowledge, 1986.

———, and G. J. Cuming, eds. *Prayers of the Eucharist, Early and Reformed*. 3rd ed. New York: Pueblo, 1987.

Jeanneret, Charles Edouard, and Amédée Ozenfant. *Après le cubisme*. Torino: Bottega d'Erasmo, 1975.

Jeffrey, David Lyle, ed. *A Dictionary of Biblical Tradition in English Literature*. Grand Rapids: Eerdmans, 1992.

Jeremias, Joachim. *The Eucharistic Words of Jesus*. Translated by Norman Perrin. London: SCM Press, 1966.

Jones, Graham. *Saints in the Landscape*. Stroud, U.K.: Tempus Publishing, 2007.

Jotischky, Andrew. *Crusading and the Crusader States*. London: Pearson, Longman, 2004.

Joyce, James. *Finnegans Wake*. 1939. Harmondsworth, U.K.: Penguin, 2000.

Julian of Norwich. *Revelations of Divine Love*. Translated by Clifton Wolters. Harmondsworth, U.K.: Penguin, 1966.

Jungmann, Joseph A., S.J. *The Early Liturgy to the Time of Gregory the Great*. Translated by Francis A. Brunner. London: Darton, Longman & Todd, 1960.

———. *The Mass of the Roman Rite: Its Origins and Development*. Rev. and abridged ed. Translated by Francis A. Brunner. New York: Benziger Brothers, 1959.

Kant, Immanuel. *Religion within the Limits of Reason Alone*. 1793. Translated by Theodore M. Greene and Hoyt T. Hudson. New York: Harper Torchbooks, 1960.

Kempis, Thomas à. *The Imitation of Christ*. Translated by Leo Sherley-Price. Harmondsworth, U.K.: Penguin, 1952.

Kermode, Frank. *The Genesis of Secrecy: On the Interpretation of Narrative*. Cambridge, Mass: Harvard University Press, 1979.

Kertész, Imre. *Fateless*. Translated by Tim Wilkinson. London: Vintage Books, 2006.

Kidd, B. J. *The Counter Reformation, 1550–1600*. London: Society for Promoting Christian Knowledge, 1933.

Kieckhefer, Richard. *Theology in Stone: Church Architecture from Byzantium to Berkeley*. Oxford: Oxford University Press, 2004.

Kiefer, Anselm. *Heaven and Earth*. Organized by Michael Auping. Published catalogue. Forth Worth: Modern Art Museum of Fort Worth, 2006.

Klemm, David E., and William Schweiker. *Religion and the Human Future: An Essay on Theological Humanism*. Oxford: Blackwell, 2008.

Knights, Ben. *The Idea of the Clerisy in the Nineteenth Century*. Cambridge: Cambridge University Press, 1978.

Koerner, Joseph Leo. *The Reformation of the Image*. London: Reaktion Books, 2004.

Kuspit, Donald. *The End of Art*. Cambridge: Cambridge University Press, 2004.

Lacoste, Jean-Yves. *Experience and the Absolute: Disputed Questions on the Humanity of Man*. Translated by Mark Raftery-Skeban. New York: Fordham University Press, 2004.

Landow, George P. *Victorian Types, Victorian Shadows: Biblical Typol-*

ogy in Victorian Literature, Art and Thought. Boston: Routledge & Kegan Paul, 1980.

Lao Tzu. *Tao Te Ching*. Translated by D. C. Lau. Harmondsworth, U.K.: Penguin, 2009.

Lauterwein, Andrea. *Anselm Kiefer/Paul Celan: Myth, Mourning and Memory*. London: Thames & Hudson, 2007.

Lewis, Agnes Smith, and Margaret D. Gibson. *How the Codex was Found: A narrative of two visits to Sinai, from Mrs. Lewis's journals, 1892–1893*. Cambridge: Macmillan & Bowes, 1893.

Lewis, C. S. *A Grief Observed*. London: Faber & Faber, 1961.

Liddell, Henry George, and Robert Scott. *A Greek–English Lexicon*. 5th ed. Oxford: Clarendon, 1864.

Lin Ci. *Chinese Painting: Capturing the Spirit of Nature with Brushes*. Translated by Yan Xinjian and Ni Yanshuo. Beijing: Chinese Intercontinental Press, 2010.

Littlehales, Henry, ed. *The Prymer, or, Prayer-Book of the Lay People in the Middle Ages*. 2 vols. London: Longmans, Green, 1891.

The Lives of the Desert Fathers. Translated by Norman Russell. Kalamazoo, Mich.: Cistercian Publications, 1980.

Maas, Sander van. *The Reinvention of Religious Music: Oliver Messiaen's Breakthrough toward the Beyond*. New York: Fordham University Press, 2009.

Madoff, Steven. "Anselm Kiefer: A Call to Memory." *ArtNews* 86, no. 8 (1987).

Martin, David, and Peter Mullen, eds. *No Alternative: The Prayer Book Controversy*. Oxford: Blackwell, 1981.

Maskell, William, ed. *Monumenta Ritualia Ecclesiae Anglicanae*. London: W. Pickering, 1846.

Mauchline, John. *Isaiah 1–39*. London: SCM Press, 1962.

McElvey, R. J. *The New Temple: The Church in the New Testament*. Oxford: Oxford University Press, 1969.

McLuhan, Marshall. *The Gutenberg Galaxy: The Making of Typographic Man*. Toronto: University of Toronto Press, 1962.

The Menil Collection. A Selection from the Paleolithic to the Modern Era. Newly updated ed. New York: Harry N. Adams, 1997.

Meyer, C. S., ed. *Cranmer's Selected Writings*. London: Society for Promoting Christian Knowledge, 1961.

Milton, Giles. *The Riddle and the Knight: In Search of Sir John Mandeville*. London: Sceptre, 1996.

Milton, John. *Paradise Lost.* 1667. *Poetical Works,* edited by Douglas Bush. London: Oxford University Press, 1966.

Mo Yan. "The Awakened Dream Teller: Random Thoughts on Yu Hua and His Fiction." In *Yu Hua 2000 Collection: Contemporary China Literary Reader.* Hong Kong: Ming Pao, 1999.

Moore, Stephen D. *Mark and Luke in Poststructuralist Perspective: Jesus Begins to Write.* New Haven: Yale University Press, 1992.

Morris, Brian, ed. *Ritual Murder: Essays on Liturgical Reform.* Manchester, U.K.: Carcanet Press, 1980.

Moule, C. F. D. *An Idiom-Book of New Testament Greek.* 2nd ed. Cambridge: Cambridge University Press, 1971.

Moulton, James Hope. *A Grammar of New Testament Greek.* Vol. 1, *Prolegomena.* 3rd ed. Edinburgh: T&T Clark, 1908.

Murdoch, Iris. *The Fire and the Sun: Why Plato Banished the Artists.* Oxford: Oxford University Press, 1977.

Murray, Peter and Linda Murray. *The Oxford Companion to Christian Art and Architecture.* Oxford: Oxford University Press, 1996.

Nancy, Jean-Luc. *Corpus.* Translated by Richard A. Rand. New York: Fordham University Press, 2008.

———. *Dis-Enclosure: The Deconstruction of Christianity.* Translated by Bettina Bergo, Gabriel Malenfant, and Michel B. Smith. New York: Fordham University Press, 2008.

———. *The Ground of the Image.* Translated by Jeff Fort. New York: Fordham University Press, 2005.

Neiman, Susan. *Evil in Modern Thought: An Alternative History of Philosophy.* Princeton: Princeton University Press, 2002.

Nicolson, Adam. *Power and Glory: Jacobean England and the Making of the King James Bible.* London: HarperCollins, 2003.

Nietzsche, Friedrich. *The Gay Science.* Translated by Josepfine Nauckhoff. Cambridge: Cambridge University Press, 2001.

———. *The Genealogy of Morals.* Translated by Francis Golffing. New York: Doubleday Anchor Books, 1956.

Nicolai de Marthono, Liber Peregrinationis ad Loca Sancta. Vol. 3 in *Revue de l'Orient Latin,* 566–669. Edited by Leon de Grand. Paris: Ernest Leroux, 1895.

Osborne, Harold, ed. *The Oxford Companion to Art.* Oxford: Clarendon, 1970.

Otto, Rudolf. *The Idea of the Holy.* 2nd ed. Translated by John W. Harvey. Oxford: Oxford University Press, 1958.

Owen, Wilfred. *Collected Poems*. Edited by C. Day Lewis. London: Chatto & Windus, 1963.

Pagels, Elaine. *Beyond Belief: The Secret Gospel of Thomas*. London: Macmillan, 2003.

Palladius. *The Lausiac History*. Translated by Robert. T. Myer. New York: Newman Press, 1964.

Pattison, George. *Art, Modernity and Faith: Restoring the Image*. London: Macmillan, 1991.

———. *Crucifixions and Resurrections of the Image: Christian Reflections on Art and Modernity*. London: SCM Press, 2009.

Pevsner, N. "The Counter Reformation and Mannerism." In *Studies in Art, Architecture and Design*. Vol. 1. London: Thames & Hudson, 1968.

Pfatteicher, Philip H. *Liturgical Spirituality*. Valley Forge, Pa.: Trinity Press International, 1997.

Plato. *The Republic*. Translated by H. D. P. Lee. Harmondsworth, U.K.: Penguin, 1955.

Poulet, Georges. *The Metamorphoses of the Circle*. Translated by Carley Dawson and Elliott Coleman. Baltimore, Md.: Johns Hopkins University Press, 1966.

Prescott, H. F. M. *Jerusalem Journey: Pilgrimage to the Holy Land in the Fifteenth Century*. London: Eyre & Spottiswoode, 1954.

———. *Once to Sinai: The Further Pilgrimage of Felix Fabri*. London: Eyre & Spottiswoode, 1957.

Prudentius. *Peristephanon*. Translated by M. C. Eagan. The Fathers of the Church 7. New York: Fathers of the Church, 1949.

Ramsey, Ian T. *Religious Language*. London: SCM Press, 1957.

Rancière, Jacques. *The Flesh of Words: The Politics of Writing*. Translated by Charlotte Mandell. Stanford: Stanford University Press, 2004.

Ratcliff, E. C. "The Sanctus and the Pattern of the Early Anaphora." *Journal of Ecclesiastical History* 1 (1950): 29–36, 125–34.

Ratushinskaya, Irena. *Grey Is the Colour of Hope*. Translated by Alyona Kojevnikov. London: Hodder & Stoughton, 1988.

———. *Pencil Letter*. Newcastle-upon-Tyne, U.K.: Bloodaxe Books, 1988.

Ricoeur, Paul. *Evil: A Challenge to Philosophy and Theology*. Translated by John Bowden. London: Continuum, 2007.

———. *Oneself as Another*. Translated by Kathleen Blamey. Chicago: University of Chicago Press, 1992.

Robinson, Edward. *The Language of Mystery*. London: SCM Press, 1987.

Rorty, Richard. *Objectivity, Relativism, and Truth*. Philosophical Papers, Vol. 1. Cambridge: Cambridge University Press, 1991.

———, and Gianni Vattimo. *The Future of Religion*. Edited by Zabala Santiago. New York: Columbia University Press, 2004.

Rosenberg, David, ed. *Congregation: Contemporary Writers Read the Jewish Bible*. San Diego: Harcourt Brace Jovanovich, 1987.

Rosendale, Timothy. *Liturgy and Literature in the Making of Protestant England*. Cambridge: Cambridge University Press, 2007.

Sancti Columbani Opera. Edited by G. S. M. Walker. Dublin: Dublin Institute for Advanced Studies, 1957.

Sandler, Irving. *The Triumph of American Painting: A History of Abstract Expressionism*. New York: Harper & Row, 1970.

Sangster, Charles, *"The St. Lawrence and the Saguenay": And Other Poems*. New York: John Creighton & John Duff, 1856.

Schwarz, Rudolf. "The Eucharistic Building." Translated by V. Hoecke. *Faith and Form* 2 (1969): 21–22.

———. *Vom Bau der Kirche* [*The Church Incarnate*]. Chicago: Regnery, 1938.

Scott, David. *A Quiet Gathering*. Newcastle-upon-Tyne, U.K.: Bloodaxe Books, 1984.

Screech, M. A. *Laughter at the Foot of the Cross*. London: Allen Lane, 1997.

Shakespeare, William. *Henry VI, Part I*. Edited by Lawrence V. Ryan. New American Library: New York, 1989.

———. *A Midsummer Night's Dream*. The New Shakespeare, edited by Sir Arthur Quiller-Couch and John Dover Wilson. Cambridge: Cambridge University Press, 1969.

———. *Hamlet*. The New Shakespeare, edited by John Dover Wilson. Cambridge: Cambridge University Press, 1971.

———. *King Lear*. The Arden Shakespeare, edited by Kenneth Muir. London: Methuen, 1972.

Sheldrake, Philip. *Spaces for the Sacred: Place, Memory and Identity*. London: SCM Press, 2001.

Smith, Jane I. "Islam and Christendom." In *The Oxford History of Islam*, edited by John L. Esposito, 305–45. Oxford: Oxford University Press, 1999.

Soskice, Janet. *Sisters of Sinai: How Two Lady Adventurers Found the Hidden Gospels*. London: Vintage Books, 2010.

Soyinka, Wole. *Mandela's Earth and Other Poems*. London: Methuen, 1990.

Steiner, George. *After Babel: Aspects of Language and Translation*. 2nd ed. Oxford: Oxford University Press, 1992.

———. *Real Presences*. London: Faber & Faber, 1989.

Taylor, Mark C. *Disfiguring: Art, Architecture and Religion*. Chicago: University of Chicago Press, 1992.

———. *Erring: A Postmodern A/theology* Chicago: University of Chicago Press, 1984.

———, ed. *Deconstruction in Context: Literature and Philosophy*. Chicago: University of Chicago Press, 1986.

Templeton, Douglas A. *The New Testament as True Fiction: Literature, Literary Criticism, Aesthetics*. Sheffield, U.K.: Sheffield Academic Press, 1999.

Thompson, Bard. *Liturgies of the Western Church*. Cleveland, Ohio: Meridian Books, 1961.

Tillich, Paul. "Art and Ultimate Reality." In *Art, Creativity and the Sacred: An Anthology in Religion and Art*, edited by Diane Apostolos-Cappadona. New York: Continuum, 1995.

———. *Theology of Culture*. Oxford: Oxford University Press, 1959.

Tolbert, Mary Ann. *Sowing the Gospel: Mark's World in Literary-Historical Perspective*. Minneapolis: Fortress, 1989.

The Travels of Sir John Mandeville. Translated by C. W. R. D. Moseley. Harmondsworth, U.K.: Penguin, 2005.

Turner, Victor W. *Dramas, Fields, and Metaphors*. Ithaca: Cornell University Press, 1974.

———. *The Ritual Process: Structure and Anti-Structure*. Harmondsworth, U.K.: Penguin, 1974.

Tyndale, William. *The Obedience of a Christian Man*. Edited by David Daniell. Harmondsworth, U.K.: Penguin, 2000.

Vattimo, Gianni. *After Christianity*. Translated by Luca D'Isanto. New York: Columbia University Press, 2002.

Vaughan, Henry. *Poetry and Selected Prose of Henry Vaughan*. Edited by L. C. Martin. London: Oxford University Press, 1963.

Viola, Bill. *Reasons for Knocking at an Empty House: Writings, 1973–1994*. London: Thames & Hudson, 1995.

Voragine, Jacobus de. *The Golden Legend: Readings on the Saints*. 2 vols. Translated by William Granger Ryan. Princeton: Princeton University Press, 1993.

Wainwright, Geoffrey. *Doxology: The Praise of God in Worship, Doctrine and Life*. London: Epworth Press, 1980.

The Wanderings of Felix Fabri. Translated by A. Stewart. London: Palestine Pilgrims' Text Society, 1892–1897.

Ward, Benedicta, S.L.K.G. *Harlots of the Desert: A Study of Repentance in Early Monastic Sources.* Kalamazoo, Mich.: Cistercian Publications, 1987.

Wheeler, Kathleen, ed. *German Aesthetic and Literary Criticism: The Romantic Ironists and Goethe.* Cambridge: Cambridge University Press, 1984.

Wicker, Brian. *The Story-Shaped World: Fiction and Metaphysics: Some Variations on a Theme.* London: Athlone Press, 1975.

Wiesel, Elie. *Night.* Foreword by François Mauriac. Harmondsworth, U.K.: Penguin, 1981.

Wilcox, Helen, ed. *The English Poems of George Herbert.* Cambridge: Cambridge University Press, 2007.

Wilkinson, John. *Jerusalem Pilgrims before the Crusades.* Warminster: Aris & Phillips, 2002.

———, ed. *Egeria's Travels.* London: Society for Promoting Christian Knowledge, 1971.

Wilson, H. A., ed. *The Gelasian Sacramentary.* Oxford: Clarendon, 1894.

Yarnold, Edward. *The Awe Inspiring Rites of Initiation: Baptismal Homilies of the Fourth Century.* Slough, U.K.: St. Paul Publications, 1971.

Yu Hua. *To Live.* Translated by Michael Berry. New York: Anchor Books, 2003.

Xia Kejun. *Painting of Remnant Image.* Translated by Cen Yixuan. Beijing: Guangxi Normal University Press, 2009.

Zabala, Santiago. *The Remains of Being: Hermeneutic Ontology after Metaphysics.* New York: Columbia University Press, 2009.

———, ed. *Weakening Philosophy: Essays in Honour of Gianni Vattimo.* Montreal and Kingston: McGill-Queen's University Press, 2007.

Index